DATE DUE

MAR 1 4 2005	
Mar. 22	
SEP 2 9 2006	
GAYLORD	PRINTED IN U.S.A.

Edward S. Curtis and the North American Indian Project in the Field

Edward S. Curtis and the North American Indian Project in the Field

Edited and with an
introduction by
Mick Gidley

UNIVERSITY OF NEBRASKA PRESS

LINCOLN AND LONDON

⊗

"Entering Apache Lands," by Harold P. Curtis, c. 1948; an
excerpt from "Traveling the Route of Lewis and
Clark—One Hundred Years Later," by Edward S. Curtis,
n.d.; an excerpt of a reminiscence by Edward S. Curtis; an
excerpt of a memoir by Florence Curtis Graybill; an
excerpt of Beth Curtis Magnuson's Log of Her Alaskan
Voyage, 1927; an excerpt from "A Rambling Log of the
Field Season of the Summer of 1927," by Edward S. Curtis,
1927; and an excerpt from "Indian Religion," a lecture by
Edward S. Curtis, 1911, are reprinted courtesy of James
Graybill.
Excerpts from "The Gods Forbid," "Among the Tewas,"
and "With the Cheyennes" by W. W. Phillips are reprinted
courtesy of the late W. S. Phillips.
"Apache Religious Beliefs," by Edward S. Curtis, c. 1911;
Field Notes on the Willapas by W. E. Myers, 1910; and A
Reminiscence of George Hunt, by Edward S. Curtis, c.
1930s, are reprinted courtesy of the Seaver Center for
Western History Research, Los Angeles County Museum
of Natural History.
The Hodge Papers letters by W. E. Myers to Frederick
Webb Hodge, 1908; by Edward S. Curtis to Frederick
Webb Hodge, 1909; and by Stewart C. Eastwood to
Frederick Webb Hodge, 1927, are reprinted courtesy of the
Southwest Museum, Los Angeles CA.
The Edmond S. Meany Papers letters by Edwin J. Dalby to
Edmond S. Meany, 1908, and by Edwin S. Curtis to
Edmond S. Meany, 1922, are reprinted courtesy of Special
Collections, University Archives, University of
Washington Libraries.
The excerpt from "Among the Blackfoot Indians of
Montana," by A. C. Haddon, c. 1914, is reprinted courtesy
of the Syndics of Cambridge University Library.
Unless otherwise indicated, all photographs in this book
were made by Edward S. Curtis; the reproductions come
from negatives or prints in the Curtis copyright files of
the Prints and Photographs Division of the U.S. Library
of Congress. Titles are as given in those files, though dates
are either those of the year in which it is known they were
made or, failing that, the year they were copyrighted. The
number given in the caption is the Library of Congress
(LC) lot number followed by the Curtis negative number
or, where it exists, the LC negative number (such as USZ62
followed by a number). Further information on a
photograph's contents and relevance is given in its
caption.

Library of Congress Cataloging-in-Publication Data
Edward S. Curtis and the North American Indian project
in the field / edited and with an introduction by Mick
Gidley.
 p. cm.
Includes bibliographical references and index.
ISBN 0-8032-2193-2 (cloth: alk. paper)
1. Curtis, Edward S., 1868–1952. 2. Curtis, Edward S.,
1868–1952. North American Indian. 3. Indians of North
America—Portraits. 4. Indians of North
America—Pictorial works. I. Gidley, M. (Mick)
E77.5.E39 2003
970.004'97—dc21
2002043037

In Memory
Doris Florence Gidley &
Bernice and Myron Gordon

Contents

List of Illustrations viii

Preface ix

Acknowledgments xi

Explanatory Notes xiii

1 Introduction 1

2 In the Southwest 30

3 On the Plains 57

4 In the Northwest 82

5 Up and Down the West Coast 108

6 Generally Speaking 131

Notes 149

References Cited 163

Index 171

Illustrations

following page 84

1. Author's Camp among the Spokan
2. Edward S. Curtis
3. Camp Curtis
4. Red Cloud, Edmond S. Meany, and others
5. The Talk
6. The Village Herald
7. The Offering
8. Hopi Snake Priest
9. Apache Still Life
10. Women at Camp Fire
11. San Ildefonso Tablita Dance
12. Bear Black
13. Hunka Ceremony
14. Tearing Lodge and his Wife
15. Indian Maiden
16. Stormy Day
17. On Quamichan Lake
18. *Kominaka* Dancer
19. A Chief—Chukchansi
20. Eskimos at Plover Bay
21. *Kenowun*
22. On the River's Edge
23. A Swap
24. Modern Chemehuevi Home
25. One Blue Bead

Preface

The book *The North American Indian* (1907–1930), credited to Edward S. Curtis, is becoming ever better known. In recent years, for example, almost all of its photographic images have been reproduced in one (admittedly very thick) paperbound volume, and Anne Makepeace's documentary film *Coming to Light* (2000), which celebrates Curtis's achievements, has been widely screened. In addition, the photogravures from *The North American Indian* have been made freely available in digitized form on the World Wide Web, and there are plans to do the same with the extensive written material to be found in the original volumes (hitherto only accessible either in a reprint edition that is no longer available or in an abbreviated form between the covers of anthologies, such as my own *The Vanishing Race* [1976]). The present book is an effort to make available materials that are not yet in the public domain. Publications have appeared that purport to be collections of unpublished data. The most significant is *Prayer to the Great Mystery: The Uncollected Writings and Photography of Edward S. Curtis* (1995), edited by Gerald Hausman and Bob Kapoun, a book that does indeed include among its illustrations many previously unpublished photographs. All of the verbal text in Hausman and Kapoun's book, however, is taken from the published volumes of *The North American Indian*.[1] By contrast, the emphasis of *Edward S. Curtis and the North American Indian Project in the Field* is on written documents, most of which have never been published—or, if they had been previously published they languished uncollected in journals and the like for some ninety years. (I give information in headnotes and endnotes on the few cases where they have been reprinted—usually only in part—more recently.) In addition, almost all the images in the present book were not reproduced or exhibited during Curtis's lifetime and have not been published since. The introduction explains the rationale of my selections. I hope you will enjoy reading the encounters presented here.

Acknowledgments

This book comes out of a long personal engagement with Curtis's expansive project, an engagement that resulted in the publication of the anthology referred to in the preface, a number of essays, and *Edward S. Curtis and the North American Indian, Incorporated* (1998).[2] I would like to acknowledge the considerable help I have received. I was granted fellowships by the American Council of Learned Societies and the Netherlands Institute for Advanced Study, that together gave me the time and opportunity to research and write up my findings. I received periods of study leave from the universities of Exeter and Leeds, and financial assistance from the American Philosophical Society, the British Academy, and the U.S. Information Service. The Burke Museum at the University of Washington, Seattle, provided welcome hospitality for an academic year at the beginning of my work. Numerous archives and private collectors, many of them listed in the references, gave generous help, either face to face or at long distance, in tracing documents reproduced here. Needless to say, the citation of a library or archive—even of a named librarian or archivist—is an inadequate acknowledgment of the many acts of personal kindness I experienced from individuals associated with these much valued institutions. The families of Edward Curtis and of some of his associates were unfailingly helpful and gracious—particularly, in the case of this book, James Graybill, Curtis's grandson, and W. W. Phillips II and Brian Phillips, descendants of W. W. Phillips. I would also like to express my sincere thanks to the owners of materials used, each of whom is cited in the references, and to the editors and publishers of earlier works of my own that are now incorporated, in revised form, here; these too are appropriately referenced. Scholars and writers interested in Curtis and *The North American Indian* seem, invariably, to be pleasant people. I have benefited from contact with this small community and, in connection with this book, would like to mention A. D. Coleman, James Faris, Bill Holm, Martha Kennedy, Anne Makepeace, George Quimby, Martha Sandweiss, Alan Trachtenberg, Gerald Vizenor, Gloria Cranmer Webster, and the two anonymous readers for the University of Nebraska Press. I am fortunate that my family—my original family, my in-laws, and my immediate family—has been wonderfully supportive; the dedication is an inadequate recognition of this fact. It is far, far from a mere duty that I must again, and most of all, give thanks for and to Nancy, my partner and wife.

Explanatory Notes:
On Dates, Omissions, and Tribal Names

In the headings for the writings reproduced here, the first date given is the year of composition; any uncertainty about the date is signaled by c. for circa. When a second date appears in parentheses it indicates the year in which the events described took place; again, any uncertainty is signaled by c. for circa. The headnote usually offers a full elucidation of the nature of the document following, including any uncertainties about its status—such as the context in which it was written, the biographical circumstances that might have affected it, and, where relevant, any previous publication history. The headnotes are not uniform in length or format, mainly because some of the records selected here simply need longer, more complex or more detailed introductions. Also, wherever possible I have used the headnotes and linking passages to construct a narrative sequence between documents.

In the documents themselves any omissions are indicated by ellipses. For the most part, material has been omitted only because I have judged it repetitious, extraneous, or unnecessary to the matter at hand, and for these ommissions no explanation is offered. Where material of some substance has been omitted—for reasons of space, availability in the same or similar form elsewhere, or the like—its nature is outlined in the headnote or in an endnote.

The names of the various peoples and tribes used here are those current during the project's era and, therefore, the ones typically used by Curtis and his associates. Almost all of them are still used or at least understood today. In instances where these names are potentially confusing, or now outmoded or considered disrespectful, the preferred current term, with a note of explanation, is used.

Edward S. Curtis
and the North American Indian Project in the Field

1 Introduction

THE ORIGINS AND SCOPE OF THIS BOOK

Edward S. Curtis's *The North American Indian* (published from 1907 to 1930) is a monumental set of 20 volumes of illustrated written text and a parallel set of 20 portfolios of large-size photogravures. Perhaps more famous than read—owing to its huge scale—it is devoted to more than 80 different Native American peoples living west of the line of the Mississippi River who, in the words of Curtis's preface to volume 1, "still retained to a considerable degree their primitive customs and traditions." Each bulky volume of written text covers a group of culturally related peoples—the first volume, for example, includes three peoples of the Southwest culture area, the Apaches, Navajos, and Jicarilla Apaches—or a single significant people. Thus volumes 10 and 12 treat, respectively, the Kwakiutls of the Northwest Coast and the Hopis of Arizona. Accounts typically embrace every part of a people's culture, from their material sustenance, their history, and their forms of kinship and government to their religious beliefs and expressive arts. Moreover, almost all the volumes include much sheer data: recorded myths and songs, oral histories and vocabularies, designs for masks, dolls, baskets and wall-hangings, and much else. Each volume of text has approximately 75 beautifully reproduced photogravures—engravings made mechanically from photographs—and the accompanying portfolios each contain at least 35 12-by-16-inch (30-by-40-centimeter) photogravure plates. At the time of first publication *The North American Indian* synthesized existing knowledge, but it was also a new work, whose content was predominantly based on first-hand field activity undertaken by the figures whose words are reproduced in this book.

Work toward what became *The North American Indian*, especially its picture-

making aspect, actually began some years ahead of the first volume's publication, certainly as early as 1895, and throughout its production many more figures than Curtis were involved. The reader will, therefore, encounter reports by the project's ethnological assistants, memoirs by Curtis family members, contemporary news stories by reporters who got close to the project but whose identities are unknown, and material emanating from Curtis himself. The project, which also led to the production of the first feature-length narrative documentary film, *In the Land of the Head-Hunters* (1914), gave rise to attendant photographic exhibitions, books for younger readers, magic lantern lectures, an epic entertainment called the "musicale," and, as can be seen frequently here, popular magazine and newspaper articles. The project was also embedded in the politics and artistic patronage of its time, and today raises a range of problematic issues in regard to the representation of Native American cultures; since it almost certainly constitutes the largest nongovernmental anthropological enterprise ever undertaken, it is not surprising that some of these issues are beyond the scope of this book.[1]

As the title indicates, this book concentrates on the Curtis project's relationships with American Indian peoples in their ancestral homelands and on the reservation lands inhabited by them throughout the American and Canadian Wests. It was created primarily to reproduce previously unpublished or uncollected records— reminiscences, letters and reports, contemporary fieldnotes, articles in magazines, newspaper items, and the like—of the project's firsthand encounters with the in-digenous groups and individuals treated in *The North American Indian*. While these accounts should—and, indeed, do—provide new, freshly ordered, and interesting information and insights about the people(s) discussed, they also tell a great deal about the figures who wrote them: about their natures, their personal histories and attitudes, their preconceptions, and their readiness to learn. That is, taken as a whole, *The North American Indian Project in the Field* has a double focus: Native American life-ways *and* white predilections. Moreover, just as sometimes happens when a person with bifocal glasses raises his or her gaze, it may be that on occasion one of the views is sharply clear while the other is but a blur. Except in this introduction, within each chapter I have given only as much contextual information—in the form of headnotes and linking passages—as seems necessary to allow the import of any particular item to come across, often by making a connection with one or more of the published volumes of *The North American Indian*. I have also tried to sequence the documents—which are of different lengths and variable significance—in such a manner that we can oftentimes discern unfolding narratives.

Given this book's double focus, it is almost inevitable that at times either the subject or the speaker will seem to take on a representative function, not just tale and teller but *Indian* life-ways and *white* predilections. There is a profound sense in that what we have here *are* Native customs and white perspectives, but I hope that the commentaries undermine any easy—or uneasy—"us" and "them" positioning to which the texts alone might lead. I have pointed up some of the postures of speakers that now seem all too typical of the forms of racism common in the dominant culture of the time. Curtis himself, for example, often assumed the right to judge Indian peoples, to categorize them as if they were less than fully human—indeed, in the first chapter here he characterizes Apache people as "possessing perhaps more of the attributes of the animal than any other tribe." It would be easy to dwell on such errors, but I have tried to treat them with a relatively light touch. After all, the special force of a primary document is that by allowing us into the mind of someone other than ourselves, it can make us aware of— and even give us some insight into—individual, historical, and cultural *difference*. Nevertheless, we readers must also realize that even when we become aware of, say, a particular commentator's bias, it does not mean that making an allowance for that bias necessarily leads to the truth. Not one of the accounts in this book grants unmediated access to Indian cultures; at a fundamental level we readers are, here, always looking *at* them. We can never escape the ideological constraints of the dominant culture of that time.

Indeed, these texts take their place among the mass of accounts often categorized as a genre of writing in its own right—the literature of encounter. The genre embraces records of contact from the period of the earliest meetings between European sailors and the indigenous inhabitants of the Caribbean, through missionary reports and the diaries of imperial government agents and the like, to the more casual asides of gentleman tourists and the contrastingly detailed ethnographies of trained anthropologists. All this writing has, in turn, given rise to extensive analysis and theoretical debate, including broad efforts to codify the common features of encounter through time, detailed studies of particular genres or subgenres (such as travel writing and ethnography), and monographs on the representation of specific peoples. In itself such analysis and theorizing is beyond the scope of this book, though I have, of course, drawn upon it.[2] At the same time it is as well constantly to remember what has become almost a mantra of such analysis and theorizing: whatever any particular document tells us about the group encountered, it always tells us much about those—such as Curtis and his associates—who wrote the account.

EDWARD S. CURTIS

Edward Sheriff Curtis was born into a relatively poor Wisconsin family on February 19, 1868. He received only an elementary school education during his childhood years in Cordova, Minnesota, probably learned the basics of photography in a studio in St. Paul or Minneapolis, and migrated westward to the state of Washington with his father, Johnson, in the autumn of 1887. The pair settled on a small farm in Sidney (now Port Orchard), across Puget Sound from Seattle, and most other members of the family joined them the following spring. Johnson died soon after, leaving the young Edward to take care of his mother and the other children. Curtis tried his hand at various ways of making a living, including brickmaking, before buying into a Seattle photographic and engraving studio. Thereafter his rise in Seattle society was rapid: he married Clara Phillips; he became the sole proprietor of his own studio (in which various members of the Curtis-Phillips family were employed); he initiated friendships with a number of influential younger business and professional people, such as Samuel Hill, the railroad entrepreneur, and Edmond S. Meany of the University of Washington (see fig. 4); he became a leading figure in the preeminent mountaineering club in the Pacific Northwest, the Mazamas; he built up his business into *the* Seattle portrait studio, the one with the most social cachet; and he began to project himself nationally.

Curtis was a gifted photographer in a range of genres. Through reading, personal relationships, and, with the passage of time, direct exposure to the work of major art photographers of his own generation, such as Alfred Stieglitz and Frank Eugene, he also became well acquainted with fashionable trends in the medium. Stieglitz and other avant garde photographers then favored pictorialism, with its emphasis on the totality of the picture and the achievement of effects through the deployment of broad masses of light and shade, often in a painterly manner. In general they did not revere attention to details through the sharp focus so often associated with the mechanical record-making properties of the camera. Rather, they preferred to deploy reflections or shadows in a studied manner. Curtis began to bring these trends to the photography of the local Coastal Salish people of Puget Sound, probably as early as 1892. By 1895 he had made several powerful images of Princess Angeline, the daughter of Chief Sealth from whom the city of Seattle had taken both its name and, literally, its title to the land. Curtis persisted with the same aesthetic practices through most of his work for *The North American Indian* (fig. 15 typifies what I mean).[3]

Curtis had extraordinary drive and much charm. His dynamism and talent

enabled him to win photographic prizes and to publish articles in regional and national magazines. His first significant national triumph was the publication in the leading journal *Century* of an illustrated article, based on his own firsthand knowledge of, as he called it, "The Rush to the Klondike Over the Mountain Passes": the Alaskan gold rush of 1897, for which Seattle was the principal take-off point. His friendships, through the Mazamas especially, brought him into contact with many figures who could—and later did—become his patrons. He was appointed Official Photographer to the Harriman Alaska Expedition of 1899, an expedition launched, financed, and captained by the Union Pacific Railroad tycoon Edward H. Harriman, to explore part of the Alaskan coastline in the company of a team led by Dr. C. Hart Merriam. The Harriman Expedition team consisted of some of the most prominent natural historians of the day, such as conservationist John Muir, ornithologist John Burroughs, and geologist Grove Karl Gilbert.[4]

Curtis's images—his landscapes, especially his mountaineering views; his portraits, particularly of children; and most of all his "picturesque genre studies" of indigenous people—began to be widely circulated and to receive praise and prizes. The picturesque genre studies were scenes of everyday life: local Indian fisher-folk canoeing home with their catch in the evening or digging for clams along the shore, and Indians from slightly further afield picking hops or weaving baskets. Sometimes they entailed visits to nearby reservations, such as Tulalip just north of Seattle, where Curtis witnessed Native American traditional life-ways more intensively than was possible among the growing urban Indian population on the fringes of the city itself. Partly out of opportunism, in that at first it was so immediately successful, Curtis increasingly devoted disproportionate amounts of time and energy to the making of his series of Indian images. But from 1900—and perhaps as early as 1898—he began to conceive of turning this Indian work, which by then was a semicoherent collection, into a major publication project. He was greatly encouraged in this endeavor by fellow Harriman Expedition member George Bird Grinnell, the editor of the national journal of outdoor life *Forest and Stream*, a man who had himself devoted many summers to studying northern Plains peoples, especially the Blackfeet, Pawnees, and Cheyennes. Curtis accompanied Grinnell on a visit to the sun dance of the Blackfeet—a religious rite in which young men fast and suffer severe mortification of the flesh in pursuit of visions—and, according to Curtis family lore, was so moved by the experience that he committed himself to the task of creating a record of such ceremonies as a memorial to peoples he increasingly saw as a "vanishing race."[5]

For some years Curtis expended much of the proceeds from the Seattle studio

on photographic field trips to many parts of the West, gathering material. He also sought patronage for the large-scale project from a range of possible sources, including government agencies, scientific institutions such as the Smithsonian, and wealthy industrialists, landowners, and philanthropists. Curtis did gain some help from local Seattle grandees—Judge Thomas Burke, for example, a far-sighted Republican interested in all the cultures of the Pacific Rim—and his services as a portraitist were demanded even by such celebrated national figures as Theodore Roosevelt, who commissioned him to take the family photographs that officially commemorated his inauguration as president. Also, Grinnell composed a laudatory essay about Curtis's "Portraits of Indian Types"—illustrated with visual examples— and, for maximum national effect, placed it in the popular *Scribner's Magazine*.[6] Nevertheless, and despite successful exhibitions at such venues as the Waldorf-Astoria Hotel in New York City and rapturous receptions for Curtis's slideshows at such prestigious locations as Washington's Cosmos Club, his efforts to secure funding for the Indian work proved fruitless.

Curtis devoted much of 1904 to Indian fieldwork, and he did not restrict himself to pictures. At the end of the season—which he spent mostly in the Southwest culture area, working with the Jicarillas in northern New Mexico, with the Hopis and the Navajos in Arizona, and with various Pueblo peoples along the Rio Grande— he told Frederick Webb Hodge, a new friend he had acquired at the Bureau of American Ethnology in Washington DC, that he wished to return soon to the White Mountain Apaches, "more for information than pictures." What was to become *The North American Indian* was taking shape. It gained its final contours, more or less, in Curtis's negotiations with the person who ultimately agreed to provide the funds to make it possible: J. Pierpont Morgan. It is not clear how Morgan, the powerful banker and magnate, was persuaded to make the publication a reality. Possibly it was through the intervention of Robert Clark Morris, a prominent lawyer friendly to Curtis who was retained as a counsel by the Morgan Bank. In any case, by the end of January 1906 Morgan had agreed to finance the fieldwork for the project at the rate of fifteen thousand dollars per annum for five years, while Curtis undertook to look after the actual publication himself.[7]

In early February 1906 Curtis told President Roosevelt of his success; the president's response was jubilant: "I congratulate you with all my heart. That is a mighty fine deed of Mr. Morgan's." Thereafter Morgan, and then his son "Jack" (who inherited the banking empire in 1913), made a succession of further subventions; one agreement, signed in 1910, included clauses to provide for the establishment of a Morgan-run corporation, The North American Indian, Incorporated, to administer

the project's affairs. When the initial 1906 agreement was signed, a New York office was immediately established to promote the colossal publication of *The North American Indian* that Morgan and Curtis had agreed upon: not just pictures, but 20 volumes of text, too. *The North American Indian* was to be sold on a subscription basis—mostly to wealthy individuals and major libraries—in a severely limited edition of luxuriously beautiful, leather-bound books. In exchange for this extensive long-term Morgan funding Curtis both passed over to the Morgan Bank all his rights to *The North American Indian* and its images and agreed to commit himself to selling subscriptions to the work. As a result, and despite the Morgan largesse, Curtis was tied to a treadmill of sorts.[8]

Nevertheless, in the initial stages at least, the injection of funds from one of the world's richest and most influential people allowed organizational improvements, set a stamp of approval on the project's more ambitious aspects, and gave the work a mighty boost. Arrangements already instituted for the management of the Curtis studio in Seattle were formalized: its running would be left to Adolf F. Muhr, manager since 1904, who would have freedom to enroll staff in addition to the various members of Curtis's extended family who were employed there over the years. One of those to be taken on was Ella McBride, who (after Muhr's death) virtually ran the studio during the teen years of the twentieth century. Another was Imogen Cunningham, later a leading modernist photographer in her own right. With the breakdown of Curtis's marriage, which ended in an acrimonious divorce in 1919, the Seattle studio came to be run by his former wife, Clara, who employed various people to operate it. Curtis moved his own studio to Los Angeles, to be managed by Edward and Clara's daughter, Beth Curtis Magnuson. By then Curtis's main preoccupation was not the studio but the North American Indian project.

Curtis remained the project's driving force until the completion of *The North American Indian* in 1930, and he was always its figurehead. He took, it seems, either all or virtually all of the thousands of photographs reproduced as photogravures in *The North American Indian*, and many of these—as well as others of his Indian images—were widely exhibited in museums and galleries, published in magazines and newspapers, sold separately as art objects in their own right, and issued as postcards. Curtis organized much of the fieldwork, employing helpers of all sorts, sometimes with careless—even callous—disregard as to whether he could afford to pay them properly, and accounted, as best he could, to Morgan Bank officials. Out in the field, along with other members of the project, he collected masses of folklore data, including phonographic cylinder recordings of music and ceremonies and, as one of his own specialties, extensive film footage. He contributed to the final

versions of the written text of at least some of the published volumes of *The North American Indian*, especially during the first and last years of the project.

The need to sell subscriptions to "the work," as he called it, increasingly took precedence. Meanwhile he tried incessantly both to raise extra funds from other sources, including many of the rich individuals targeted as subscribers (such as Gifford Pinchot or Andrew Carnegie), and to publicize the project through other means. In the early years of the project, for example, he ingratiated himself with Francis Leupp, Roosevelt's commissioner for Indian Affairs, and in the twenties he chaired the Indian Welfare League, an organization which, among other things, campaigned successfully for Indians to be granted the mixed blessing of U.S. citizenship. (They were mixed in that with individual citizenship many Indians risked losing specifically *Indian* rights, such as recognition of treaties negotiated with them as nations). Curtis orchestrated numerous "interviews," such as one with Edward Marshall that was published in *The Hampton Magazine* in 1912, as publicity for himself and the project. In a story too long and complicated to relay here, Curtis was always looking for the main chance to break through into "establishment" fame and fortune, as it were; in fact, he even sometimes borrowed money he couldn't repay and often overcommitted himself to several related activities. Perhaps not surprisingly, it was his extended absences from home that ruined his marriage and, to varying degrees, endangered his relationships with his four children.[9]

Curtis's publicity-seeking role meant that he came to write a series of accessible, illustrated Indian articles for *Scribner's*, to produce popularizing books such as *Indian Days of the Long Ago* (1914), and to embark upon lecture tours, exhibitions, and other events that placed him and the project in the limelight. In 1911 he mounted an elaborate "musicale," or "picture opera," on Native American cultures, complete with original music and sizable orchestra, that both filled New York's Carnegie Hall and toured the eastern states. He set up a corporation to produce *In the Land of the Head-Hunters*, his narrative documentary film set in Kwakiutl land in the Pacific Northwest, originally released in 1914, and he later spent time in Hollywood in the commercial movie industry. In 1915 he secured a year-long commission from *Frank Leslie's Magazine* to provide images of the "beauty spots of America" on a regular basis, and simultaneously entered into an agreement with the Hearst Corporation to produce short movie treatments (known as "Curtis Scenics") of the same locations. Curtis tried continually to establish business and publicity links with various world's fairs. He made a number of property deals over the years, some of them involving Indian reservation lands, and in the late twenties began to develop an interest in mining. Once *The North American Indian* was finally completed he maintained his

mining concerns and, as he lost some physical mobility through advancing age, tended a small holding in Whittier, California. Until his death in 1952 he devoted much of his time during these last years to writing about his Indian experiences, and some of these accounts appear in this book.[10]

THE NORTH AMERICAN INDIAN

The requirements demanded by the amount and range of textual material agreed upon by Curtis and Morgan led Curtis to seek an authoritative figure as the official, credited editor of *The North American Indian*. Frederick Webb Hodge, his contact at the Bureau of American Ethnology, agreed to serve as the work's editor at a fixed fee per word, and in fact stayed with the project until the end. When appointed, Hodge, who was born in 1864 and lived until 1956, was already editor of both the *American Anthropologist* journal and what was to become a standard two-volume reference work, the *Handbook of American Indians North of Mexico* (1910). At the time Hodge was one of the most respected figures in American anthropology. He had conducted important excavations at Enchanted Mesa, near Acoma, New Mexico, and had written numerous papers on a range of Native American topics, from ancient migratory patterns to current social conditions. Most significant of all, Hodge had the knack of maintaining friendships with a gamut of other anthropological scholars, some at loggerheads with one another or with conflicting interests, which meant that he was trusted by most leading practitioners of the fledgling discipline. He was later to head the Museum of the American Indian in New York City before moving to a similar key directorial position at the Southwest Museum in Los Angeles. Fortunately, much of Hodge's correspondence survives, and it is clear that his role in the project was very important though not truly pivotal. He supplied up-to-date publications about each people to be visited, gave advice on other sources of expertise (to be found both in academia and in the field), checked the text before it went to the printer, and compiled an index to each volume. But, except in the case of one of the final volumes—the tone and content of which he tried to change at a late point in its evolution—Hodge seems to have been more of a facilitator than an interventionist editor. He did his utmost to keep the publication going.[11]

Equally crucial from an ethnological point of view, the Morgan money made it feasible to employ Native American assistants, informants, and interpreters on a regular basis and, in effect, put a (constantly changing) team together. Interpreters were usually recruited out in the field as the project progressed, but key informants and link personnel were arranged ahead of time or even kept on a retainer. Some

of these figures—Sojero, an interpreter who helped out among the Tewas of New Mexico, for example, or the better-known George Hunt, a part-Tlingit dubbed "the anthropologist's anthropologist," who was a key personality in the Kwakiutl work on the Northwest Coast—appear in the records reproduced in chapters here. Probably the most important Native American fieldworker—certainly in the early years—was Alexander B. Upshaw, an educated Crow who worked casually with the project in the summer of 1905 and on a regular basis from early 1906 until his death in 1909 (see figs. 4 and 5). Upshaw, born in 1875 and the son of the great Crow warrior Crazy Pend D'Oreille, graduated from the Carlisle Indian Industrial School in Pennsylvania in 1897, became an Indian Office schoolteacher himself, and married. By the time he came to work for the Curtis project he had largely turned his back on "white" ways, was a tireless campaigner for Indian land rights, and was much admired by his own people. Upshaw was able to get the confidence of the older folk so that the Plains culture area volumes of *The North American Indian*—especially the one devoted to the Crows—came to be acknowledged as rich collections of data and have been frequently cited by other anthropologists of Plains peoples, such as Robert Lowie and John Ewers.[12]

Over the years Upshaw collected ethnological data from members of a number of tribes, including the Sioux, the Arikaras, and the Blackfeet. For instance, Curtis himself recorded an anecdote of the time when, under arrangements Upshaw had painstakingly made over a period of months, the two of them were able to participate in a purification ceremony which enabled them to see (and photograph) the Sacred Turtles—effigies made of thick buffalo hide, normally covered by feathers—of the Mandans. In 1907 Upshaw helped arrange a thorough investigation of the Little Big Horn battlefield, in the company of elderly Crows who had served as scouts under George Armstrong Custer. The surviving manuscripts of *The North American Indian* include a wealth of handwritten notes, typed materials, and vocabularies that show much evidence of Upshaw's contributions. Most impressive, in a file labeled "Blackfeet" there are two copies of material titled "Upshaw Notes," both of them typescripts of interviews and histories, and in one carton of material on the Apsaroke and Hidatsa peoples the typed and indexed volumes of fieldnotes cite Upshaw's name frequently. Most of this material, if without specific acknowledgment to Upshaw, found its way into the published volumes of *The North American Indian*. In one sense Upshaw became more famous than any other member of the project except Curtis himself: in March 1909, with the newspapers giving him an aura of the exotic as "a full-blooded Crow Indian," he accompanied Curtis on a highly publicized visit to President Roosevelt's White House.[13]

Much of the early organization of the fieldwork fell to Curtis himself, but the responsibility was also shouldered by someone who later documented his own project experiences: William Wellington Phillips, Curtis's cousin by marriage. Extracts from Phillips's memoirs—describing his experiences among the Apaches, for example, and with the Cheyennes—are reproduced in this book, along with more biographical information. The project was also able to take on clerical and other field staff workers for extended periods. One such individual, Edmund August Schwinke, makes an appearance here in the records relating to work conducted while the team voyaged down the Columbia River. The single most important recruit was William Edward Myers, a former Seattle newspaperman (see fig. 4). From soon after his appointment in 1906 Myers became the project's chief ethnologist and, increasingly with the passage of time, its principal writer. Hodge, in recounting his own role during an oral history interview, remembered Myers thus: "[Mine] was a pretty good job altogether, but I must say that Mr. Myers, who accompanied and assisted Curtis in the field, was the one who really wrote the text. I took over the text and checked every word of it, of course, and edited it, . . . before it went to the printer." Myers's role as a fieldworker is acknowledged in each of the first 18 volumes of *The North American Indian*, but the true extent of his contribution to the project as ethnologist and author has generally gone unnoticed. Unfortunately, even in this book, devoted as it is to Myers's chief sphere—encounters in the field—it is not possible to reproduce reports by Myers himself that are truly commensurate with the scale of his input. A fair number of his letters to Frederick Webb Hodge survive, as do some of the typescripts of the text produced for *The North American Indian*, but the former mostly cover points of technical detail or comparisons with the work of other scholars, and the latter are virtually identical to the published volumes themselves. Materials contributed by Myers similar to those produced by Curtis and other prominent figures such as William Phillips—logs, memoirs, and the like—do not appear to have survived. At any rate, although Myers had himself listed in a city directory as an "author" even after leaving the project, and although he was meticulous as a scholar, it has not been possible to trace any of his more extended manuscript material.[14]

William Myers was born in Springfield, Ohio, on September 20, 1877. He attended local schools and Janesville High School in Janesville, Wisconsin, before studying for two years at Wittenberg Academy (now Wittenberg University), the Lutheran college in Springfield, Ohio. After Wittenberg, Myers transferred to the more prestigious Northwestern University in Evanston, Illinois, from which he received his bachelor's degree in 1899. Myers was an excellent, linguistically gifted student who stayed on

after graduation to conduct research in German. He taught for a while, and early in the first decade of the twentieth century moved to Seattle to join the reporting staff of the *Seattle Star*. At some point in 1906, as Curtis remembered, Myers joined the North American Indian project to begin his new career as an ethnologist. Myers collected and collated data on tribal organization, myth and folklore, history, vocabulary, and the host of other topics treated in volumes of *The North American Indian*. To give some indication of the range of his fieldwork, the following is a small selection of examples. In 1907 he was working with northern Plains peoples, such as the Teton Sioux, Atsinas, and Hidatsas. In 1913 he was ensconced—it seems alone, as was often the case—with the Haida people on the coast of southeastern Alaska. During the teen years of the century, when not on the Northwest Coast he seems to have split his time between various California culture area groups, such as the Miwok, Maidu, and Yokuts peoples, and the Pueblos of New Mexico. During the summer of 1914, but also at other times, he conducted interviews among the Hopis on their mesas in northern Arizona. Most of the early twenties was given over to the complexities of the Rio Grande Pueblos. In 1925 he did the planning for and the bulk of the fieldwork among the far northern peoples of Alberta, such as the Sarsis and the Crees.[15]

Over time Myers became, in effect, the project's intellectual authority; Curtis's daughter Florence remembered that in the field Myers could dig into "a tailor-made 18-by-24-inch metal trunk filled with books about the tribe they were with." He speculated on issues of fact and significance with Hodge and C. F. Newcombe, the Northwest Coast collector, corresponded with other anthropologists such as E. W. Gifford and James Teit, and even disputed theoretical aspects of linguistic and kinship system issues with the leading anthropological figure on the West Coast, Alfred Kroeber, of Berkeley. From the winter of 1908 onward it was Myers who went East to see each volume of *The North American Indian* through the press stage. It was a matter of deep regret to him that he was unable to maintain his association through to the completion of the full 20 volumes. For family and financial reasons he left the project in 1926. At first he managed some property in San Francisco. Then, during the Depression, he became the company secretary to a local San Francisco soft drinks manufacturer. His final years were spent as the manager of small motels, the last at Petaluma, north of San Francisco, and he died of heart disease on April 29, 1949. In the brief obituary notices that appeared in the local newspaper there was no mention of Myers's contribution to *The North American Indian*.[16]

SOME CULTURAL CONTEXTS

The North American Indian project was embedded, sometimes uneasily, in the American political and financial establishment. President Theodore Roosevelt wrote the foreword to the first volume of *The North American Indian* and, just as significant, allowed his name to be coupled with it for publicity purposes. As noted, the fabulously wealthy financier J. Pierpont Morgan, literally the richest person in the world at the time, provided the bulk of the funds, and other patrons included the railroad tycoons E. H. Harriman and Henry E. Huntington, U.S. chief forester Gifford Pinchot, other government officials, several bankers, and Andrew Carnegie and a variety of other prominent industrialists. Indeed, while here is not the place to elaborate the point in detail, the thesis presented by William H. Truettner and others in *The West as America* (1990), that much Western art reflected the entrepreneurial, even exploitative, aspirations of America's financial (predominantly Eastern) elites, could, in general, be profitably applied to the North American Indian project. That is, to some extent the treatment of Indian peoples by the project—and certainly the subsequent representation of Indian histories and life-ways in *The North American Indian*—was conditioned by the interests of those elites.[17]

This is a subtle matter. It is *not* that in the following chapters the reader will witness specific instances of treatment or representation overtly and specifically determined by elite interests. Rather, by putting the matter in broad terms one can see that it is more simply a given of the whole enterprise. Morgan and his bank invested in railroads, ranching, mining, and oil exploitation that resulted in constant political pressure at multiple levels for the appropriation of Indian lands. The same or a very similar statement could be made about many of the project's other patrons and subscribers so far named. One might at first think that there would be a contradiction in those same forces investing in a project dedicated to studying, recording, and reporting upon the lives and cultures of peoples who stood in the way of their considerably larger investments. But in effect there is no contradiction because—with some notable exceptions that need to be examined in greater detail—the project always accepted the fact that Indian lives must inevitably be given up, and that Indian cultures must progressively be swept away, precisely to enable the triumph of "civilization." This process may have been thought sad, even tragic, but it was also considered a fact of life, something natural and unavoidable. Indeed, part of the project's cultural work may have been to show the inevitable "truth" of this process.

The project was considerably aided in this effort by the establishment scientists—

the Smithsonian's Charles Doolittle Walcott, for instance, or Harvard's Frederick Ward Putnam—who lent both their support and intellectual credence. Such figures, like Curtis's most significant early mentor and traveling companion, George Bird Grinnell, tended to be old school "natural historians"; they saw indigenous peoples—in sharp contrast to so-called "civilized" peoples—as part of a continuum, together with geological formations, flora, and fauna, rather than as exemplars of the rich variety of cultural behavior in the manner of Franz Boas and the proponents of anthropology as a new social studies discipline. One of them, the paleontologist Henry Fairfield Osborn, president of New York's American Museum of Natural History and the man who actually introduced Curtis when he delivered the musicale at Carnegie Hall, was not only a long-term opponent of Boas but also became an influential scientific racist in the teen years of the century.

In light of this, Curtis's oft-expressed belief that Native Americans constituted a vanishing race doomed to extinction, peoples whose cultures were in urgent *need* of recording and memorialization, requires a pause for thought. These beliefs were *not* the equivalent of Osborn's overt and increasingly politically oriented racism. (Ultimately Osborn was at one with Madison Grant and others who propounded eugenics and who were determined to limit immigration and perpetuate various forms of racial segregation.) But they did consign Native Americans to a very limited future. Curtis's famous 1904 picture of a line of Navajos riding away from the camera toward the engulfing shadows of cañon walls—a picture he titled "The Vanishing Race"—was selected as the key initial image in *The North American Indian*. Its caption declared: "The thought which this picture is meant to convey is that the Indians, as a race, already shorn of their strength and stripped of their primitive dress, are passing into the darkness of an unknown future." Curtis's Indians, as I have shown elsewhere, would frequently ride into the darkness of an unknown future. This was the key trope, so to speak, of Curtis's pictorial representation of Indians. It is at one with his photographic concentration on "traditional" ways, even to the extent of issuing wigs to cover shorn hair, the provision of costumes, or the erasure of signs of the mechanistic twentieth century.[18]

In reading the documents in *Edward S. Curtis and the North American Indian Project in the Field* the reader will be able to judge whether and to what extent such assumptions animated the project's actual relationships in the field. (To "fill out" the picture in this respect—to deepen its shadows and burnish its highlights—chapter 6 contains several previously unpublished or uncollected items on Indian population demise and the like.) There is one sense in which these assumptions *must* have affected relationships between the project and the Indians, and it happened

with such frequency that it goes unremarked in the commentary on the writings reproduced in the following chapters. The emphasis on the picturesque as dictated by pictorialism, and on the "traditional" in the sense just mentioned, meant that out in the field Indians were often guided toward noticeably beautiful landscapes that could serve as appropriate backgrounds, or they were asked to reconstruct scenes from the "past," such as war parties, preparations for ambushes, and so forth. (In one document reproduced here Curtis reports how he had taken a party of Crows to scenic Black Cañon.) Needless to add, this poses interesting problems as to the degree Indians themselves were able to determine their own actions versus when they were being produced—or at least directed—by the project: did the Sioux shaman praying in the famous image "The Invocation" (1907) choose to pray? Did the San Ildefonso man offering corn or pollen before the rising sun in "The Offering" (1925, fig. 7) enact the scene out of religious regard or for the camera, or from a combination of both motives? Whatever doubts may be entertained, it has to be said that these images might communicate *more* (or something different) than their maker intended: despite the pictorial emphasis on Indian disappearance, they might still register an Indian ontological *presence*. Kiowa author N. Scott Momaday has written of the power of the Curtis portraits, and the final chapter will address this issue.[19]

The relationship between the project and the U.S. federal government's Bureau of Indian Affairs (and, for that matter, its Canadian equivalent) should be seen as a mirror of this overall "given." It is apparent when we look at the way in which the policies of the bureau operated, not only in Roosevelt's time but throughout the duration of the project. These policies were certainly a major factor—perhaps *the* major factor—in producing both the material conditions and, perhaps even more important, the mental climate in which Native Americans found themselves. It cannot be stressed too much that each of the peoples represented in *The North American Indian* was experiencing significant change throughout the period in which the project was underway.

INDIAN HISTORIES

The reservation system first came into being to cope with the enforced removal of Indian peoples such as the Cherokees and the Creeks from the East. These uprooted peoples were allocated portions of land in so-called "Indian Territory"—land that was, of course, already home to various Plains peoples and that later constituted part of Kansas and the state of Oklahoma. The Curtis project visited the area in

1926, by which time it consisted of numerous separate reservations, many directly adjacent to one another. During the latter half of the nineteenth century the system of reservations—reserves, in Canada—came into force against western Indians. In the West the pace of change, however, was considerably accelerated. In 1829 Speckled Snake, a Creek leader who was by then over a hundred years old, spoke to his people: "I have listened to many talks from our great father. But they always began and ended in this: 'Get a little further; you are too near me.'" While it took Speckled Snake more than an average lifetime to see the beginning of the end, most western Indians experienced the complete transition from freedom and self-determination to restricted life on a government-controlled reservation in little more than a quarter-century. Indians, the Plains Indians especially, resisted white encroachment heroically, as is well known. Eventually, however, whatever the course taken by a particular people, the end—as the following brief examples show—was the same: confinement to the reservation.[20]

The Northern Cheyennes ranged over a vast part of what is now southern Montana, northern Wyoming, and the Dakotas. They lived alongside the Teton Sioux, with whom they had shared both the great victory over General Custer at the Battle of the Little Big Horn in 1876 and the subsequent defeat at the hands of the avenging U.S. armies. It was decided that instead of being granted a reservation of their own or with the Sioux, the Northern Cheyennes should be transported to share a reservation with their distant cousins, the Southern Cheyennes, in Indian Territory. They were marched overland for three months; several died on the way. Down on the arid southern plains many more died of malaria and malnutrition. So, in 1878 the majority of the survivors, under the leadership of Little Wolf and Dull Knife, broke out of the reservation and headed northward. They were starving, pursued by several armies, and then winter descended as they journeyed. But they made it—only to be captured and incarcerated at Fort Robinson, Nebraska. When they escaped they were hunted down, like animals, in the snow. It is an epic story that has been told several times, most compellingly by Mari Sandoz in *Cheyenne Autumn* (1953). Eventually the tiny remnant of the tribe was granted a reservation in a fragment of its own former territory in the southeastern corner of Montana. There, in 1905, W. W. Phillips encountered them and—if the identification is correct—Curtis photographed the elderly Little Wolf.[21]

The Navajos had a similar devastating experience when, after a protracted campaign against them in the 1860s by Kit Carson, they were taken to live for several years on a reservation that proved almost uninhabitable. The site was at Bosque Redondo in southern New Mexico, far from their grazing lands and the

peach orchards of their last retreat, Arizona's Cañon de Chelly, in the Four Corners region of the Southwest. They were ultimately allowed home but to a reduced territory that became their reservation. In comparison with other peoples, however, the Navajos were singularly fortunate. The Comanches, who formerly roamed the whole of the southern plains from Texas northward, received but a bitter portion of land in Oklahoma, as did their former allies to the north, the Kiowas, and their former enemies the Otoes, the Caddoes, and the Osages. Geronimo's Chiricahua Apaches were separated from other Apaches—such as those who settled on the White Mountain Reservation in Arizona, which Curtis parties visited in 1904 and 1906—and had to scrape by on part of the Oklahoma reservation originally set aside for the Comanches. Furthermore, those peoples who fought alongside the U.S. Army fared no better: the Utes who joined Carson against the Navajos were, in their turn, ousted from Colorado and dumped in Utah. Even the Crows, who scouted for Custer against the Sioux and who harried the Nez Perces for General O. O. Howard during their attempted flight to Canada in 1877, received a reservation that was nowhere near the size of their traditional domain. (While not every one of these reservations is featured in the writings collected in this book, they were all visited by the project.)

In the Pacific Northwest, where Curtis initiated the photographic work that became *The North American Indian*, the story was the same. The region was extraordinarily rich in its representation of indigenous language families. Let me take the Curtis studio's home, Seattle, as a reference point, and mention the stories of but some of the peoples. To the far northeast were the Algonkian-speaking Blackfeet: by the time Curtis photographed among them for the first time in 1900—possibly as early as 1898—they were hemmed into just part of their former lands in the foothills of the Rockies, with an agency at Browning, Montana. They were no longer a threat, as had traditionally been the case, to any of the Plateau peoples mentioned. Also to the northeast, and spilling over into Canada, were the Kitunahan-speaking Kutenais with their beautiful bark canoes. To the southeast were the Shoshonean-speaking Bannocks and Shoshones, enemies who nevertheless traded with the Plateau peoples, sometimes as far north as The Dalles on the Columbia River. In the south were the Lutuamian-speaking Kalapooias of the Willamette Valley and the Klamaths of southern Oregon. The many-branched Athapascan language family— which includes the Navajos in the Southwest and the Sarsis on the northern plains— was represented in the Pacific Northwest by tiny pockets of people, such as the Willapas near the mouth of the Columbia, but they were rapidly being extinguished at the turn of the century. In comparison with the other peoples just mentioned, they

were judged too few to warrant any kind of reservation. On the British Columbia coast quite far to the north of Seattle were the Wakashan-speaking Kwakiutl and Nootka peoples. Canadian policies granted them, in effect, lots of tiny reserves that extended only to the limits of their villages, graveyards, or other frequently used sites, with all the surrounding areas being opened to non-Indian settlement and exploitation. During the very period that the North American Indian project was at work among them they were subject to a Royal Commission established in 1913 supposedly to create "a final adjustment of all matters relating to Indian Affairs in the Province"—which resulted in a settlement that left the Indians with more acreage than they had before, but acreage considered of less real estate value.[22]

Also on the western seaboard, mainly from Puget Sound southward, were Salish-speaking tribes such as the Clallams, the Suquamishes, and the Snohomishes. Soon after the establishment of Washington Territory in 1853, its first governor, Gen. Isaac Ingalls Stevens, made a series of treaties with these Coastal Salish peoples that almost totally extinguished their rights to their homelands. War inevitably followed, and the tribes were crushed, coming out of it with but poor reservation plots that were eventually surrounded by a rapidly expanding white population and an economy in which they had no place. The fate of these peoples was borne in mind by tribes from the interior when they were called to councils with Stevens. Further south, from the mouth of the Columbia and along its shores to The Dalles, were bands of the Chinookan-language group. The Chinooks were great traders, befitting their position on the Columbia, the principal artery of exchange in the region. However, from the 1820s on, as the fur trade with whites was established, and then missions and white settlement, the Chinooks were decimated by smallpox and influenza, diseases that continued to strike down interior tribes on into the twentieth century. Many individual Chinooks were absorbed into other tribes, including those of the interior. In 1910 the project voyaged down the Columbia looking for the sites of the Chinooks' former villages. Their language, with elements from Nootka, became the basis of the Chinook jargon. The jargon, with words taken from English and French, became the lingua franca of the whole Indian Pacific Northwest. Any whites dealing with Indians had to learn it. Curtis, Meany, and others who figure in this book certainly spoke it. It is known that Edwin J. Dalby, who conducted ethnological fieldwork for the project almost exclusively in the Pacific Northwest, was recruited partly because he had a good command of the jargon.

The two language groups with the largest number of speakers in the interior Pacific Northwest were of the Salishan and Shahaptian families. Furthest east of the Salishan tribes were the Flatheads of western Montana, allies of the Salish speakers

and Shahaptian speakers from the west when these fellow Plateau peoples ventured over the Rockies to hunt buffalo. Despite the fact that many of the Flatheads had become practicing Christians and all had enjoyed friendly relations with whites, it was their lot to be placed by Governor Stevens on a reservation that was a mere fraction of their former hunting grounds. At the same 1855 treaty council with Stevens their neighbors to the west, the Pend d'Oreilles, also accepted the inevitable reservation. The Coeur d'Alenes, on the other hand, resisted such treatment. At first they were successful: in 1858 they defeated a detachment of regular troops under Lt. Col. Edward J. Steptoe. Before long another army, with sophisticated weaponry and the ruthless Col. George H. Wright in command, was sent to avenge the defeat. After much hanging of innocent Indians the Coeur d'Alenes submitted to reservation life.

The formation and development of the Colville Reservation, which was established in the eastern part of Washington State in 1872 and visited by the Curtis project for the first time in 1905, is typical in many respects of those large (and sometimes not-so-large) western reservations that housed more than a single people. Bounded originally by the Canadian border to the north (it later lost the so-called "north half" to white settlement), the Okanogan River to the west, and the Columbia River to the south and east, the reservation became home not only to peoples who had traditionally lived wholly or partly within its borders—such as the Salish-speaking Nespelems, the San Poils, the Lakes, the Okanogans, the Colvilles, and Chief Moses's Columbias—but also to members of tribes belonging to the Shahaptian family of languages. Some of the latter were scattered individuals, such as a number of Yakimas and Umatillas, but others constituted significant groupings in their own right. Most famous among these were the uprooted and exiled Nez Perces led by Chief Joseph, who had participated in the Nez Perce War. These Nez Perces had been imprisoned on the southern plains and had refused to accept Christianity to the same degree as the Nez Perces who had been granted a reservation in a fragment of their own home territory in Idaho.[23] In one sense the dumping of the Nez Perces at Nespelem completed the creation of the Colville Reservation. The institutional status and modes of operation of the Colville as a reservation were more or less established, paralleling those assigned to the Flatheads, to the remnants of northern California peoples, and to numerous other peoples that the Curtis project was to visit throughout the West.

THE RESERVATION

On all of the reservations—except for sporadic troubles, one of which led to the massacre of numerous Sioux at Wounded Knee in 1890—overt armed Indian

resistance was over. During the period from 1875 to 1933 (the whole life span of the project) the "great father," as Speckled Snake and others had dubbed him, was not content simply to leave his "children" alone in their allocated spaces. Every effort was made by the Bureau of Indian Affairs and its employees to force Native Americans into first becoming wards of the government and then part of the mainstream of American life. With some significant differences Canadian policy followed the same general pattern: on the Northwest Coast, for example, the potlatch and other important ceremonies of cultural perpetuation and identification were forbidden by Canadian government decree in 1884.[24]

Since many peoples could no longer fully sustain life by traditional means such as hunting, they were made wards by being dependent on the government for beef rations, farming supplies, sawmills, blacksmith shops, and the like. Certain peoples could nearly survive by fishing and growing vegetables, such as the San Poils on the Colville, who insisted on paying for whatever provisions they took: their insistence guaranteed them a fragile degree of autonomy. Others, such as the Hopis and the Pueblos of the Southwest, who were able to continue their traditional means of support—for them, predominantly dryland farming—refused any government support they could. On the other hand, some peoples were dependent on the government for much of the very food they put in their mouths. The Colville Nez Perces, for instance, even had they been able to farm, were settled their first year on the reservation too late to do any planting that could have done them any good. Sometimes the beef rations or the seedlings for sowing either did not arrive or were not distributed. Malnutrition—even starvation—were not uncommon on reservations. On occasion food was deliberately withheld in order to coerce a people into a particular course of action.

Thus, in the early 1900s several Plains peoples were refused their beef rations because their leaders opposed the sending of their children away to boarding schools. The Hopis, as was widely reported at the time, were divided during the early years of the twentieth century into "hostiles" and "friendlies," largely according to whether or not they would submit to their children attending schools in or just beyond their mesa villages. Education, of course, was to be the primary instrument in the making over of "Indians"—as the word was pejoratively used—into appropriate members of the wider community. While Native Americans were not to be granted formal citizenship of the United States until 1924, they were encouraged at the turn of the century to wear "citizens' dress," to cut their long hair or braids, and to live in fixed houses. To this end government schools were established, though in many instances agents considered day schools insufficient or

ineffective and children were sent away—sometimes far away—to boarding schools. Often these boarding schools were built in or made out of former army barracks and forts and were commanded by former army personnel, which meant that military discipline usually prevailed. Children worked on the grounds in detachments, they were lined up on parade squares for roll call and exercises, the speaking of Native languages and such exchange languages as the Chinook jargon was punished by beating, and the wearing of shoes was compulsory. It is doubtless true that to survive in twentieth-century North America the acquisition of English was important, but the overwhelming emphasis was negative. The cultural work of the school was to crush "the Indian" inside each child. "The first step to be taken toward civilization, toward teaching the Indians the mischief and folly of continuing in their barbarous practices," wrote Commissioner of Indian Affairs J. D. C. Atkins in 1885, "is to teach them the English language."[25] A generation of children was urged to feel shame and revulsion toward its own language, even toward its parents.

In Canada there was less emphasis on Indians being made to join the mainstream. In fact, since public schools were run by the provinces and Indians were regarded as a federal responsibility, in many instances they were excluded from attendance at school—but they were not left to run their own affairs. In both countries, under the guise of "development" and "civilization," groups of Indians were hired as day or permanent laborers—leveling wagon roads, building houses and bridges, and constructing ferries across major rivers. Some of this construction work was allocated by contract to private companies and some was initiated by the Indian Agent and his staff. Equally widespread was the use of Indians as itinerant laborers—in the hop fields and fruit orchards of Washington state, or in the canneries of the British Columbia Coast, to give just some examples that Curtis and his associates definitely knew about. This movement between the "Indian" and "white" worlds—like the material changes to the infrastructure that enabled wagons and larger machines, such as a thresher for the mill and, sometimes, boxes of drugs for the doctor, onto the reservations—worked, above all, to reduce the isolation of Indians from the expanding centers of white civilization in their regions and brought more whites to reservations. This last fact, as will be seen, ultimately made reservations less secure for Indians.

The U.S. Bureau of Indian Affairs busied itself in every sphere of life, from formal regulation and record keeping by the agent, the agency clerk and the Indian police service, to instruction in schools and in farm practices, to informal intelligence gathering, and even to the provision of services ostensibly intended for the well-being of its charges. (Harold Curtis, Curtis's son, even while still a youngster noticed

the typically officious nature of the bureau.) While the schoolteacher was intended to Americanize the younger generation, the Indian Service farmer, for example, was in day-to-day contact with the adult generation: in addition to issuing equipment and rations, it was his job to teach farming methods to inculcate the proposed means of support. Obviously, such a man had to be aware of the aboriginal means of support he was attempting to supplant, but he would tend to give his guidance to those who would use it and did not, therefore, need to be in conflict. The Indian Service doctor, on the other hand, had to confront Native practices head-on, and at their most sensitive point. The Bureau of Indian Affairs recognized this challenge and vociferously encouraged its physicians to wean patients away from "medicine men" or shamans, to undermine their role, and ultimately to supplant them. Generally speaking, those tribes who had resisted becoming Christians—albeit in different ways—were obviously intensely religious in their own ways, all believing that it was a fundamental necessity for a human being to observe the larger laws of the universe, to be in a right relationship with the earth, to have respect for the sanctity of all life. Understandably, they revered their own shamans. The practice that most enraged white doctors was the sweat bath, and their annoyance is easily understandable when smallpox victims were urged to sweat and then dip themselves in the freezing waters of nearby rivers. But the sweat—as can be seen in connection with a project visit to the Blackfeet—was a prominent feature of the cultures of the Plains, as well as of other culture areas. The sweat was intended to purify body and mind. The attempt to eradicate it was another effort to destroy the "Indian-ness" of Indian life.

In fact, toward the end of the nineteenth century judicial courts were established for the trial of "Indian offenses" and various aspects of Native American culture were designated "crimes." In the regulations drawn up in 1892 by Commissioner of Indian Affairs Thomas J. Morgan, these crimes included various dances, plural marriages, intoxication, refusal to engage on road-building duty or other "habits of industry," and, of course, the "practices of medicine men." This particular offense was described as follows: "Any Indian who shall engage in the practices of so-called medicine men, or who shall resort to any artifice or device to keep the Indians of the reservation from adopting and following civilized habits and pursuits, or shall adopt any means to prevent the attendance of children at school, or shall use any arts of a conjurer to prevent Indians from abandoning their barbarous rites and customs, shall be deemed to be guilty of an offense, and upon conviction thereof, for the first offense shall be imprisoned for not less than ten and not more than thirty days."[26] Clearly the much-vaunted American constitutional right to freedom of worship did not extend to include Indians, but then, Indians were not considered

citizens. The situation is doubly ironic in the light of the fact that genuine offenses against Indian persons on the reservation were frequently not brought to any sort of trial. Before the accession of whites to a position of power over them, tribes had often dealt with murderers within the group by banishment, and outside the group by vengeance. On the reservation neither was possible. Indeed, such matters had to be dealt with by the agent or by a white court, and all too frequently white courts would not go to the trouble or expense of trying an Indian accused of nothing more serious than the killing of another Indian. Offenses against property, on the other hand, whether white or Indian, were punished severely whenever possible since respect for property and the acquisition of it by individual Indians was considered a most effective manner of Americanization.

Such thinking received classic expression in the U.S. General Allotment Act of 1887, often known as the Dawes Act. The act was intended to break forever any collective tribal stewardship or ownership of land. Indians were to be allotted individual, family-sized farms, and the "surplus" reservation land was to be opened to white settlement (the Indians receiving a token payment for the surplus land). This policy received much support from real estate interests and led to the sale of over half the land previously owned by Indians. Since many of the allotments were not economically feasible as farming units in any case, and since the new individual owners were unskilled in farming, many parcels were leased to neighboring whites for grazing purposes or sold outright. Forced to look after only the immediate family unit—and unable to do even that—Indians on many reservations became chronically poor and some were made homeless. The latter tended to congregate around the agencies and on the edges of towns, and too many took the turn to skid row in the expanding cities. More than ever they were dependent on the government and the seasonal labor that became available in the white economy.

On some reservations the Allotment Act was not the only thing that attracted white speculators: there was also the lure of gold or other minerals. In many cases the Bureau of Indian Affairs proved totally ineffective in preventing incursions by prospectors, leading a significant number of Indian leaders to believe that their tenure of the land would not be protected and that mining would lead inexorably to the sale of further lands. Such anxiety was well founded. In general the bureau was notoriously corrupt: numerous government employees were known to be trafficking in whiskey, and nearby settlers commonly knew that certain officials would turn a blind eye not only to illegal prospecting but also to illegal, unpaid-for grazing. Certain individual agents were not blameless. Given the vastness of some reservations, such as the Navajo Reservation or that of the Sioux at Pine Ridge,

there was probably no way for the best of agents to be fully informed of all that was happening in their domain. Nevertheless, some made little effort to find out and others were too busy running their own businesses (conducting agency affairs only as a sideline). And some were positively corrupt. To give but two Colville examples, both John W. Bubb, in 1896, and Albert M. Anderson, in 1904, were removed from their posts after discoveries of financial irregularities. It was alleged that Anderson had even gone so far as to claim guardianship over Indian children in order to take the monies from the leases of their allotments.

Of course, at the end of the line all Native American men and women had to adjust to their new ways of life. Sometimes their leaders were reduced to indulging in clan-based factionalism or endless political bickering. All too often their own individual adjustments reflected what William Brandon described so vividly—if patronizingly, with too little regard for an Indian standpoint—in *The American Heritage Book of Indians*: "thousands of dispirited people killed time in the institutionalized slums of their reservations, becoming adept in the skills of wise old boys who have lived a long time in the orphanage. They learned how to wheedle and hoodwink the agency staff for the nickels and dimes in scraps of supplies that trickled down through the budget to their level, and how to give some point to a pointless existence by finding delight in unutterable trivia. And the friendly agents said in a fond way, 'They're children'. Unfriendly agents said, 'Indolent, insolent, and uncivilizable.'"[27] Yet a surprising number found the strength to endure, to raise their children with a measure of pride, and even to prevail. Many of these were people who *did* adapt, who successfully found new ways of living that previously would have seemed untenable. But many, too, were people who sustained a link with the tribal past, the traditional culture. Sometimes the link was sustained only in terms of material culture—a continuing delight in the showing off of well-executed beading, the making of cornhusk baskets or carved canoes, a cradleboard prepared in the old manner, the construction of a complex fishing weir at the right point on a fast-flowing stream, or the elaborate painting of a mask. When such items were still prized—for instance, the fine baskets produced by California peoples seen by Florence Curtis Graybill and her father—they could be arranged and photographed. But, of course, in the end these things were more than merely bits and pieces of material culture: they inevitably carried a symbolic meaning. Thus, among Plateau peoples, in some of the great "give-aways" held after deaths of prominent figures, items of material culture that were no longer being made were highly prized by both givers and receivers. The Columbias, for instance, had once made many fine stone implements, carved mortars and pestles, stone axes, and adzes. When Chief Moses

died in 1899 examples of this work were distributed and treasured even though the white man's trade versions of such implements were the ones that were actually used.

I think this points toward the sustaining importance not just of relatively infrequent ceremonial events, such as "give-aways," but also of the annual July Fourth celebrations held by many Indian groups throughout the U.S. West. Brothers and cousins would come from various points on the reservation and from further afield. Perhaps folks from neighboring peoples would ride over to join in the celebrations or to watch. Artifacts of the traditional culture were worn and displayed. For many folks gambling, when it had previously been a crucial factor in people's lives, was liberally indulged in. On the Plains and the Plateau horses were raced. Everywhere old games were played at a furious pace, often accompanied with much betting by both participants and spectators. Among some peoples, such as the Apaches—as W. W. Phillips remembers in the next chapter—alcohol lubricated the proceedings. And, of course, there were dances, both secular and sacred. So it happened that an occasion ostensibly meant to celebrate the birthday of the United States became for these peoples an affirmation of their *own* cultural identity.

Most of the peoples encountered in this book had something similar, whether ceremonies to give thanks for the return of the salmon, so-called "Shaker" meetings, or such famous rites as the Snake dance of the Hopis (see fig. 8) or the sun dances of various Plains peoples. Indian population was at its nadir when the project began and, as chapter 6 demonstrates, to Curtis it showed but scarce signs of revival thereafter. Indian ceremonies were periodically attacked by the bureau—most systematically during the 1920s, when (in what might initially be seen as a paradox) Curtis himself weighed in with a powerful essay denouncing various Pueblo practices as pagan, obscene, and dangerous—and their maintenance was not always possible.[28] But when they were able to survive, such festivities were an outward sign to all concerned that the "Indian" in these people was certainly not dead.

THE PROJECT IN THE FIELD

The project's fieldwork, if viewed chronologically, may be divided into five broad phases. The first was pre-1906, when Curtis was working largely alone or with members of his family and concentrating mostly on photographic work; that is, before the Morgan agreements provided a framework and a defined goal in the form of a series of volumes with similar desiderata. The second phase occupied the

years 1906 to 1912, during which time the project was probably best funded and at its most active, often with several data-gathering parties in the field simultaneously. Nineteen twelve—the year after the 1911 tour of the musicale, when Curtis was at the acme of his personal fame—marks the opening of the third phase, which lasted for three years. This was the period leading up to the 1915 publication of volume 10, when work toward *The North American Indian* was conducted simultaneously with work on the 1914 film *In the Land of the Head-Hunters* (both centered on the Kwakiutls, one of the major Northwest Coast peoples of British Columbia). The fourth phase, between 1915 and 1922, in which only one volume (11) of *The North American Indian* appeared, was one of relative inactivity. Part of the problem was brought about by the hostilities of World War I: it was difficult to acquire from Europe the fine quality paper used in the printing of the sumptuous publication. But there was not only a hiatus in printing and publication; less actual fieldwork was being undertaken. Frequently only Myers was out collecting data, researching, or writing up future volumes. It is likely, in fact, that Curtis was to some degree distracted from the project, even the photographic part of it, by a combination of marital problems and his efforts to undertake movie work in Hollywood. During the fifth and final phase, represented by the years 1922 to 1927, the last of the fieldwork was conducted, the ethnographic aspect of it mainly by Myers (who was succeeded at the end by Stewart C. Eastwood) and the photographic aspect by Curtis. (The years from the end of the summer of 1927 until the publication of the final two volumes in 1930, in which Eastwood wrote and rewrote volume 19 and worked up the text of volume 20, saw no fieldwork at all.) Each of these periods is represented in the selection of writings that follows.[29] Here I should add that in this periodization I am referring to the moment of encounter, *not* to the moment of writing, which sometimes occurred long after the events described (see also the note on dates at the beginning of the book).

Edward S. Curtis and the North American Indian Project in the Field offers sample accounts of the project's field experience. "We long ago saw the impossibility of pretending to give a complete survey of all the western tribes in 20 volumes," wrote Myers to Frederick Webb Hodge in 1926, when the project was nearing completion, "and have been trying to do the best we could in various cultural areas."[30] While one or two documents here are included primarily for their own intrinsic interest, I have generally followed a similar strategy, and—while moving (if unsteadily) northward, and in a very broad chronological order—have composed this book from records of work with a small selection of the peoples encountered and studied by the project. Nevertheless, with the exception of the Great Basin and the subarctic, each of the

major culture areas of the North American West—the Southwest, California, the Plains, the Plateau, the Northwest Coast, and the Arctic—is granted some attention. Indeed, representation of a variety of culture areas—and with *enough* on each one to make something of a contribution to an understanding of it, or to round out, as it were, an understanding of it—has outweighed other considerations, including the need to illuminate the nature of the project—even if light falls on it in any case (as I trust it will). For this reason, and with the intelligent and interested general reader in mind, where it seems necessary I have indicated how the views expressed in the documents reproduced here compare with more recent anthropological findings.

There are noticeable omissions. Let me take just the Southwest culture area as a representative example of all the culture areas studied by the project. We know that much time was spent on the U.S.-Mexico borderlands with the Pima, Papago, Maricopa, and other peoples that Curtis, in one of his popular *Scribner's* pieces, called "The Village Tribes of the Desert Land." Yet they go unmentioned here. The second volume of *The North American Indian* was devoted to these peoples and, despite Curtis's disdainful remarks about them in *Scribner's* (he claimed they lacked "bravery and the war spirit," and that the Yumas and the Mohaves, in particular, while "physically a magnificent group of people" were mentally "inactive"), that volume contains rich accounts of their myths, religion, burial practices, and the like. So much so that it must have been the case that the project's encounters with these peoples would have been as interesting as those with any other groups. Similarly, we know that a whole volume, 12, was devoted to the Hopis, who were also prominently represented in the musicale performances of 1911, in which Curtis not only evoked their Snake Dance in some detail (see fig. 8), but featured what he called his "personal note" about his own participation in the dance. Much the same could be said about the Navajos, together with their Yebichai ceremony. (Indeed, there has been interesting historical scholarship on whether or not, and under what conditions, Curtis participated in or witnessed the Yebichai rite.)[31]

So, what more may be said about the principles of selection followed here? A fundamental constraint was, inevitably, the nature and sources of the records that have survived to become accessible. In terms of their nature I have gone for as much variety as possible, covering a spectrum from serious fieldnotes that were later incorporated almost verbatim in *The North American Indian*, through yarns and travelers' tales, to the cryptic headings of an *aide memoire*. In terms of their sources I have already noted, for example, that despite his twenty years in the field, and despite the fact that he probably had more *sustained* contact with more Indian peoples than Curtis or any other ethnologists engaged by the project, very few field experiences

written by Myers have come to light. By contrast, because of Curtis's fame during the most active phase of the work—and because, of course, *The North American Indian* says on its title page "written, illustrated, and published by Edward S. Curtis"—a fairly large body of field material by Curtis, both as published in magazines and newspapers and in manuscript or typescript form, has proved traceable. Indeed, I have just referred to Curtis's accounts of his participation in the Hopi Snake Dance and the Navajo Yebichai ceremony. This balance, or imbalance, has been reflected in the selection's disproportionate emphasis on Curtis's experiences.

More generally, I have selected (so as to emphasize) the *variety* of peoples encountered. I hope that by such means the book grants some insight into the project's activities over time and in different culture areas. (It was not possible to cover all the peoples that, ideally, should have been treated here.) Most fundamentally, I have endeavored to select or excerpt from the project records in such a way as to give a sense of the *presence* of Native peoples. In the case of pieces authored by Curtis himself this was not always easy, not because Curtis was uninterested in Indians or their cultures in their own right, but because the purpose of so many of his surviving accounts was to arouse public awareness of the project and the importance of its work, largely by drawing attention to the danger and heroism of his own role. To do this he often resorted to notions of Indians as exotic, difficult to understand, and wild. Thus in the case of the Snake Dance, as Curtis told his musicale audience, it was the sensational aspects of the ceremony that remained memorable:

> *In the instance in mind I was the new member, and the priests felt that it augured well that the gods were pleased at their having taken me as one of them, when they found within a minute a large snake. Now came my first surprise. I had agreed to do without question what my brothers asked or directed, and as the first snake was taken, one of the men, who clumsily spoke a few words of English, explained that when they took with them a new brother, on capturing the first snake they wound it around his neck four times. Then my good prompter continued to explain: "Soon we will get another snake. That will be a blue racer. We will put that around your neck. Then we will get a rattle-snake, and that we will put around your neck, and that will be all." I have yet in mind a very vivid picture of that rattle-snake wound around my neck, its head extending far enough forward that I could clearly see its apparently angry expression.* [32]

While there are, of course, accounts of adventures, I have tried to give greater weight

to episodes of *interaction*. Here we must return to the notion of a double focus that I raised at the outset. The interaction *cannot be* fully two-way. We have no accounts here *by* Indians themselves. The Indian voice is always, at best, ventriloquized by the white writer. Nevertheless, although certain peoples and individuals were very badly treated by the project, and many more were insensitively represented, they were not *merely* its subject matter. Often they were actors in it. For example, if we look again at Curtis's memory of the Snake Dance, we may well wonder whether the Snake Priests were, in their turn, taking *Curtis* for a bit of a chump, making him *pay* emotionally for his privileged access to the rite. In the writings that follow we will see many other instances of a Native presence. By deploying memoirs and essays written by a range of figures—Curtis family members, friends of the project such as Edmond S. Meany, employees such as Schwinke, and anonymous newspaper reporters—I have selected to give a picture of interactions, over time, that cover a goodly number of very different Native American peoples living between the Mexican border and the farthest tip of the Alaskan landmass.

2 In the Southwest

I. INTO APACHE LANDS

In prereservation days the various tribal groupings and bands of Apaches lived mainly in the mountainous border region between Mexico and Arizona and New Mexico, but they ranged and raided over vast distances—deep into Sonora, Mexico, into the far north of Arizona, to the Rio Grande pueblos of northern New Mexico, and even well into Texas. By the time of the final defeat of Geronimo and his mainly Chiricahua band of followers—the survivors of whom were eventually returned from their humiliating imprisonment in Florida to Fort Sill, Oklahoma, and then to the Mescalero Apache Reservation in New Mexico—the majority of Western Apaches were settled on the part of their former domain comprised of the adjacent White Mountain and San Carlos Reservations in east-central Arizona. The Western Apaches belong to the heterogeneous Southwest culture area and, like the two other peoples treated in volume 1 of The North American Indian—*the Navajos and Jicarilla Apaches—they speak an Athapascan language. They were visited several times by various Curtis parties in the years leading up to the publication of volume 1 in 1907, while the bulk of the fieldwork for the volume was conducted in 1906 (see fig. 9).* The North American Indian *includes data on the Apaches as a whole, but the following documents, composed at various points in the succeeding years, concern only the Western Apaches. These reports represent the views of Curtis's son, Harold Phillips Curtis, who was a schoolboy at the time the events described took place; William Wellington Phillips, Curtis's cousin by marriage and the project's first principal ethnological assistant; and Curtis himself.*

"Entering Apache Lands" by Harold P. Curtis, c. 1948 (c. 1905)

Harold, the oldest of the Curtis children, was born in 1893. With the Curtis Studio in Seattle a financial success and coincidental with Edward's more frequent visits to the

East—mainly to try to raise interest in and funds for The North American Indian—
Harold was sent to boarding school in Pennsylvania. As his father spent more and more
time traveling and his parents' marriage deteriorated, Harold was spared some of the
pain of the family tensions, at least in one sense, by being away from home. In fact,
because of his father's friendship with the lawyer Robert Clark Morris and Morris's
wife, Alice Parmalee Morris, Harold often did not return to Seattle during school
vacations but spent them either with the childless Morrises at their home in Morris,
Connecticut, or in the field with his father. Later Harold was informally adopted by
Alice Parmalee Morris and stayed with her—viewing her virtually as his mother—after
her marriage with Robert collapsed. As an adult Harold was close to his father—"the
Chief," as Harold and others referred to him—and, after the conclusion of the Indian
project, even worked with him on various business ventures. He enjoyed a long and
physically active life. For example, he regularly drove the length of the American west
coast between his two homes in Southern California and the Olympic Peninsula of
Washington State, even into his eighties—and died on July 26, 1988.[1]

Harold Curtis jotted down several reminiscences of his adventures in the field,
and shared them with others interested in writing about the Indian work, especially
his sister, Florence Curtis Graybill. One memoir in particular—mainly about his
experiences on the northern plains, when he caused much worry by contracting typhoid
fever—was extensively quoted in a Westerners' publication and has since been widely
circulated in other books. The present essay was probably composed in the late forties—
or perhaps only typed then—at a point when various members of Edward's family were
encouraging him to write his autobiography and may have donated materials to that
end. It is difficult to say precisely when the journey described took place. For example,
A. B. Upshaw, the Crow fieldworker mentioned at the outset, did not join Curtis until
too late for the 1905 work in Apache lands, yet the 1906 field season did not reach
Apache country until June, after the early spring described here. Possibly two seasons
were conflated in the telling.[2]

I had had many delightful but tantalizingly short weeks with Father in his camps
with the Indians, and now I was to be really one of the party and live in camp month
after month, winter and summer. That would be real life.

My questions as to when we were to start and where we were to go were many.
The Chief thought our year's work in the field would begin in Apache land. From
there we were to go to the Navaho country, and finally to the Hopi villages in time
to see the Snake Dance [see fig. 8]. Joy of joys! What a summer that promised!
The very words Apache land set my blood afire. And what pictures the thought

of the Navaho country brought to my mind, and then the high-perched villages of the Hopi fairly alive with mystery, where they have the strange, uncanny Snake Dance.

Winter was scarcely past when our party assembled for the season's work. Holbrook, Arizona, was the point where all traffic to and from the White Mountain Apache country touched the railroad, and here we made our final preparation for life in camp.

Our conveyance was a stout affair termed by its makers a four-seated mountain stage. With its long baggage boot aft it made a roomy vehicle for such an expedition as ours, and when loaded, rode with the swing of a Pullman coach. The team was four good bays equally as used to the saddle as the harness. These, with two added saddle ponies, formed our equipment of stock.

Our party was Justo, the cook, horse wrangler, and general help; Mr. Stewart, whose work was to gather all manner of lore and information from the Indians, young and old; Mr. Lang, who was general assistant collector of information and keeper of the records. Mr. Upshaw formed a most important member of this expedition. He was a pure blooded, educated Indian, a thinker, and leader, and in addition to his educational training at Carlysle [i.e., Carlisle Indian School, Pennsylvania], had done post graduate work at a theological institution. His work was to keep in touch with the Indians, to assist in bringing out their thoughts, as well as to give aid in collection of materials. The characteristic pride of race oozed from every pore, and each argument proved his great pride in the Indians as a people.[3] Last of all came Father. We called him Chief. He directed the activities, looked after the welfare of everyone, and photographed everything photographic.

With so many expert workers in camp, I had ample opportunity to absorb Indian lore and knowledge, and as a further aid there was the field library, a chest stored with books dealing with the different tribes. I saw at once that I would have a great time with those books, and it was instantly apparent that it was one thing to go to books in search of information bearing on subjects which are alive and before one, and quite another to work with them on subjects in which one has no interest. It was quite plain to me that this was to be no loafing, loitering vacation, but one of work for the love of work.

Soon we were off. First our road was across the open desert, and our first camp was made on the almost treeless plain. Here and there a pinon tree was seen. It was early spring, the altitude of the plateau high, and the night was crisp with frost. Ours was a seasoned party of campers, and no confusion could be noticed. Each man did his part, and supper was soon cooked. While Justo was preparing that more than

welcome meal, each man spread his blankets in readiness for the night. As it was a clear, starry evening no tents were needed.

With our supper over, the men gathered about the small camp-fire to talk of Indians of many lands, and the possibility of securing such information from the Apaches as was needed. It was old ground to the Chief, he having worked among them before, but the important lore possessed by them had so far been carefully withheld. Few tribes had proven so secretive as to their religious beliefs and practices; at least I gathered this from the campfire talk of the men. Personally I had never thought of the Apache as having even the first trace of religion. The only mental picture I could form of them was as a wild, desert and mountain tribe of marauders, giving no thought to anything but warfare. Later the workers of our party demonstrated that the Apache creation story is one of the most beautiful and poetic known to literature. . . . This is anticipating my story, so I must return to our camp-fire in the desert.

The day had been a busy and hard one, and naturally every one was glad to wrap himself in his blankets and drop off to sleep. For a time after creeping into my blankets I could not sleep. I lay there looking up at the stars and watching the different constellations. What mysteries of the universe the wonderful starry sky suggested, and what did the Indians know of the stars, and what were their names for the constellations. "I will get the Indian boys to talk with me of all this," was my thought as I dropped off to sleep.

It seemed but a minute until I heard Justo starting the fire, and the men calling a morning greeting. The hobbled horses were soon found and brought in. Each man doing his part, we were soon through with breakfast and our camp equipment loaded, horses harnessed and saddled, and under way.

Today the Chief and I took the saddle horses and rode on ahead. The road we were travelling was the old government road to Fort Apache. Every mile of the way seemed to bear some land-mark which formed a part of the stormy days of conflict between the hostile Apaches and the troops. Time after time troops had been hurried over this route, at times to quell a threatening outbreak, again to give aid to comrades lacking the strength to hold their own. . . . The roads winding across the desert, the plain, and through the mountain forests of pine seemed so closely associated with the romance and spirit of frontier life. . . .

Our second night camp was high in the mountains among the pine, and close to a stream which seemed to promise trout, but it was too early in the season for fishing. The evening seemed more like winter than spring, and the weather-wise ones foretold a snowstorm. So certain were they of this that two tents were put up.

These we placed side by side with the fronts open, and then with a fire of pine knots and logs, how delightful it was. With the dark came the snow, great feathery flakes drifting down and soon making the world like a fairyland, and how comfortable it was in the cozy tents warmed by the fire.

The morning found all the meadows and forest white with snow, more beautiful to look at than comfortable to camp in with summer equipment. We were soon on the road, with the expectation of reaching Colonel Cooley's place for our next camp. I had heard so many stories of Colonel [Corydon E.] Cooley that I was chafing with impatience to see him. The Chief explained that he was a friend of practically all the officers of the United States army, and that he was mentioned in and formed a part of everything written of the southwest. I had read Major Burke's "On the frontier with Crook" [sic]. He mentions [Cooley] many times. He was chief of scouts under [George] Crook in his campaign against the Apaches. As he came to the Apache country when only a boy, married a native woman, and in the war was a scout and an emissary between the Indians and the army, he certainly should know the Apache subject.[4]

We reached the Cooley place by mid-afternoon. We were to tarry here a few days, that the Chief might have a visit with the old scout and go over some of the Apache historical material. The gray-haired pioneer came to meet us, and the warmth of his greeting to the Chief demonstrated how it was that he had made and kept warm friends in such countless numbers.

In establishing his place here, scarcely a nick had been made in the forest. The low, rambling house, stable, and corrals, were fitted into different park-like openings among the pines. Those who stopped could make their own choice of taking comfortable quarters within the house or making camp in the forest near. It was not a mere roadside inn, but rather it was "Cooley's," a place like no other known throughout the States. Aside from hospitable quarters for those who passed, be they soldier or civilian, it is an army road station, with a few soldiers on detail to care for supplies and passing stock, and an army telegraph station, which helps to keep isolated Fort Apache in touch with "Washington."

With our greeting over, we drove a short distance out among the pines and pitched our tents. We were not the only ones tarrying there that night, for scarcely had we arrived before a six-horse army ambulance with its escort drew in. It was the officer in charge at Fort Apache, and his wife. They were starting back east for a vacation. Camping close by was a party preparing for a bear hunt. It was made up of a few army officers and their friends from the East out for a good time. The baying bear-dogs made my blood tingle, and I wished we were joining the bear hunt. But

Father reminded me that we were hunting Indians with camera and pencil rather than bears with dogs and guns. If the Chief had been fifteen rather than forty he would certainly have felt differently about the hunting.[5]

The passenger on the stage was a teacher who had been transferred to some other out of the way corner of the earth. Later I found that teachers in the Indian schools were always being transferred: if they were fortunate or had influence they were going to better places, if they were unfortunate they were being sent to undesirable locations, and thus the shifting went on forever. Another passenger on that sorry stage was an Indian missionary returning to the East to report on his work and beg for increased funds to continue his activities in a trying field.

The incoming stage brought a government farmer, a carpenter, and an Indian inspector. I found that a government farmer was an employ of the Indian department who supposedly knew something of farming, and his duties were to teach the Indians to farm. Also I found that, to use their own expression, the majority of them came in to "learn the dirty Indians how to farm." The government carpenter is one who does the carpenter work at an Indian agency, and the Indian inspector is one who investigates the finances, manners, and morals of all those who have to do with Indian agencies. I soon learned that wherever there is an Indian there is something or somebody to be investigated, and usually the investigator is in evidence, to look after the agent in charge, the farmer, the teacher, the carpenter, the blacksmith, the matron, the doctor, the post trader, the missionary, and all their relations. It is a never-ending cycle. The Indian does not like the agent. He asks for an investigation. The matron does not like the farmer: she asks for an investigation. [And so on.] Thus it has been, and thus it will be until the Indian has passed on and the Indian office ceases to be. This is rambling from Cooley's road station, and those who tarry there.

With the closing of the day the long, toiling freight teams drew in, hitched to wagons piled high with merchandise of all sorts, trail wagons fastened on, one behind the other and all drawn by a team of ten to twenty horses or mules. They were driven by a Mexican with a jerk line riding the wheel animal. Both outgoing and incoming freighters drew up and went into camp.

A little group of Apache were camping where the meadow and forest met. Cowboys with high boots and Mexican spurs were everywhere about, and there beneath that hospitable roof or encamped close up were gathered on that spring night the coming and going throng of army officers and soldiers, missionaries and priests, teachers, carpenters, cowboys and Indians, Mexicans and Mormons, Jew and Gentile, bear hunter and ethnologist.

From "The Gods Forbid" by W. W. Phillips, 1911 (1904–1906)

William Wellington Phillips was born on March 4, 1880, in Little Falls, Minnesota. Like Curtis, he came with his family to the Bremerton area of Puget Sound, where his older cousin, Clara Phillips, met and married Curtis. Phillips lived in Seattle with Edward and Clara Curtis as one of the family from the age of sixteen. He supported himself while attending the University of Washington through a succession of jobs in the Curtis studio and graduated in 1904. As the tone of his writing in the memoir suggests, Phillips was at an impressionable stage in life during the period it describes. For three or four years—until, it seems, W. E. Myers superseded him—he was the mainstay of the North American Indian project, employed both in the field and seeing volumes through to press in Cambridge, Massachusetts. It was while in the East, in Boston, that he met his future wife, Harriet Caroline Sias, and it was probably his marriage in December 1912 and a consequent need for a more stable income that led him to leave the project. For some years thereafter he farmed at Greenacres, near Spokane, before returning to Seattle in 1916 to engage himself in a variety of business enterprises, including working as the secretary-treasurer of Fraser, Goodwin, and Colver, a brokerage firm that collapsed in 1931 as a result of the Depression. Phillips died, suddenly, in 1936.[6]

The following text is the bulk of a "chapter" bearing the same title in a lengthy memoir Phillips almost certainly wrote in 1911 as a contribution to the publicity campaign for the musicale performances Curtis gave that year. It is possible to date it thus from comments made elsewhere in the memoir that indicate Phillips's length of service with the project. The events it records took place some time or times between 1904 and 1906.[7]

Thus . . . with permanent camp made in a beautiful grove of cottonwoods on the very brink of White River at Agency headquarters, it was time to begin . . . the recording of tribal lore, customs, habits and observations. . . . Rare good fortune provided [an] excellent man for the position [of interpreter] there among the Apache in the person of one Gray Oliver. Lapai—meaning gray—was his original Indian name. He was a full blood, over forty years of age. His quaint English gathered during a somewhat nomadic existence from boyhood, never fell short of its needs, and he knew his own Apache tongue in its complete, idiomatic fullness. . . .[8]

Gray and I soon became boon companions—for a period one and inseparable. We spent the first few days acquiring a mutual understanding of methods and purpose to secure as complete information on all native customs, laws, crafts, foods, rites, medicine practices, ceremonies and such like as circumstances and

the natives there permitted, then mapped a plan of campaign, listed veterans to be approached as informants, and started. First on our list was Goshonne. Goshonne was a medicine-man of long experience; successful, as Indians conceive success, for he was popular and well to do. He remembered the early days, and had participated in important tribal wars and councils and ceremonies. Whether Goshonne would talk at all was at the moment unknown, but Gray was dispatched to his camp up stream on the White River to ascertain. Yes, Goshonne would talk. If need be, for many days, for he could tell us much, but we would have to pay him well, for once a man had offered him a big sum—yes, a big sum—we were let to know, for just such information, and he had refused to talk to him. However, he had been taken away to jail not many weeks before by the Government Agent for violating the Department edict that Indian Medicine-men must not practice medicine, and unless I would agree to absolute secrecy relative to his revelations, not a word would he speak. This condition being agreed to and the per diem arranged, a day was set for the beginning of the story telling.

Accordingly, Gray and I rode up to the old fellow's *kowa* on a morning. We found him, not in his own little hut, but out by the river. Just above the river's edge lay a stretch of deep yellow sand, backed by a fringe of willow and cottonwood at the base of a slope which raised to the sagebrush plains above. There on the sand beside a crackling fire sat Goshonne, smoking. The day was hot, and why the fire I could not see. Across it we hailed him, receiving a grunt and a nod in response. Gray sat down beside him, rolled a cigarette, and the two began an Indianesque conversation— quiet, unemotional, interspersed with frequent silences. Apparently nothing related to me or my purposes, so after listening to their monotonous dronings for what appeared to be a sufficient time, I broke in with: "Well, Gray, what has he to say? Is he going to talk?"

"Oh yes—pretty soon—he talk alright."

After which interruption they resumed their confidential chat. They talked and talked, while I wandered about within hearing distance waiting for an indication that I was to be made a party to the confidences, but none came, so, becoming restive, I interrupted again, insisting on learning what the old man's attitude really was.

"Oh, he say he talk. Pretty soon—he talk alright."

So it went. Noon arrived. Gray and I mounted and returned to our camp for luncheon.

"What did Goshonne say about me, anyway?" I asked Gray as we rode back.

"Oh, he wasn't talking about you. He didn't say much. Just things. He talk alright, though."

"This afternoon?"

"Yes, maybeso."

And "maybeso" it was. On our return to resume work we found the old fellow still sitting in the sand, smoking. The conversation began in the same way as before, and so continued for more than an hour. My interruptions received the one, sole response: "Oh yes—he talk alright; pretty soon he talk." But the annoying monotony was relieved somewhat when Goshonne got up, cut an armful of willow withes and implanted their stems in the sand in a small circle. The tops of these he bent over and tied together from opposite sides, thus forming the framework of a conical *ka-che*, or sweat-lodge. A loud call brought a boy with an armful of quilts and blankets. These the two covered snugly over the willow framework; then the boy went to fetch a wicker bottle of water, rain water—or blue water, as they term it—caught on buckskin or canvas and saved to be used for sacred occasions. While the boy was gone, his father dug from the sands beneath the fire some well heated rocks, which he placed inside the tiny structure. On these, after disrobing and crawling inside, he poured blue water until the whole filled with hot steam. When air grew short inside, he flung the blankets up, dashed out and plunged into the river. On emerging, he dropped beside his fire with a shake and a shrug, rolled a cigarette and began his gossip. Apparently I was not only a third party but a useless fifth wheel. I grew apprehensive and inwardly rebelled. However, there was nothing to do but wait and watch. The baths continued; the talks continued; my interruptions continued, resulting always in that most complacent reply, "Oh yes, pretty soon, he talk alright."

But night came, together with supper time. Gray and I rode home. He had earned four dollars and Goshonne five. It was time for me to express myself with some force, which I did as soon as we had got beyond the old man's hearing.

"Wait, jus' wait," said Gray.

The following morning we returned to Goshonne, finding him seated in the sand between his fire and the river, smoking. He and Gray at once fell into their apparently aimless gossipy conversation. After a while the old man took a steam bath and a plunge in the river. The forenoon hours whiled away. Only Goshonne's steam baths and plunges interrupted the visiting between him and Gray. We rode back to camp for our noonday meal. All I could get from Gray was an impatient "Wait, jus' wait! He talk alright—pretty soon he talk."

Our early return found Goshonne in his accustomed place. He and Gray at once resumed their cigarettes and quiet, contented conversation, broken only by more steam baths and plunges. So it continued until four o'clock in the afternoon when to

my surprise and great relief old Goshonne suddenly announced that he was ready, what was the nature of the information that I wished.

Not wishing to alarm the old fellow by indicating a too all inclusive inquisitiveness, I suggested that we would let each day take care of itself. I would want to know about old times; about wars and raids and many things, but first, why did he take so many steam baths in the sweat-lodge and plunges in the river? After some slight hesitation he explained, and Gray interpreted: "He says he is going to talk to you; he is going to be honest; he is going to tell you what he knows, but they are looking at him." And "they"? They were the gods who might become angered when talked about, and Goshonne had first to make his peace with them; to make himself physically, mentally, morally clean before engaging upon a contract which he knew would lead to a discussion of them and their powers. Hence the many baths as a sort of moral purgative. So was the long wait justified, and no more willing informant did I meet than Goshonne. He launched early into the Apache origin story, or Creation Myth; gave full details of medicine ceremonies, practices and dances; discussed freely the entire Apache pantheon and covered many local historical events, [most] noteworthy [of which was] a Messiah Craze which had but recently run its course among them.[9]

Frequently during a long day's conversation Goshonne would have to acknowledge honestly that he could not answer a given question or supply certain information, and invariably his explanation would come back through Gray in a laconic "He says Bizhuan, he knows."

Bizhuan, I thus learned, was regarded as one of the wisest men among the Apache of the White Mountain region. Interviews during the following weeks with various other old men about the reservation unfailingly revealed the same high respect for his knowledge. To check the accuracy of information I had been collecting, and with the hope of finding more, I determined on a trip to Bizhuan's home. He lived about sixty miles away on the Cibicu [Cibecue], in one of their remotest corners. Gray and I outfitted with light camping equipment and food for a ten days trip with saddle ponies.

Our start was made on July first. Once safely out on the trail, Gray confided— "Maybeso you will see a hell'f time." The directness of the allusion was a great surprise, and was wholly lost until I asked what he really meant. "Well, you know, Fourth of July is coming. You white mens can go out to the railroad, get plenty whiskey and have big time. Injuns living way off like where we're going where soldiers can't see 'em, make plenty *tulapai* and have big time too."

Tu is their word for water; *lapai* means gray. Gray water. Sounded perfectly

harmless. However, *tulapai* is their festive beverage. Quantities of their staple Indian corn would be soaked in water and spread beneath damp blankets to sprout, which quickly occurred in hot summer weather. In winter it was placed under the blankets on which they slept, until the warmth of their bodies, added to that of their huts, occasioned the desired sprouting. The well sprouted corn is crushed and boiled along with various roots and herbs having slightly intoxicating or narcotic values, then set aside to ferment. From the moment of cooling until just crisply ripe for drinking is a period well known to the *tulapai* makers. Gray was quite right. Preparations were well under way for a *tulapai* spree on the part of the Cibicu band when we arrived, timed for its climax on July Fourth.

A small rough board cabin had been built by a young German for a trading post some years previously, but the Indians had demanded from him so many presents of goods for the privilege of remaining among them, threatening trouble if he refused, that he had to abandon his project. This cabin afforded good shelter for camping, and Gray and I took possession. Behind it was a small corral of posts set close together to protect the trader's hay and fodder from ranging ponies. This compound became useful too.

It was the night of July second when we moved in with our blankets and bacon. The morning of the third we found Bizhuan in his little limb-ribbed, grass-thatched, dome-shaped *kowa*. Very much at ease out of the hot sun, lying on his back on his pallet of blankets, Bizhuan discoursed cordially through Gray about weather, and crops, and live stock and what not for an hour or more. Then with all possible caution I explained that I had come to make his acquaintance, and to talk over some old times with him, if he would, for proper recompense, for his many friends had said that he knew much and remembered well. He bridled at once, saying he knew all about me. Knew what I had been doing and what I wanted, but he was very busy and really didn't know anything anyway. I attributed this extreme brevity and directness to the fact that many curious eyes and ears had been gathering about the hut, having long since learned that wise old heads never took the chance of losing the respect of their followers by agreeing before others to sell their knowledge to the alien Whites, and thereupon took my leave for the time in as friendly a manner as possible.

The rest of that day I spent in riding about in search of other possible prospects. One woman proved worthy of remembrance. When some years previously an outlaw band of Apache had been rounded up in the Cibicu region by a troop of U.S. Cavalry, she got permission to enter the lines on the pretext of seeing her husband, and then in an army tent exchanged clothes so quickly with the leader of the band that the latter was enabled to walk out immediately and make his escape. . . .

When the morning of the fourth dawned I found myself alone in the cabin. Gray had heard the call of the *tulapai* in the night. Up and down stream in the various huts all was as quiet as death. Not a soul in sight—not a sound. Everyone was inside drinking *tulapai*. [According to Phillips this led to several scenes of mayhem among the Apaches and feelings of trepidation in him.]

After the *tulapai* festivities were over and the participants had quieted down—which they did surprisingly quickly—I resumed attempts to have a talk with Bizhuan. It seemed impossible to catch him quite alone, yet imperative that I do so, since [it was] most unwise to approach him again unless he was alone. A day or two passed when word was sent to me that he would stop at my cabin when passing the day following. He came, accompanied by Das Lan (the Apache of Messiah Craze fame) and two other men.[10] I asked the privilege of photographing him and his noted friend, stating the price I was willing to pay. Didn't I want pictures of the other two men as well? When I replied in the negative he said they would not sit at all. However, a bargain was struck in time and all were photographed. At the conclusion of the camera work we all strolled over to the river and along up stream, when a very sudden gust of wind and rain struck us, occasioning all to scurry to trees for shelter. I caught Bizhuan by the arm, calling Gray, and turned back to a cottonwood we had passed while the others ran forward. At last I had him alone! It was necessary to be direct and brief. Again I told him I had come purposely to see him; that I wanted him to talk and would pay him well, meeting him secretly at any time or place he might designate. But no. He contended that he didn't know a thing. He was sorry, he would like to help, but didn't know anything I would wish to know. Twenty-five dollars for a single day; five dollars for one hour, would not tempt him. He was sorry, but he didn't know.

The shower ceased quite as suddenly as it had come. We bade Bizhuan good bye, waived a hand to the others who had started on, and turned toward camp. Gray summed it all in his, "Hunh! No luck!"

No time was lost in returning to headquarters camp at the Agency above Fort Apache and soon thereafter I proceeded northward to visit the Navaho Indians, blood brothers of the Apache of the Athapascan family. There during the remainder of July, throughout August and September I witnessed the transition from hot summer, with its severe electrical storms, to the clear crisp weather of autumn, discovering there that ultra conservative old informants lost some of their conservatism as soon as the season for thunder and lightning had passed. Thunder and lightning were the speech of the gods, speaking in anger, who were more easily aroused in summer than at any other season. Greater freedom was therefore enjoyed when fall arrived.

This discovery made me feel certain that I had stumbled upon the cause of Bizhuan's extreme reticence, and that another call on him would prove fruitful. Accordingly I returned to the White River Agency at Fort Apache early in October, securing a small secluded log cabin for camp. To allay suspicion and quiet the inquisitive I let it be known that I had finished seeking information or informants, or talks or stories; that that part of my work was done, except being made ready for the big books, for everything had gone well and I needed nothing more. Then I got hold of Gray and arranged with him that he should go out to the Cibicu alone and endeavor to bring Bizhuan back with him, and to my cabin at night unknown to anyone. Gray went. Before he returned I had fully concluded that he liked the task and was making it last, but in this I did him an injustice. There was a big roundup on at the Cibicu. Buyers were there for pack-ponies and mules; colts had to be branded as well. Bizhuan, capable, shrewd and a highly respected medicine-man, owned large numbers of horses and mules, then being offered for sale. When the roundup was over, Gray persuaded him to come in to his home for a visit—he had a lot of grain sacks he wished to present to him. The ruse worked well. On a pitchy black night, unknown to others and unsuspecting, Bizhuan was ushered into my little log cabin. Cordial greetings and his choice of "makings" for cigarettes or real cigars (both of which he took) put Bizhuan at his ease. I discussed the roundup with him, also other current topics, finding him interested and talkative. All seemed propitious, so I turned the conversation into channels of greater concern to me. Inquiry for the whereabouts of an old man whom many regarded highly for his knowledge of old legends and early days, brought the answer that "He no longer bends the grass." That is, he was dead. But the moment I ventured on topics of a secret or sacred nature, the old man ceased to reply—parleyed long with Gray, insisting and explaining that he knew nothing and therefore could not answer. No arguments or urgings, no persuasions or offers of money availed. He was sorry, but he didn't know.

One thing among others I wished much to secure from Bizhuan if possible was a review of the names, powers and attributes of all the deific conceptions constituting the complete Apache pantheon, by which their lives were so materially guided. Defeat for a second time seemed more than immanent [sic]. Then I tried one more tack. "Gray," I said, "you tell Bizhuan that I have traveled everywhere among the Indians; that I have been a friend to all of them, and they have been friendly toward me." Gray told him. "Tell him that the best of their old men have talked to me and always told me the truth." The old man said yes, he understood, he would tell me the truth too, only he knew nothing. "Tell him that when he says he doesn't know,

that I know he is lying to me—will prove it to him soon—and that my heart is sore because he does it." Bizhuan shifted nervously on the dirt floor, but made no response, waiting wonderingly for what was coming. . . . "Now, Gray, you tell him he is an old man—that he ought to know much—that he ought to know about the People Above before he dies, and that if he doesn't know, then I will teach him." Gray grew nervous too, but finally interpreted to Bizhuan fully. While he did so I brought from a bag under my cot a buckskin tablet bearing some direct picturings, and conventionalized and symbolic representations of all Apache deities, which I spread on the ground before him. Also a maternity belt, made of the skins of the antelope, the white tail deer, the blacktail deer and the mountain lion, with drawings of deities on the four segments, following the same with a medicine cap and other potent or sacred articles. Hardly had the last been placed before Bizhuan than he began to tremble visibly, and to repeat something in a plaintive voice.

"What is he saying?" I asked Gray quietly.

"He says, 'they are looking at me; they are looking at me'."

"Who is looking at him?"

"Why, all those people there, and don't you see, he's scared."

I certainly saw, and said, "Tell him that I would like to know now if he has known about these people all the time."

"He says, tell you yes, he knows; that he has not been telling you the truth; that it was not right to talk, and he was afraid and is afraid now." However, quietly and earnestly I led the old man into nodding assent, dissenting or correcting, as with a pointer I began going over the sacred buckskin, naming the characters and symbols on it. Soon he named them of his own volition, as I pointed. When that review was completed, I urged him into detailing some of his methods and practices in doctoring the sick; which he revealed as consisting chiefly of customary songs and prayers and incantation, and the liberal use of pollen as a sacred powder sprinkled upon the patient, upon representations of various gods and upon the air to their spirits in different directions. He was quite proud of results obtained through the use of one prayer to Stenatlihan, which he patiently repeated several times, until I had recorded both its Apache text and translation:

> *Stena pehinda nzhoni, togonil adahe beoishkan.*
> *(Stenatlihan, you are good, I pray for a long life.)*

> *Inatesh nzhoni beoishkan.*
> *(I pray for your good looks.)*

Enudetsos nzhoni beoishkan.
(I pray for good breath.)

Inyatil nzhoni beoishkan.
(I pray for good speech.)

Behnandahi inkehi togonil adahe beoishkan.
(I pray for feet like yours to carry me through a long life.)

Induh binandahe beoishkan.
(I pray for a life like yours.)

Beh nashalolezh nde; nasheyo shichisigon zhondolezh.
(I walk with people; ahead of me all is well.)

Nde shinkloho beh sanandahe beoishkan.
(I pray for people to smile as long as I live.)

Beh sanashado beoishkan.
(I pray to live long.)

No oskongo adishni dahazhi behnashado ti nde ta nasheyo gonzhodo.
(I pray, I say, for a long life to live with you where the good people are.)

Shagocho paogo nasha.
(I live in poverty.)

Akud nde sa nzhoni yesitchi yeatido.
(I wish the people there to speak of goodness and to talk to me.)

Pidi yugga sa nzhoni yekissin shidil endo.
(I wish you to divide your good things with me, as a brother.)

Shituh gozhondolezh pogo hadishndi.
(Ahead of me is goodness, lead me on.)[11]

The prayer finished, Bizhuan rose quickly to his feet, ready to leave on the instance. A package of Bull Durham, with papers, another cigar and a five dollar bill were accepted with evidences of appreciation, but the most obvious expression was that of the sense of relief it gave both him and Gray to escape from a situation which neither had anticipated as being fraught with quite the misery both had endured.

"Apache Religious Beliefs" by Edward S. Curtis, c. 1911 (1904–1906)

Curtis felt he knew Apaches well and devoted a large portion of "The Tribes of the Southwest"—his first popular article on "Vanishing Indian Types" written for the May 1906 issue of Scribner's—*to them. But he was even more pleased with the Apache work of the 1906 summer season itself. "I think I can say that the Apache work has been quite successful—far more than I had hoped for," he told Frederick Webb Hodge, adding that "a little later" he would "go over the different points" upon which they had "been able to get information." Hodge was also the editor of the* American Anthropologist *at the time, and Curtis offered a contribution to the journal: "If you care for it I might furnish you something on the Apache for the Anthropologist, taking up some point or a general paper on the legends, mythology, and religion of these people." Later in the same letter Curtis stressed the Messiah Craze. "It gave us a chance to study one of these things during its upbuilding, and, we might say, its highest power," he said, and outlined the power of "The Medicine Man . . . at the head of it." The following account, which is presumably a rendering of the 1906 experiences, was probably composed for use in—or as publicity for—the musicale of 1911 or 1912. In later life Curtis retained fond memories of his times with the Apaches and wrote several other accounts of his efforts to secure "information," especially of a religious nature, from them. Interestingly, in these he mainly stressed his assumed nonchalance and lack of curiosity about that which he sought, but they do roughly parallel the one which follows.*[12]

When starting my work among the Apaches, I found that there was not a word in print dealing with their religious beliefs and practices. The Caucasian's knowledge of their mythology was minus.[13] I quickly learned that all information relative to their religious beliefs was jealously guarded; their favorite method of evading the discussion of their beliefs was for the medicine men to insist that they did not have knowledge of such matters.

One of my interpreters—who was selected for his dumbness—when led into conversation, told me who the foremost medicine men were and gave an inkling of their beliefs; at the same time telling me that a certain medicine man had a chart which told the whole story, and at that time explaining that there was another medicine man on White River who knew more than any one else; also, that there was a very bad medicine man on the Cibacu [Cibecue] who knew everything.[14] This information was my sole key to the situation—three medicine men; one owned the sacred chart and all three of them said to be unapproachable. During my first season on the reservation, I talked with the owner of the sacred chart. He first disclaimed

any knowledge of anything of the sort, in fact, had never heard that the Apaches possessed anything like that. I then asked him, "If you had such a painted skin and I offered you one hundred dollars to see it, what would you say?" " 'I would say no, for if I showed it to you, I would be killed by the other medicine men and all the spirits would be angry and misfortune would come to our people'." Then I asked him, "If I would give you five hundred dollars, what would you say?" " 'I would still say no, for if I was dead the money would do me no good'." I then tried to talk with the White River medicine man. He insisted he knew nothing and that if he did he would not talk with me. I then confronted him with the fact that I had seen him while making his morning prayer to the rising sun. "Who were you praying to?" " 'Oh, I was just praying'." Thinking he might be bribed, I offered him an unheard-of sum to tell me of his prayers. To make certain that he would realize the magnitude of my offer, I spilled out on a blanket several hundred dollars in silver. The silver held his eyes but did not change his "no" to "yes." He then talked to the interpreter telling him that he had received word from the Cibacu medicine man and that he—the medicine man—knew I was trying to learn of the Apache beliefs and had sent word that I should leave the reservation at once or something would happen to me.

I then went to the Cibacu in an effort to see the reputed bad medicine man. He refused to see me and repeated his warnings, sending word that I must not camp another night on the Cibacu. That I remained for more than two weeks seemingly surprised him. He sent some one to my camp each day to look me over. The spy would invariably ask when I was going to leave. I, as invariably, answered, "Pretty soon, maybe tomorrow." The old chap was clever and constantly sent women to my camp, thinking that I might take a fancy to some one of them, and thus give him a chance to complain to the Government and shift the responsibility of having me put off the reservation. This obvious trick amused my interpreter greatly. . . .

The first season closed and I had not gained a glimpse of the religious life of the Apaches, rather than that it was known that I was endeavoring to secure information dealing with their religious thought and there was an understanding among all the medicine men that no one was to give any information.

On returning the following year, I continued my effort to secure the needed material. There was a slight change in the situation; the medicine man who was the keeper of the sacred chart was dead. His wife had used the household axe to good purpose and he had gone to the Great Beyond. This meant that the aged wife was the keeper of the much desired chart. Goshonne, the White River medicine man, was in bitter conflict with Das Lan of the Cibacu. The latter had gone to the mountains to commune with the gods and had received in a vision a message from the divine

ones. This was the beginning of the so-called Messiah craze. Goshonne well knew that, if Das Lan succeeded with his new cult, his position as head medicine man of the tribe would be usurped by his rival. From my point of view there was conflict among the medicine men which broke the unity of action. I might play one against the other which I did. Weeks passed with little accomplished. I spent much time with the old medicine woman in a continued effort to secure the chart. I was at last rewarded with success, paying her a substantial sum in hand and a monthly pension for life. The woman gave a complete description of the chart naming all characters represented and giving their functions. We can say that the chart and its description as given at that time forms the basis of the mythology of the Apaches. Any further information gathered from the medicine men was but confirmation and amplification.

After the victory of securing the sacred articles, weeks passed without securing other information; then in a last effort I again went to Goshonne's camp, reaching there before the sun came up. From a little distance we—my interpreter was with me—watched the old priest during his prayers to the rising sun. I then made my plea that he tell me something of the Apache's beliefs—I was under promise not to tell any one of having the sacred skin, so did not mention the matter to him. Without word or protest he led the way to a secluded spot some distance from his hut and at once began to tell the story of the creation and continued with an outline of their mythology.[15] Our session lasted until past mid-day; his story confirmed all information secured in connection with the sacred chart and gave a complete outline of their mythology. It soon became known to Das Lan that Goshonne had talked with me and the whole reservation was in a turmoil. Das Lan predicted all manner of dire happenings to Goshonne and his family. Goshonne sent word that I must not try to see him again. The outcome was that I never had word with him after our—for me—most fortunate interviews. Das Lan sent word that he wanted to see me. A two days drive took me to his camp. Our interview was somewhat stormy. The old man had a keen brain and asked far more questions than he answered. He insisted that I had helped him kill his enemy as that Goshonne had in talking with me killed himself and even, I, a white man, would be destroyed by the angry gods. Regardless of his antagonistic attitude and determination not to add to my information, he did directly and indirectly give some valuable points.

As to the curse upon Goshonne and his family—two of his brothers had tuberculosis; they died within a year, also a daughter passed away within a few months and in less than two years Goshonne followed. Considering this, it is not surprising that no further information dealing with the Apache religion has been secured.[16]

II. AMONG THE PUEBLOS

Included within the extensive and varied Southwest culture area are the aboriginal peoples of New Mexico. For the most part they lived—and live—a settled agricultural existence in villages and towns. The Tanoan linguistic family is represented by the Tiwa speakers of Taos, a large pueblo in the north of the state, and the Tewa speakers of such pueblos as San Juan, San Ildefonso (see figs. 7 and 11), Santa Clara, and Nambé, which range southward along the often deep and impressive ravine formed by the Rio Grande River. Also situated roughly along the line of the Rio Grande are pueblos that represent the Keresan linguistic group, such as Cochiti, Laguna, Santo Domingo, and Acoma, perched on its rocky mesa some way west of Albuquerque. Further west still is Zuni, which belongs in a linguistic family of its own. All these peoples built adobe or stone and adobe houses, often one on top of another like apartment blocks, with entrances frequently situated on the roofs. They are accomplished dry farmers, traditionally hunted for local game, practice pottery and a diversity of crafts, and once traded extensively with other tribes. In each village there is a large semi-underground estufa or kiva, and the people place much emphasis on a cycle of religious ceremonies.

At the time of the Curtis project the Pueblos, despite centuries of successive Spanish, Mexican, and American colonial expansion, had managed to retain much of their original land base and, perhaps more significant, their profound and complicated religious beliefs and customs. To outsiders they seemed notably colorful, exotic, and secretive. In the first third of the twentieth century, especially in comparison with many Native American peoples who had found it more difficult to maintain "traditional" life-ways, the sedentary Pueblos were thought of by government agencies—and, if we can make such a broad claim, by the dominant culture as a whole—as conservative and, sometimes, intractable. Given the imperative of ethnology in general—and of the North American Indian project in particular—to discover and explain Native practices, relations between the Curtis project staff and the Pueblos were sometimes fraught.

Since the two volumes of The North American Indian *devoted to the Pueblo peoples (volumes 16 and 17) appeared relatively late in the sequence—in 1926—and Curtis himself first visited at least some of them in 1904 or 1905, the project maintained sporadic contact with various Pueblo communities for approximately twenty years. The fieldwork was conducted at many different times by a variety of people, including Curtis, W. W. Phillips, W. E. Myers, and Charles Munro Strong, an instructor in Spanish at the University of Washington who spent from February 1909 until February 1910 there, mostly in "the examination of documents and papers stored in the old Spanish churches." For a variety of reasons too complex to go into here, members of the project*

were never fully at ease among the Pueblos. Even Myers, who has been characterized here as somewhat reserved and as both subtle and a stickler for accuracy, felt constrained to express not just fears about but also animus against the Pueblos in reports to Frederick Webb Hodge in 1924. "We are starting for Zuni Sunday morning, and will remain in the Pueblo country all summer unless they run us out," he said on one occasion. "I understand that they think less of white folks than ever." On another occasion, when writing up his findings, he said: "I am hard at work on the Pueblo material, and if I don't get lost in the mazes two more volumes will be ready for you by the Spring." Perhaps most surprising, when recording his "good progress" in acquiring ethnological data for the volumes he claimed that he was especially happy over "perpetrating a very satisfactory coup on Santo Domingo, one of the very worst nests of the lot."[17] In the following two documents, both taken from accounts written fairly early in the project's life, there is an emphasis on secrecy, but not the positive distrust that emerged later.

From "Indians of the Stone Houses" by Edward S. Curtis, 1904–1909

Curtis's own visits to the Pueblos were in the main short and for the purpose of securing pictures. For instance, on September 18, 1908, he wrote from Santa Fe to Hodge, who had tried to contact him only a couple of weeks earlier in the Dakotas: "I have closed my short piece of rather trying work here [among the Pueblos], and I am happy to say that while I think it has added a few gray hairs it has given me splendid additional footing in the southern work." Some of this assurance carried over into the following account, published in 1909 as one of his series of Indian articles for Scribner's.[18] *The article is more personal than the corresponding much longer accounts that later appeared in* The North American Indian *itself. In its treatment of several very different peoples of varying linguistic families and culture groups, from the Hopis of northern Arizona—a people granted the whole of volume 12 (1922) of* The North American Indian—*to the most southern Keresan pueblos in New Mexico, the article is much more general than the multivolume work. It is also, of course, more "popular" in tone. Indeed, as is manifest in the very phrasing of its final sentence, it reads like a travelogue.*

When the mail-clothed Spanish soldiers of fortune forced their way into the desert lands of the South-west, the land that we now call Arizona and New Mexico, they found it dotted here and there with human habitations, habitations apparently as time-worn as those of old Spain. They were communal structures of stone, cliff-perched, their six stories or more towering high toward the blue dome, so high that when we look up to them from the plain they seem to be on the level with the high-soaring eagles. For miles across the outlying desert or along the valley stretched

their farmlands. Peculiarly administered communities they were, with so advanced a form of government that the remnants of it, though shadowed by three centuries of white men's greed and politics, remain praiseworthy to the present day. To quote [Charles] Lummis, in "[Land of] Poco Tiempo" [1893], "There were many American Republics before the sailing of Columbus."

The booty-loving Spaniards, who first found this land, were in search of the seven cities of Cibola, with their fabled hoards of gold and portals of turquoise, the cities of the many-times-told and exaggerated tales of the Negro Estevan and the Friar Marcos. Rather than the expected riches, equaling those of the Incas in the Perus, they found no gold and little turquoise, only simple Indians without riches, but with a life far advanced from that of the nomadic tribes, possessed of many arts and crafts. They were tilling fields of corn and beans, and from wild cotton wove cloth which would do credit to any art-loom of to-day, and fashioning from clay utensils of superb workmanship, decorated with highly conventionalized designs; they were tanners, dyers and workers in gems, and beyond all the arts of their domestic life was the ritual of their ancient pagan one, a life exceedingly rich in religious ceremony; while their astronomical and astrological lore is even to-day a thing of wonder to the student.

The women held legally a higher place in the domestic scheme of life at the coming of the white man, three centuries ago, than is granted by the laws of many states to the white mother and wife to-day. The Pueblo wife was the owner of the home and the children. Descent was traced through her clan, not that of the father. In case of a defection of a husband, the wife could divorce him; if he returned to the home to find his personal belongings placed outside the door, it meant that her decree of divorce was sealed; in which case, if he saw fit to apply to the council in hopes of a reversal of judgment, he might secure sympathy and even assistance from her clan, but not from his own.

The dwellers of many of the villages are a people of peace through religious principle and in obedience to the command of their God. Poseyamo, the Creator and God, according to the Tanoan religion, commanded his people to live in peace until his return, and the stars in the sky will make signs to the earth-people in the day of his coming to his own children. Then, if they are to fight, he will lead them. They have believed this for ages, and they wait for the signs in the sky. Meanwhile, they are a peaceful people who go not forth to battle, but when assailed they have written their names large in the blood of the Apache, Piute and Navajo.

Of the stone villages where the dwellers still live and go about their daily tasks, much as they did a century ago, are the seven cliff-perched villages of the Hopi:

Walpi, Shongopovi, Shipaulovi, Mishongnovi, Sichomovi, Hano and Oraibi; Acoma, the beautiful, whose only rival is Walpi of Hopi-land; Zuni, all that is left of the seven cities of Cibola; Laguna, of a later day, but conveniently skirted by the railroad, giving the tourist a glimpse of the Pueblo life without the effort of leaving the Pullman; Isleta, with its primitive and interesting life, also close to the railroad; Sandia, San Felipe, Santa Ana, Sia, Jemez, far up in the mountains, Pecos, Tesuque, San Ildefonso, the almost extinct Pojuaque; Nambé, old and interesting, but fast blending its blood into the Mexican; Santa Clara, San Juan, Picuris, and lastly Taos, the courageous and primitive, nestling in the forested foot-hills of the Don Fernandez Mountains. . . .

Five days' march to the east of the Hopi Villages is Zuni, all that is left of the seven cities of Cibola, the goal of Coronado's great march into the desert, the scene of much of [Frank Hamilton] Cushing's life-work; a group of proud villages dwindled to a single one having a life so rich, in fact, that Mrs. [Matilda Coxe] Stevenson found it a task of many years to record it in its entirety, and her magnificent work is a splendid illustration of the religion and philosophy of the Indian.[19] Many of the Zuni ceremonies are like those of the Hopi. Each has, without doubt, borrowed from the other many features of ritualistic work. The Zuni is delightfully conservative. They accepted the teachings of the church at the point of Coronado's guns. As it was accepted then, so it is now; evidently it did not penetrate very far into the Zuni body. From that day to this many of the children are baptized into the church, but this does not lessen by one the thousands of prayer plumes planted to the gods of their fathers. After generations of labor and martyrdom by the patient Friars the church was abandoned and has long since fallen into decay. All that is left of it is the plot of the dead. Here for generation after generation they have buried their dead, clinging to the sacred spot as only an Indian can. Neither priest nor chief can drive them from it.

Acoma, the dauntless, was first noted by Fray Marcos de Niza in 1539, but was first visited by Coronado's men a year later. [Thereafter there was intermittent contact until] Juan de Oñate visited the Pueblos in 1598, and later this same year Juan de Zaldivar visited them with a small troop. The Acomas showed resentment of this encroachment by killing one-half the number. This was followed, some months later, by a second force of the Spaniards, who stormed and subdued the village, killing a large portion of the tribe. Theirs was a stubborn resistance against the encroachment of the white man. In them we see emphasized the character of all the Pueblo people. Superficially smiling and hospitable, and, as long as all goes to their liking, most kindly. Anger them, and they are fiends. A purring cat with an ever-ready claw.

To fortify this cunning the Acomas have far more bravery than the other people of the Pueblos. They claim never to have been conquered. Spanish history, however, does not bear them out in this. It is one of the three most picturesque of the Pueblos: Walpi, in Arizona; Acoma and Taos, in New Mexico.

In days of old, to get from the valley to the mesa and reach the street of Acoma, we had only the choice of winding, precipitous trails cut in the walls of the rock. Of late years there is a new trail for the use of man and beast, more winding and picturesque, entering the village through a fortress-like natural gateway.

The water-supply of the village is, in most part, from small reservoirs in the rock filled from the rainfall, and as a reserve supply there are two large, deep reservoirs, one fed by a tiny spring. The women, with beautifully decorated earthen jars poised gracefully on their heads, coming and going from the wells, make a picture long living in the mind.

The Acoma fields are far away at Acomita. There, during the summer, they dwell in tiny box-like adobe houses and till their small but well-kept farms, journeying back to their cliff-perched home for all ceremonial occasions. They are, as a people, and have been for generations, devout followers of the Catholic Church. This fact has not, however, in any way seriously affected their primitive religion or crowded out one of their pagan ceremonies. They are a positive argument that a people can be loyal followers of two religious creeds at one and the same time.

In the valley of the Rio Grande we find many small villages. The buildings are usually one story in height, and, from their location in the valley, lack the picturesque features of Walpi and Acoma. Here, differing from Hopiland, and like Zuni and Acoma, farming is by irrigation. Compared to the Hopi, it is princely. Compared to the white man's farming, theirs is petty. Prehistoric irrigation by the dwellers in this region was probably of the simplest order—small ditches drawn from the stream, the water dipped in earthen jars and carried out to the crops. This form of irrigation necessarily meant that very limited areas could be cultivated. Slight evidence is seen which would lead us to believe that Indians of prehistoric time used any other system than this in irrigating their fields. In the valley of the Gila, even where the ditches were miles in length and carried a considerable volume of water, it is probable that the actual application of water was made by carrying it in jars rather than by flooding. To look at the cultivated portion of the Rio Grande valley from a slight elevation, it is a field of grain and other crops divided into squares of slightly different shades of green, reminding one of a patchwork-quilt carried wholly in one color. Their principal crop is wheat. This they care for in the simplest way: when ripe, they harvest it with a hand sickle, and the gleaned crop

is gathered at the threshing ground, which is simply a plot smoothed and enclosed with a rough fence. At the time of threshing, the horses belonging to the family are turned into the enclosure and driven around in a circle until the grain is threshed from the straw. Then with forks they separate the straw and chaff from the grain, sift it in a large box-sieve with a perforated bottom made of rawhide, and then, for the final cleaning, take it to the small streams or canals and wash it. In this washing the grain is taken in large coarse baskets, carried down to the water and stirred about in the basket, the chaff and lighter matter floating away with the current. The clean grain is then spread out on cloths to dry. This drying must be finished the day of washing, and to hurry it the grain is taken in baskets, held high in the air and let sift slowly to the ground. This is repeated time after time until it is thoroughly dried. For daily use, such as is wanted they grind on the hand mealing-stone or metate.

Here, too, among these villages we see the church religion blended with the primitive one. Generation after generation of patient padres have worked and laid down their lives, many in their own red blood at the hands of those whose souls they thought to save. The Indian cannot yet see how or why his soul should be lost. To-day, when we talk to an old man of the village[,] of religion he will tell us, with certainty, that he believes in the true God of the priests. "Yes, I know you believe in the true God, but the story of that God is all written in the big Book. I want to talk with you of your own God, Poseyamo, who lived once on earth and who went long ago to the South." His face lights as if he, himself, was already entering the eternal paradise of his fathers. "Do you know Poseyamo? Tell me about him, and tell me, will he soon come back to care for his children? The signal fire burns at the old shrine on the one night of each seven. It has burned thus many lifetimes to show him that we are faithful and that we wait. Tell him to come soon or I will not be here to see him." And so it is; that which their forefathers accepted for policy's sake they have grown, in a measure, to take for granted, but cling to the old with but slightly shaken faith. They plant their crops as of old, by the star which governs each special growth. The Navajo plants his corn by the Pleiads, but the Pueblo farmer plants by the corn star, or the wheat, or the star of the melons, on the day when the *cacique* gives out the word that the stars say that planting should be done. Only the *cacique* and one other man knows the potent day of each star, and he, the reader of the stars, is kept secret from the tribe. One may not read their movements and tell the secrets in any but matters of great tribal importance.

Taos is, if anything, more conservative than the others, and is delightfully primitive, and the blood of its people exceptionally pure. Tribal laws stand firm against intermarriage with blood not their own, and the same tribal laws forbid all

white man's garments. The youth can go to the village to our schools and learn the white man's ways and cunning in order to be better fitted to cope with encroaching neighbors, but when he returns to take up tribal life he must leave outside the village gates his dressy school uniform and wrap himself in a blanket of the tribe.

Taos is built where the mountain forests come down to meet the plains. A beautiful, and to them sacred, stream flows down through the forest's cool shadows and passes through the heart of this village. At its forested bank, above the village, the women get the water for home use, and on its banks below are gathered groups of matrons and maidens washing the clothing of the family, for these are a cleanly people. The forest above the village is, in a measure, like the stream, a sacred one, and is jealously guarded by the men of the tribe, and in its great depths are held many of the old-time rites, rites never seen by any except members of the order or tribe.

Spring, Summer, Autumn, or white-robed Winter, this wonderful old forest is a master creation, and the like can be seen nowhere else. You, who say there is nothing old in our country, turn your eyes for one year from Europe and go to the land of an ancient primitive civilization. The trails are rarely traveled, and you will go again.

From "Among the Tewas" by W. W. Phillips, 1911 (1905)

This is part of another unpublished "chapter" of the memoir Phillips produced as potential publicity material for Curtis's musicale appearances in 1911. The journey it describes—like others included in it, such as a night-long secret ride in search of a Tewa sacred shrine apparently previously unvisited by whites—probably took place in 1905. As well as constituting both a fact-finding mission of possible ethnological significance and an adventure in the "Wild West," the project was interested in visiting ancient sites in order to gauge the scale of Indian population prior to the arrival of Columbus in the New World. By showing that there had once been crowded towns in what had become sparsely populated arid lands, the project wanted to establish that Indians were, in fact, a "vanishing race."[20]

As we plodded in on that moonless night across rolling sand hills, guided solely by the Milky Way, Sojero [the Tewa interpreter and informant] encountered difficulty in getting into and out of *arroyos*. His English was very slow and deliberate, without a particle of inflection. The moment he met confusion he would call back from the darkness, "I—think—we—will—not—get—home—tonight; we—have—lost—the—trail; here—it—is"; for before he could communicate the loss his horse had found the way. Too limp to laugh when I dropped on my blankets in

camp, I fell asleep more quickly at having deciphered one puzzling reply of Sojero's: In the outskirts of the pueblo we passed a peculiar "dug-out" in a sand bank—peculiar for that region—resembling huts of other Indians, so I asked him what it was. "I—think—it—is—a—frost," he answered. It came to me on the verge of my dreams that he meant a place in which to store field produce in the winter.[21]

The curiosity of an Irish-Mexican, regarding Sojero and myself, who took Mr. Curtis and me with his team through the Rocky Mountains on a week's trip to some old Indian ruins, starting on the very next day, came near causing us trouble. Moonshine whiskey is distilled from rye by Mexicans in the little mountain valleys, and in such nooks unknown strangers are none too welcome at best. Our driver quietly inquired at various places along our route if the people there had seen me pass through these parts with an Indian a day or two before. All had to answer in the negative but at once suspected that some spying was being done,—one irate Mexican threatening to kill us all if we passed through his premises again on return from our alleged search for Indian ruins. The threat disturbed no one but the Irish-Mexican who brought it out, and he worried no little during the several days we spent up in the Rockies.

The hope of being the first white people to visit these ruins among the mountains was dispelled when we had inspected them and learned from Mexicans in the district that another party had been escorted thither a year before, from the opposite direction; but the trip was fruitful in the extreme, nevertheless, if only for the speculation it afforded regarding the prehistoric dwellers of these rocky heights.[22]

The remains of the former village indicated that a thousand or more Indians had once lived on a rock-walled mesa of less than five acres area. To approach it, one had to pass through a stretch of thickly wooded mountain forest on a high plateau, descend a steep incline to a narrow dyke leading to a straight-sided mesa, scale to its top and cross to another dyke which led to the outermost portion of a veritable peninsula, high in the air. The trail from the second dyke up to the mesa rim is cut in the rock wall, once being defended by a stone wall across it at the rim.

The surface rock in that vicinity appeared to be agglutinated volcanic scoria, easily quarried and chiseled, for the walls of all the rooms and houses were made of long stone blocks. Numerous round cisterns, some as much as thirty feet in diameter, had been cut in this soft rock of the mesa top, arguing, in connection with the fact that precipitous walls dropped to a tiny stream several hundred feet below, that the natives once there had had to depend on the heavens for their water supply.

Quantities of flint and obsidian chips were strewn throughout the vicinity, indicating the nature of the old rock-working tools, while beautiful arrow-heads—

the never failing finds—were to be picked up in the debris at the base of nearly any crumbling wall. A sandy bench along one side of the outer mesa, accessible from above only, gave the appearance of having been a garden plot, but the prehistoric dwellers must have ranged the wooded slopes of nearby hills and mountains for their food supply.

We spent a day or two only in and about the old village site, and then wound back over the mountain trails and roads that had guided us up to that high elevation.

In those lonely haunts we met a lithe white-haired old fellow who looked every inch a Spaniard, but he stoutly contended to be a full blood Tewa Indian, never having known in boyhood any people but the Tewas, to whom his mother belonged. It was near his home we camped the night of the first day outward bound. The cordiality of the old man's reception marked him superior to his environment, and was in marked contrast to that we had met in Mexicans all along the way as we journeyed up. Neither the teamster nor our Indian guide on his pony, would touch a pair of fence bars on the homeward trip, but their fears were groundless, for not a soul appeared at a distilling ranch, or elsewhere, to disturb our peace of mind, or impede our progress. We halted only to camp at noon or at night, except at times for making pictures.

A peculiar religious sect of that locality is the Penitentes, a Mexican organization of fanatics who believe in self torture as a means of salvation, and for the remission of sins. Crosses on which penitents had been hung; little churches with blood-stained walls, inside of which members of the cult had been whipped with rawhide lashes, and devotional retreats, were here and there encountered, calling for hurried inspection and the use of cameras.[23] But as Indians were always the first and last objective, we seldom heeded other peoples or matters of deep interest. On [sic] a night, by the light of a round full moon, we drove through the last sand hills skirting the Rio Grande on the west, and forded across to the village of San Juan, to complete our searches there, and prepare for a seventy-five mile drive northward to the pueblo of Taos.

3 On the Plains

The vast region of North America roughly between the line of the Mississippi River in the east and the Rocky Mountains in the west was populated in precontact times by numerous tribes speaking an assortment of languages. Algonkian speakers included the Blackfeet, the Cheyennes, and, in the far north, the Chipewyans and the Crees. Peoples whose languages belonged to the Siouan family included the Assiniboines, the Lakotas or Teton Sioux, the Apsarokes or Crows, and the Hidatsas. Tribal members of the Athapascan linguistic family from the Plains were, among others, the Sarsis of Alberta and the Kiowa-Apaches of the Arkansas River valley. Certain Plains peoples were Shoshonean speakers, notably the much-feared Comanches, while others, such as the Wichitas and the Pawnees, spoke brands of Caddoan. In historical times—as well as, to a large extent, in earlier periods recoverable only through orally recorded myths and archaeological remains—these speakers of very different tongues nevertheless manifested some cultural affinities: similar hunting practices, especially in the pursuit of buffalo (including, latterly, a marked reliance on horses); the development of military societies and powerful warrior codes; and often a religious sensibility directed to the attainment of a visionary state of being. Also, they frequently participated in shifting alliances with tribes belonging to other linguistic groups—sometimes against tribes belonging to their own linguistic families. In prereservation days many Plains peoples were nomadic and moved over great tracts of land, living in hide tipis. Others hunted but also farmed and inhabited lodges constructed of timbers and packed earth or, in the south, wood and grass.

Since the six volumes of The North American Indian *devoted to Plains peoples appeared in two sequences—the first between 1908 and 1911 and the second much later, between 1928 and 1930—Curtis and his associates inevitably dedicated many visits over a protracted period to the gathering of data on this extensive culture area. The accounts that follow relate to the fieldwork that fed almost exclusively into the earlier sequence of volumes, which were predominantly devoted to northern Plains peoples.*

From a Newspaper Item, "Did You Ever Try
to Photograph an Indian?" 1900 (1898–1900)

This October 1900 item from the San Francisco Sunday Call—*noticeably shot through with the nonchalant racism all too characteristic of the period—was one of the earliest newspaper accounts of Curtis's Indian activities as he began to establish a national reputation. He visited the Blackfeet, or Piegans, of Montana at least as early as 1898, possibly again in 1899, and returned once more in the summer of 1900, most likely in the company of George Bird Grinnell, who already enjoyed a longstanding relationship with this people. The experience of the Piegan sun dance so moved Curtis, at least according to Curtis family tradition, that it was one of the factors that led him to conceive of building the Indian work into a comprehensive record. The sun dance ceremony, as well as some of the figures mentioned in the article, did indeed feature prominently in volume 6 of* The North American Indian *(1911).*[1]

There is just one feat more difficult than introducing an Indian to the bathtub, and that is, to make him face a camera. E. S. Curtis is probably the only "paleface" who is past grand master of the art of photographing Indians. The famous Curtis collection of Indian pictures now on exhibition at the art store of William Morris [in San Francisco] is attracting a great deal of comment. The pictures won the first prize at the recent National Photographic Convention, and aside from their photographic and artistic value they are of ethnological interest.[2]

For the kodak fiend these pictures are irresistible. Only the "button pressers" realize the difficulty of photographing Indians. To go among the red men armed with a camera usually means inevitable defeat. The Indian is the photographer's Waterloo.

There isn't any mystery about the methods of Mr. Curtis. The average Indian will neither be cajoled nor bullied into posing. Mr. Curtis does very little urging. His rule is an old one—"money talks." It is with gold and silver bait that he catches the Indian and charms away his ingrained aversion for the camera. . . .[3]

Among the Blackfoot people, whose reservations are found in among the foothills of the Rocky Mountains, Mr. Curtis is regarded as a brother. He went among them three years ago and remained many months, finally breaking through the well-nigh impassable barriers to their confidence.

The Blackfoot people have a sun dance once a year commencing in the first week in July and lasting five days. They are five days crammed with weird customs that few white men have been permitted to witness. Mr. Curtis is one of these fortunate few.

"Even more interesting than the snake dance of the Moquis [Hopis]," says Mr. Curtis, "is the sun dance of the Blackfoot people. The 'snake dance' of the Moquis has been much exploited, but the 'sun dance' is almost unheard of. It was only through the friendship of White Calf, chief of the Blackfoot tribe, that I was allowed to be present during the ceremonies. As I had, by various means, endeared myself to his people there was little protest against my presence."

"I found these Indians comparatively easy to photograph, thanks to the intervention of White Calf, in addition to the usual 'open sesame'—money. However, despite even this combination, I had some trouble and once almost lost my scalp. It is the custom of the men to collect the logs for the lodges constructed for the sun dance. I wished to get a picture of them riding back from one of these wood sorties and stationed myself accordingly. Three horsemen dashed into sight, at the head an Indian called 'Small Leggins,' who had a particular disgust for the camera. I got the picture, but the quick eyes of 'Small Leggins' saw what I was about and with an angry cry he headed his horse for me, intending to ride over me. By a miracle of good luck Chief White Calf, riding from the other direction, saved my life. Afterward I won the friendship of Small Leggins, but he never lost his distrust for the camera."

"White Calf, though he urged the others to pose, was very coy when it came to taking the medicine himself. Finally he consented. I was anxious to get him not only because he was chief but he is one of the few baldheaded Indians I have ever heard of. He appeared as promised, but alas! instead of the picturesque everyday garb he was got up regardless in a faded misfit blue uniform, obtained heaven knows how. His bald head was covered with an elaborate blond wig, on which perched an army hat several sizes too small."[4]

From "With the Cheyennes" by W. W. Phillips, 1911 (1905)

In this extract from a "chapter" of Phillips's reminiscences of his project experiences— which, as noted, were most likely composed in 1911—he recounted episodes that almost certainly took place in 1905 on the Northern Cheyenne reservation in southeastern Montana.[5] None of its material, whether on superstitions or healing practices, for example, was incorporated into the Cheyenne section of volume 6 of The North American Indian—*and even most of the figures featured in it were not mentioned in the larger study.*

In due time, without mishap or adventure, Curtis, Upshaw and I, with fresh supplies, decamped on the upper Rosebud stream, along which numerous Cheyenne camps were strung. "Haste," was the watchword of that brief sojourn and pictures the

primary object, for plans provided for a revisit a year or more later. The camp site was decided upon at noon; by night the big photo tent, a square, "A" sleeping tent and a "catch-all" Indian tepee adorned a small fenced-in patch that lacked little of being an island, and a dozen or more Cheyenne portraits had been taken.

With a youthful Cheyenne Indian, Davy Bear Black, as interpreter, I rode about telling the Indians of our purpose and asking them to call at camp and see us. They did so, scores of them. By dawn of the next morning our presence was known at the outermost limits of the reservation. The Cheyennes were pictures of poverty. Theirs is essentially a grazing country; hilly, rough and rather dry, with small valleyless streams winding through it, but they had almost no live stock. The chance of getting a square meal, of selling some bit of handiwork, or being paid for a portrait, appealed to them. Soon our camp became a busy scene, and so continued for several days; they came in the morning and stayed till dark. We fed as many as twenty at a meal, sometimes, old and young, men, women and children.

Davy Bear Black, as interpreter, did well enough but was too young to be of value in translating war, hunting or other stories, so we searched for a better, but in vain, till the afternoon previous to pulling up stakes, when a long, lank fellow who had been at camp every day, lounging on a horse out in front, hour after hour, sent a youngster into the tent for a piece of paper, and wrote a note in a splendid hand to the "Photographer." Mr. Curtis went out and talked to him, and found him to be a returned Carlisle student, completely reverted.[6]

Except when intoxicated, when he speaks all he knows, the average English-speaking Indian of mature years will hide his English under several "bushels." This fellow could easily have earned as much from us in those few days as he was getting per month breaking broncos for horse buyers, and he knew it, but not a sign did he show of his ability until we were about to leave.

Reticence of this nature is characteristic of all Indians in their intercourse with white men, but among themselves and about their campfires, they display levity in various ways. The different plains tribes talk, one tribe with another, in a highly perfected sign language. I had learned some of it from Upshaw as we drove from the Crow country into the Cheyenne hills, so one day as he sat silently conversing with a group of Cheyennes, I riveted my attention on the movements of the hands all were making, catching a "remark" now and then. My interest amused the Cheyennes and one asked Upshaw if I understood. Upshaw turned to me and said: "He wants to know if you understand." "Tell him not much," I answered, "now, but if I could remain a month or two longer I would be able to talk Indian with both hands and feet." All eyes glanced at my number ten, high-topped, cow-hide boots, and how

they laughed! Later, newcomers at camp were entertained by the hangers-on with a story of the talking boots.

Brief as was our stay, it was replete with incidents and happenings quite Indianesque. While riding about with Davy Bear Black one forenoon, I passed through an enclosure in which was a small board cabin. A little porch protruded from the front, and to each of three slender poles acting as porch-posts, and to the door knob, were tied small cedar boughs. "What are those branches on the porch-posts?" I asked him. "I don't know; just brush, I guess," he replied, but his voice lacked conviction, so I swung out of the saddle with the remark, "Guess I'll take them down!"

"Oh no! Don't!" Davy called.

"Well then, tell me what they are doing there," I urged.

"Why!" he said, "that's mountain cedar, and it keeps the bad spirits out of the house while the people are away. They're going to be gone till nearly winter, and don't want spirits in the house when they get back."

Between eight and nine one evening a wagon stopped in the road opposite camp, some distance away, and a stoutly built man strolled over to where several of us were enjoying a brisk fire. He was a half-Crow, half-Sioux Indian married to a Cheyenne woman. He talked a little of four languages, including English, though none any too well, so found no difficulty in conversing with Upshaw, for signs could be resorted to if words failed. We soon learned that he was on his way up stream to the home of a medicine-man—young Davy Bear Black's father—with a sick baby. The distance was not great—a mile perhaps—so when he drove on with his wife and child, Curtis, Upshaw and I followed in the hope of being privileged to witness the performance that would take place over the baby.

Arriving at the house where Bear Black the elder [see fig. 12] and his large family lived, we found the stout fellow there, but his wife and infant were not in sight. Our purpose was at once made known to the medicine-man, through his boy; then we waited. The night was chilly, so chilly that we found waiting outside uncomfortable; then we went inside. The room was barren and cheerless, but a door led from it to another beyond; in the darkness we couldn't tell where. Silent children were crouched against the wall when we entered, but none of them stirred. When standing grew tiresome, we too, crouched against the wall. After a while the children grew sleepy and one by one they disappeared into the darkness. What the decree was regarding us we could not conjecture, but steadfastly we waited. By and by Upshaw, who had been out with the father of the infant, came and called us, ushering us to a round tepee some distance beyond, made discernible in the darkness by a fire inside. A piece of canvas covered a doorway so low that we had to drop on our

knees to enter. We crawled in, all three of us. A small fire, of well burned coals, on which steeped a pot of herbs, occupied the center. On the right sat the mother with her peevish infant; on the left stretched an old, old Cheyenne, once a prominent medicine-man, but now deaf and blind; back of the fire Bear Black was making ready medicine paraphernalia—feathered wands, rattles and other articles.

The child was feverish and limp, with every appearance of being very ill. Bear Black took it and placed it on a furred skin before him. Pressing his hand to the earth, he then rubbed the bottom of one little foot. Again he pressed the earth, then rubbed the sole of the other foot. The palms of the baby's hands and its forehead were next gently rubbed; and then from sole and palm along the child's limbs to its chest Bear Black glided a hand, rubbing over the heart, each time first touching the earth. The mother then took the babe on her lap, and from the steeping herbs a swallow of medicine which she regurgitated into its mouth. The little one made a wry face, sputtered and cried, but swallowed the dose nevertheless, for it soon vomited.

After that Bear Black began sucking blood from the little one's body, through the skin. He began at its feet and hands, and sucked at spots all over its body several times spitting crimson blood onto the fire. When he had finished, the child seemed quieter; its mother wrapped it up and hugged it close in her arms.

Upshaw had vanished soon after entering. Mr. Curtis and I quietly crawled out and whistled. Before we could get together and out into the main road, Bear Black had started his medicine-rattle and a droning song. We listened till a cold wind drove us on, and went to sleep that night with the sounds of the rattle repeating in our heads.

The next morning early, a happy father and mother with a baby as bright and well as a child could be, stopped for a short time at our camp as they drove homeward, down the Rosebud Creek.[7]

This little narrative, graphically and truthfully related to medicine-men in tribes far to the south, was more than once the means of gaining the confidence of old men in those regions, who at first refused to divulge ought of their own medicine practices.

To secure data relative to medicine practices or ceremonial rites from new tribes, without undue delay, forces one to resort to many stratagems. I find that relating stories of foreign tribes to members of one under study, proves a good method of drawing them out, though by no means successful at all times. Another way is to exhibit photographs of striking scenes and types of some foreign tribe to a local tribe; it does more to arouse interest and curiosity in the average Indian than

endless explanations, or pounds of sugar and tobacco possibly could. A score of Crow Indians once sat intently viewing and discussing a number of photo prints picturing Hopi and other Pueblo groups of the Southwest. They marveled at the terraced homes, but more at the beauty of the Hopi maidens, whom one old battle-scarred veteran pronounced the best women for wives he had ever seen. When asked why, his reply was, "because they are pretty." How universal the belief that a pretty woman makes a superior wife!

The time came all too soon to depart from Cheyenne-land, the country of round hills and breadthless valleys. We did depart, leaving behind us on the camp site a motley, pitiful array of hungry-looking men, mothers and children. We began packing about an hour before noon, and when luncheon time arrived continued packing with one hand while eating a few scraps with the other. Although we had replenished our stock of supplies from a little store on the Cheyenne reservation twelve miles distant, during our short sojourn, the day we left to return to Crow Agency and the railroad, with a two day's drive ahead, we didn't have food enough in camp to fill a soap-box. To have to leave so hastily with a score of wistful faces and hungry mouths gazing after us disappointedly, though stolidly, was a necessity that then did, and has since, filled me with compassionate regrets, but necessity mothers far more than ingenious inventions.[8]

From "Vanishing Indian Types: The Tribes of the Northwest Plains" by Edward S. Curtis, 1906 (1905–1906)

Curtis devoted the second of his Scribner's *articles to peoples of the vast Plains culture area, with some commentary in passing on such Plateau groups as the Nez Perces and the Flatheads. The article is largely an opinion piece, giving his views on U.S. government policy, Indian demise, and the like, but it did also relay his own firsthand experience of a variety of reservations and their occupants, the emphasis in the selection that follows.*[9]

The Crows, of Montana, who call themselves "Absarokas," are one of the strong groups of the Northwest Indians. They did not take to fighting with the white settlers or soldiers, but from the earliest traditions they have been constantly engaged in inter-tribal war with the Sioux, Piegans, and other tribes. At no time were they allied with the other tribes of the region, and, being fewer in number, their very existence was a fight for life. This fact kept them up to the very height of physical condition. None but the strongest could survive. To this they perhaps owe the fact that of all the Northwest tribes they are the finest in physique. They have a splendid reservation.

It is allotted, and, so far as it is possible for the Indians to get on in the battle to be self supporting, they are doing well. But the remodeling of their life to meet the changed conditions forced on them by advancing civilization is solving the Indian problem for them, and at the present rate of decrease there will not be a living Crow in forty years. [10]

The Custer battlefield is close to the Crow Agency. In a desire to know all that I could, at close range, I spent many days in going over the battlefield foot by foot, from where the troops left the Rosebud to the ridge where the men had made their last stubborn fight [see fig. 22]. White marble slabs mark the spots where they fell. In most cases the slabs are in twos, side by side. Strange how it is when it comes to the final end, we reach out for human companionship. There they made their last earthly stand, bunkie by bunkie.

Among the dozens of Indians I questioned of the fight was Curley, who is so often called the sole survivor of the Custer fight. He has been so bullied, badgered, questioned, cross-questioned, leading-questioned, and called, by mouth and in type, a coward and a liar by an endless horde of the curious and the knowledge seeking, that I doubt today, if his life depended upon it, he could tell whether he was ever at or near the Custer fight. [11]

I was particularly interested in getting the Indian point of view as to the bravery and respective fighting qualities of the different tribes. The Crows, in summing up the other tribes, claim that the Flatheads were the most worthy foes in intertribal fights, "as they fought most like us." On the other hand, they claimed that the Blackfoot was brave to recklessness, but was foolhardy and lacking in judgment. The Sioux were a worthy foe, and so greatly outnumbered the Crows that the latter could succeed in their fighting with them only by quick, bold strokes, and then back into their own country. Many a Crow war party went out to the land of the Sioux never to return.

One expects to find the highest development of the Plains Indians in the Sioux, but I question the fact. Physically they are not equal to many of the other tribes of that region. In legend and mythology the field is more sterile than with the small, isolated branches of the Algonquin stock, the Blackfoot and Cheyenne. [12]

But it is among the Sioux that we find the greatest number of old historical characters. Each year cuts down their number, and soon these old fellows who know of the old days before the coming of the white man will be no more. Red Cloud is, without doubt, the record holder of the living North American chiefs today [see fig 4]. His home is close to Pine Ridge Agency. Ninety-one years old, blind, almost deaf, he sits dreaming of the past. No wonder he is irritated by the

idle information seeker! Who would be called back from the dreams of his youth? Sightless and infirm, he is living over the days when in youth he sat his horse as a king, the pride of the great Sioux nation. To his ears must come the roar of the hunt as the countless bison herd, like a tidal wave, rolled by: and, again, the great day of his life, when his red-blanketed band swept down on the hapless Fetterman troop. Even now his heart must seem to stand still as he lives over again that day. And then that fearful day of the "Wagon Box" fight, when he hurled the pick of the Sioux nation against those thirty-two riflemen concealed in that corral, only to have his men mowed down by the repeating-rifles, with which this was the Indians' first meeting. [13]

In working with the Crows I gathered together a party of the men and made a long trip across the reservation and into the mountains. My bunch of Indians were certainly a picturesque and interesting group [see figs. 5 and 23]. Two of the best characters were old Bull Chief, eighty-five years old, but still good for a forty-mile day in the saddle, and old Shot-in-the-Hand, quite a few years younger, but old enough to know a good deal of the old life. Our tents were the Indian lodges, and at night-time, around the lodge fire, the old fellows told me stories of the old Indian life. Bull Chief was the best Indian story-teller I have ever known. With clear, keen memory he traced back the Crow history through the lives of ten reigning chiefs. He was old enough to kill buffalo calves with bow and arrow when he saw the first white man, and his people were still using stone axes. His picture of the first time he saw a white man and the things of the white man's make was most vivid. A trader, whom the Indians called "Crane," from his slender build and great height, came up the Yellowstone in a canoe, stopping at the junction of that stream and the Big Horn. . . .

Our camp was by a particularly beautiful mountain stream, in a deep, narrow canyon. One night the whole band of Indians was gathered by the lodge fire to listen to stories by old Bull Chief. Story after story had been told by him of the terrific fights with Piegan and Sioux. Many of the men had dropped off to sleep, when on the quiet air rang out two signal shots. Every Indian was awake and out of the lodge in an instant. Their conversation was low; all was nervous excitement. "Who was it? What could it mean?" You would have thought we were a war party in the land of the enemy. I had them fire shots in reply to the signal, thinking it might be someone in distress, but could get no reply. My attempt to allay their anxiety and get them to telling stories again was useless. No more stories that night.

W. W. Phillips, in one chapter of his memoirs, recorded some of these same events,

making it obvious that Curtis was not the only member of the project present. Phillips also made it clear that Upshaw was a key organizer of the trip, which was engineered partly to produce good photographic landscapes and backdrops for the aesthetic aspect of the project's endeavors. He also was an important facilitating factor in securing and interpreting Bull Chief's tales. Interestingly, and perhaps because Curtis himself seems to have viewed at least part of his role as an effort to show that the project really was out in the wild West, the incident of the mysterious gunshots did not appear in Phillips's version. However, the remainder did. Much of the data collected from Bull Chief and Shot-in-the-Hand came to be deployed in the Crow volume of The North American Indian. [14]

From "Hunting Indians with a Camera" by Edmond S. Meany, 1908 (1907)

Edmond S. Meany, born in 1862 in East Saginaw, Michigan, and brought west by his family during his youth, was a dynamic figure in Seattle public life from the 1890s until his death in 1935. Meany first rose to prominence as a newspaper reporter—an activity he continued on a freelance basis throughout his life—before becoming an institution as professor of history at the University of Washington. He was a prolific writer, editor, and popularizer. He was a good friend to Curtis and a key supporter of the project, both in helping to "sell" it to potential patrons and in providing academic respectability (and, on occasion, input). Curtis engaged him to write the "Historical Sketch" of the Teton Sioux for volume 3 of The North American Indian *(1908). Mainly as a result of this commission, Meany accompanied the North American Indian party as it traveled on the plains during the summer of 1907, and he helped gather data, both for the project and for his own extensive files. He also sent reports back home for local publication in the* Seattle Sunday Times. *At Curtis's urging he worked up one of these newspaper pieces, partly based on his own project experiences, for the popular national magazine* World's Work. *This article, from which an excerpt follows, was illustrated using Curtis photographs.* [15]

Catching glimpses of the inner life of the Indian is uncertain and often a dangerous occupation. Sudden caprice or unfounded suspicion may spoil the work of months.

The story of Mr. Curtis's visit to the Sioux of the Wounded Knee will give a little idea of the difficulties. Two years ago Mr. Curtis—or, as the Sioux call him, "Ba-zahola Wash-ti" (Pretty Butte)—made a long trip into the Bad Lands of South Dakota. His guide and leader was Chief Red Hawk. Mr. Curtis promised to return and give a feast to the chief and twenty of his followers on the banks of the Wounded Knee. Through the good fellowship growing out of the feast, Mr. Curtis hoped to

secure photographs and records of many of the ancient Sioux customs. But Red Hawk found it impossible to restrict the invitations; instead of twenty, 300 gathered for the feast, and among them were chiefs equal in rank to Red Hawk. They felt that they must make their importance felt. Chief Slow Bull had brought his council tepee, decorated with buffalo-tails and with a horse's tail floating from the peak. It had come down to him from his father, and his father's father, with traditions of war-parties and the chase. Into this tepee Curtis was invited for a council. After his speech, Iron Crow, one of the chiefs, replied that to make all perfectly happy would take more beeves than Mr. Curtis had provided. He was reassured, and the council broke up with many "Hows" and much handshaking. But, as the first procession formed in the morning, Slow Bull raised his voice in that wild, matchless oratory of the Indian and brought the procession to a sudden halt. He, too, wished to be placated with more beef. Then a careless teamster nearly ruined the whole enterprise by throwing off one of the sugar-bags with the oats. After it had been rescued, the feast was finished without offense to anyone's dignity. Then, with true Indian caprice, they decided that they must rest and smoke for the rest of the day. Again the plan seemed on the verge of failure. Red Hawk had lost control.

Mr. Curtis quietly folded up his camera, as if he had not traveled many weary miles just to get these pictures. There was no fault-finding, no impatience; but, with infinite tact, he discussed affairs with some of the leading spirits. During the night a reaction in sentiment set in. In the morning the warriors, led by Red Hawk and Slow Bull, rode into camp. Their hearts were happy, they said, and they wished to help their white friend. Old rites were reenacted, old battles re-fought, old stories retold; and Mr. Curtis's pen and camera recorded it all [see figs. 6 and 13]. . . .[16]

During the past season I was with him among the Sioux on the great Northern plains. The study of the Indian has been my summer work for a number of years. During this time I have met ethnologists, archaeologists, linguists, historians, and artists, but none of them seemed to come so close to the Indian as he; so close that he seems a part of their life. A rugged old chief who had been a leader of his people for a lifetime once asked Mr. Curtis: "How did you learn to be just like the Indians?"

He will discuss religious topics with a group of the old men; they will pass the pipe around the circle and say, "He is just like us, he knows about the Great Mystery."

There have been many hardships in Mr. Curtis's work besides the dealings with the Indians. I have a keen recollection of our first camp among the Ogalallas. At dark a terrific storm struck the camp. The tent-poles broke and the tents flattened to the ground. Five Indian ponies in the neighborhood were killed by lightning.

Letter by W. E. Myers to Frederick Webb Hodge, 1908

Scarcely a year after W. E. Myers joined the project in 1906, Curtis informed Frederick Webb Hodge (in June 1907) that Myers was among the Sioux at Pine Ridge in advance of the remainder of the Curtis party, which was about to join him. Clearly Myers was already the project's leading ethnologist. By January 1908, when the following letter was composed, Myers was writing authoritatively to Hodge on matters of substance with regard to Plains ritual in a manner that combined an inquiring mind with already-established empirical knowledge. Not only was Sioux ceremonialism not the "sterile" field that Curtis had claimed it was in his 1906 Scribner's *article, but Myers was keen to understand its intricacies.*

All of the Titon bands observe a ritual called *Hunkalowanpi* [Foster Parent Chant], the purpose of which is to implant certain virtues in the child for whom it is given [see fig. 13]. Priest and child assume the relation of godfather and godchild. It is found among the Yankton, the Assiniboin, and in slightly different form among the Hidatsa and Mandan. The same songs appear everywhere, but with the three tribes last named Arikara words are set to the music.

I think the Siouan tribes borrowed the ritual from the Arikara version of the Pawnee Hako; either that is true, or else the Caddoan ceremony is an adaption of the Siouan. But the use of Arikara words by Hidatsa and Mandan certainly favors the former supposition.

Do you not think that the question would be answered conclusively by the presence or absence of the ceremony among those Santee who have not come in contact with the Caddoan?

One other piece of information I should like to have: Do the Santee bands relate a legend of the Grey Buffalo Woman, mentioned in Clark's Sign Language under head of *Buffalo, White?*[17]

The subsequently published Sioux volume of The North American Indian *contains fuller results of Myers's work, including "answers" to his speculations. There is a long account, for example, of the* Hunkalowampi *or Foster Parent Chant, complete with transcriptions of songs. Myers was characteristically concerned to relate his own field findings to already-published work. At the same time the actual record of the ceremony in* The North American Indian, *while not written in the first person, is wholly based on meticulous observation, with each movement in the long and complex rite carefully described and, interestingly, containing a minimum of interpretive commentary. For instance, near the beginning of the description the reader is told that a second principal*

purpose of the ceremony is to try to achieve continued well-being for the people as a whole, and the attentive reader should be aware of this in that so many of the ceremony's prayers are expressed on behalf of the total community and addressed to all the directions and dimensions of nature. Similarly, chief figures in the ceremony, Singer and Work-do, do not restrict their attention to the child initiate.

Interestingly, in a practice that prefigured ones adopted by present-day ethnohistorians, Myers promoted the idea that data taken from Indians should and could be collated with information taken from "white" sources. For example, a few months later in 1908 he wrote to Hodge with a series of questions, the answers to which would correlate events shown on a Sioux winter count—a pictorial representation drawn on animal hide meant to act as a mnemonic device for recalling history—to episodes in white-Sioux contact recorded in the contemporaneous journals of white travelers.[18]

Letter by Edwin J. Dalby to Edmond S. Meany, 1908

Edwin J. Dalby was a student of Meany's when Meany recommended him to Curtis as an ethnological assistant. Dalby was a practiced speaker of the Chinook jargon, the lingua franca for Indians of the Puget Sound region and others located far into the interior of the Pacific Northwest. Dalby was somewhat overweight but accustomed to an outdoor life, bright, ambitious, and keen to write (he had edited student newspapers). He started in the field early in the summer of 1908 and at the end of July Curtis sent Meany a report on him: "The work with the Rees [Arikaras] and Mandans has been rather trying. Your boy Dalby has had an experience he will not forget in a few days. Every few minutes he cries out wanting to go back to Washington. The mosquitoes proved almost too much for all of us, to say nothing of a juicy boy like Dalby." Despite mosquitoes and other such hindrances, Dalby settled to the work. By August he was able to write to Meany from Poplar, Montana, with confidence—indeed, it is a pity that he did not communicate more substantial information:

Just a few lines to let you know how we are getting along. Have been working with the Yanktons here for several days and go from here to Wolf Point, among the Assiniboins. The work this summer has been successful, I think, and we will be through for the summer in about a month. I am coming back to college this fall . . . I am going to take up the Washington work in March, by myself, I believe, unless Mr. Curtis changes his mind.

There is very little I can tell you by letter, as I have had so many experiences that I don't know what to tell first, so will wait until I can have a long wa-wa with you. . . .

Well, I reckon I will stop and write up a few field notes. . . .

Next address Minot North Dakota.

Meany's response encouraged his young protégé: "I judge by [the letter's] tone that you are getting on well with the important task you have undertaken."[19]

Dalby apparently became known to some Indians as "Man-Without-Hat," and was, indeed, entrusted with a field party of his own in the summer of 1909. According to Dalby family lore Dalby experienced great difficulty making ends meet in the field and the resulting frustration probably caused him to leave the project after only two or possibly three seasons, during which time he mostly worked among the Coastal Salish peoples of Washington and British Columbia. He then became a reporter for the Seattle Post-Intelligencer *and continued his career as the paper's waterfront correspondent for almost three decades thereafter.*[20]

From "Among the Blackfoot Indians of Montana" by A. C. Haddon, c. 1914 (1909)

In November 1908 Curtis wrote to his tireless editor, Frederick Webb Hodge, that, "by the assistance of an influential English friend" (the press baron Lord Northcliffe), he thought he could get a prominent review of the first volumes of The North American Indian *into a British publication, and he asked Hodge to advise him on a suitable reviewer. Hodge, who in any case was British by birth, knew virtually everyone in the field through his various official positions in American anthropology. Among the names he put forward must have been that of Alfred Cort Haddon (1855–1940), then the reader in ethnology at the University of Cambridge and a fellow of Britain's premier scientific body, the Royal Society. Haddon had been the leader of the 1898 Torres Straits Expedition, one of the first truly thoroughgoing exercises in empirical anthropological fieldwork. Haddon was, in fact, a founder of anthropology as a social science, and had achieved respect throughout the world. Moreover, he had a good grasp of anthropological developments in the United States, and in 1901 he had joined George A. Dorsey of the Field Museum of Chicago in conducting fieldwork among the Pawnees.*[21]

Perhaps coincidentally or perhaps not, Haddon was invited to give a series of lectures on the evolution of culture around the Pacific Rim during the run of the 1909 Alaska-Yukon-Pacific Exposition. With Edmond Meany as one of its organizers, this world's fair was to be mounted in Seattle. In any case, probably through Haddon's long association with yet another of Curtis's patrons, Henry Fairfield Osborn of the American Museum of Natural History in New York, Haddon was already a familiar name to Curtis. Curtis seized the opportunity offered by Haddon's Seattle sojourn to invite him to join the North American Indian *project in its fieldwork. In his very next letter to Hodge Curtis*

was able to mention that Haddon was to be involved with the project for much of the following summer: "He will probably spend more time at one of the branch camps, which will be on Puget Sound, than he will with my personal party." At the very time Curtis was writing to Hodge in November 1908, Haddon was beginning to wonder what he had let himself in for. On November 17 in a letter to a friend of some standing, Clark Wissler, curator of ethnology at the American Museum of Natural History in New York City, Haddon set down the following questions: "I shall be spending part of next summer in Seattle with my wife & elder daughter. . . . By the by—who is Mr. E. S. Curtis? & what is he doing in the N.W.? He has offered to take me on some Expedtn. & I don't know who the devil he is and what the devil he is doing. Do enlighten me." "In reply to your kind letter . . . asking for information as to Mr. Curtis," wrote Wissler, on December 2, "I beg to say that he is an enthusiastic photographer who has a great deal of interest in the ethnological side of Indian life, but whose chief effort is to photograph as many of the living Indians as possible. He is publishing a magnificent book of some twenty volumes, each volume accompanied by a large atlas of portraits and views. While he is primarily an artist, I believe you would enjoy spending a day or two with him."[22]

Haddon was sympathetic to photography and to visual anthropology in general. His Torres Straits Expedition had been the first ever to take along a movie camera together with still cameras and sound recording equipment. Nevertheless, he seems to have taken the slightly derogatory tone of Wissler's words to heart, at least for a time, for he wrote a detailed letter to Dalby, the leader of the Puget Sound "branch camp" he was to join, advocating that the Curtis parties utilize W. H. R. Rivers's truly systematic means of recording family relationships in any given community, a method first employed in the Torres Straits. Although Haddon probably thought that his strictures on the need to surpass the mere collection of "folklore data," as he sometimes saw it, were not taken seriously enough by Curtis and his associates, his time with them appears to have been a happy one.[23]

For a start, as plans developed over the following months the "day or two" recommended by Wissler stretched to several weeks. Haddon told newsmen in July 1909 that he was preparing to spend about two weeks with Dalby's "Curtis" party on a research trip among Indians who had gathered for their annual summer fishing season at the mouth of the Fraser River in British Columbia. While there Haddon apparently became involved in a police raid on the Chinese barracks at one of the Canadian canning companies. He also spent some time with a Curtis party among the Nez Perce in Idaho and the Kutenai on the U.S.-Canada border. But his biggest adventures— as recorded in the following reminiscence—took place the following month among the

Blackfeet in Montana, with Curtis himself present. According to a story in the Christian Science Monitor, *by the time the journey began Haddon had become "much attached to Mr. Curtis" and intended to have a "thoroughly delightful trip" making his own observations and taking physical measurements among the tribe.*[24]

As it happened, Haddon appears to have taken no measurements and his experience seems to have been more personal, and deeper. He definitely received no material recompense for his weeks in the field. Instead, Curtis probably intended that Haddon should receive a free subscription to The North American Indian. After the trip was over, on November 2, 1909, Curtis wrote from New York: "Yesterday I had a delightful chat with Professor Osborn, and also talked with Miss Green [sic], Mr. Morgan's secretary, and feel certain that there will be no trouble in getting a set of books for your personal use. Professor Osborn will take the matter up with Mr. Morgan at the first opportunity. I cannot tell you how happy I am that this seems to work out so well. Both Osborn and Bumpus expressed their pleasure in your having been with me this summer." It is evident from the same letter that the subscription would also constitute a reward for writing a (doubtless laudatory) review of The North American Indian: "In regard to a review of the work," Curtis wrote, "I have not yet had a reply from Lord Northcliffe, but wish that you might prepare something of the sort and have it ready, as I am certain that I will be able to get in touch with Northcliffe in the very near future, and it would be a great help to me in my winter campaign if a review by you could appear." He added that William McGee's review of "the last three volumes" was due to appear in the American Anthropologist then "in press," and that he would send off a copy to Haddon. In the remainder of the letter Curtis reported the receipt of an order for The North American Indian from Lord Strathcona and other such developments: "Mr. Morgan is giving the work to King Edward, and I believe that Mr. Carnegie is to present it to some one of the more important libraries in Europe within the month. . . . I am now devoting a few weeks to creating a wave of enthusiasm for the work," he declared, "and [I] want you to join me with all your heart. Let us all give one grand push at the same time and it will be over its trying period, and I will be free from the financial worry and will be able to devote all of my time and energies to the building of the book. . . . All I ask," he concluded, "is that people give me a chance to make the book what it could be."[25]

No doubt Osborn and H. C. Bumpus, secretary of the American Museum, were enthusiastic, possibly also Morgan's close assistant Belle de Costa Greene, but Morgan himself was a hard man to persuade. Curtis's "influential English friend" Lord Northcliffe took out a subscription for himself, but whether he ever commissioned a London review is unknown. McGee's review did duly appear, but the "grand push" failed to

solve Curtis's financial problems, as his next letter to Haddon, written six weeks later, in December 1909, showed: he referred to the previous six months as "a trying period," saying "Mr. Morgan has once more come nobly to my rescue in the matter to furnishing $60,000 additional capital for the Indian undertaking." He padded the letter out with tidbits about Myers—in the company of Ralph Armstrong, an educated Nez Perce–Delaware informant—working with the Nez Perces at a time chosen to coincide with their ceremonial cycle, and about government promotions accepted by W. H. Holmes, the artist and ethnologist, and Hodge. But its chief point must have seemed all too obvious: "And now comes the heartbreaking part of my letter. I have no means of knowing why, or anything about it, but Mr. Morgan declined to send you the books. The matter was brought up, I understand, in person by Dr. Osborn. When I talked with the Secretary, just before that, she seemed to feel that there was absolutely no question but what the matter would go through, and I took it as a settled thing. . . . I assure you that I regret this as much as you possibly could."[26]

In the years that followed Curtis and Haddon seem to have remained in touch in only a desultory way, but with the passage of time Haddon's adventures in Montana became an ever more vivid and cherished memory. His reviews in 1911 of The Old North Trail, *Walter McClintock's intimately autobiographical account of the Blackfeet, resonated with remembered excitement. His short piece on "The Soul of the Red Man" (1914) included a brief mention of his Pawnee and Piegan experiences, followed by these words: "No one who has witnessed religious ceremonies such as these, or has seen solitary Indians sitting on rising ground on the prairie wrapped in a blanket engrossed in meditation at sunrise and sunset, can doubt their intensely religious nature, which is further evinced by their conduct and conversation."*[27]

Haddon told the Christian Science Monitor *that he had no intention of publishing anything on the Blackfeet, and he never did. He did collect, however, notes and quotations from several authoritative writers on the Northern plains—including Grinnell and his own friend Wissler—that he incorporated in his memoir. It was probably written during World War I, though Haddon may well have first started it soon after his return from America, in response to Curtis's call for a review-cum-endorsement of* The North American Indian *enterprise.*[28]

Early in August, 1909, we crossed the Rocky Mountains from west to east by the Great Northern Railroad & got off at the station of Browning, Montana, which is over a mile distant from the little township of that name. Browning is one of those places which have the appearance of having been dumped down casually without any particular reason—there is no shelter and only a small stream of water—the

gently rolling prairie presenting no feature at the spot to differentiate it from any other area within a radius of many miles. It is however the administrative center of the Blackfeet Reservation in Montana, the Agency and other official buildings being fenced off from the township proper, which contains two small hotels, a large store, several smaller ones, and the dwelling-houses of the few residents. In the center is a large square, and in front of the principal buildings are hitching rails for horses.

To the east the prairie stretches illimitably; to the west it ends almost abruptly at the foot of the serried Rocky Mountains. The lowest slopes of the mountains are pine clad, then follow the firs, but the upper third appears devoid of vegetation and every here and there are patches of snow.

Not a tree is in sight; there appears to be nothing but eternal grass, though as a matter of fact the prairie supports a very varied flora. Owing to the shortness of the summer most of the flowers blossom about the same time and the sward is gay with blooms of diverse hues . . . and the air is redolent with the scent of the sage-grass. It is only along river valleys that trees and bushes are to be found.

These plateau prairies are rarely level, the surface having been carved into gently sloping low hills and open valleys, in some of which small streams run even at this time of the year, in others the water may be too low to run at all. In scattered hollows are pools of water, converging to some of which may still be seen the beaten trails of the herds of the exterminated buffalo, and near by may often be seen the buffalo wallows where these shaggy brutes rolled in the mire. The numerous pools afford ideal breeding spots for mosquitoes, the numbers of which constitute the only drawback to the prairie in summer. The weather is brilliant most of the time, with hot days and cool and sometimes cold nights, for the general altitude of the plateau is about 3,500 feet.

About fourteen miles south of Browning we pitched our camp on a terrace of the valley of Two Medicine river, immediately above the spot where it is joined by Little Beaver creek.

My trip to the Blackfeet country was due to the invitation of Mr. Edward S. Curtis to visit one of his camps and see Indians under present conditions. Mr. Curtis is publishing a series of twenty quarto volumes on the native tribes of the United States . . . in an attempt to describe the real life of the people before it was modified by contact with the white man . . . in a uniform and systematic manner, for, strangely enough, nothing of the kind has hitherto been attempted for America. Special attention is given to the religious life and ideas . . . as Mr. Curtis rightly holds that the genius of a people is best expressed in those customs, ceremonies, and ideals which are grouped under the general term of religion. The work as a

whole is from first-hand field-notes, being a record of facts without expression of personal opinions.

In the collection of these data Mr. Curtis is assisted by several able young field-ethnologists, and all the information published has been specially collected, nothing being copied from other sources, though the latter are studied and are checked by fresh observations. Mr. Curtis is essentially an artist who works through photography, and many of his studies of Indians have received fame in the United States though they are practically unknown [in Britain]. His aim is to put the Indian in his natural surroundings, clad in native costume, and often performing some characteristic action of daily life or some incident in their rich and varied ceremonial life. . . .[29]

For the securing of these pictures Mr. Curtis is in many cases only just in time: much, alas! that is of great interest has irrevocably disappeared, and what remains often exhibits painful signs of degradation from older conditions. In a few years it will be very difficult to obtain any pictures at all to illustrate the Indian as he was in his prime. . . . Continuous contact with the white man, the influence of Indian and Mission schools, the restriction to Reservations, the constraint to labor, and other circumstances have profoundly affected the mode of life of the Indian, and will do so to an increasing extent. Concurrently with change in habits has come a psychical modification: how far their nature is changed it is impossible to determine, at all events there are no longer the excuses or the opportunities for the reciprocal injuries which formed such a sad page in the history of the winning of the west. Enough has probably been said in books concerning the cruel and vindictive nature of many of the so-called "Red Indians," but there is another side to their character which has too often been minimized. The sympathetic study of the American Indian by various investigators has revealed the fact that he is a man of peculiarly high moral tone, and imbued with a high sense of honor and a great appreciation of personal repute. What has struck me most in my slight acquaintance with members of various tribes is their intense religious feeling. To know the Indian it is necessary to associate with him in spots as far removed as possible from the haunts of the white man, and it is equally essential that he should realize that his visitor has a sympathetic interest in him, for nothing destroys confidence more rapidly than patronage, supercilious behavior, and cynical or jocular criticism. The finest specimens of his kind are to be found among the older men who retain their old beliefs. The Indian who has been to an Indian school and has gained a more or less superficial knowledge of some form of Christian belief has at the same time lost many of the psychical and moral qualities which give such distinction to those who were raised under the old regime.[30]

As the knowledge of the customs that have disappeared and of obsolete ceremonies is confined to the old men, it is necessary to engage their services in order to rehabilitate the past. Very few know English, or at best have but a very superficial acquaintance with that language, consequently an interpreter has to be employed which renders investigation slow and laborious. It can readily be understood that very much depends upon the personality of an interpreter. Some are apt . . . to abbreviate what the informant narrates: some are too ready to air their own cleverness . . . ; save the few blessed with a logical mind they are apt to ignore the due sequence of events: but some are splendid, . . . keep the narrator on the right track [and] suggest questions. . . . Most of those employed among the North American Indians are of mixed blood. Informants likewise vary. . . . Some dwell with loving care over every detail and slowly but accurately revive a whole ceremonial: others again are forgetful or are careless. Most, however, are conscientious and their faults are temperamental and not of malice aforethought. One good pagan among the Blackfeet prayed before he began to speak at his first interview, and occasionally he would not give certain information or sing particular songs because he did not think it right to do so. Indeed we frequently came upon a religious reticence which was as praiseworthy as it was annoying. Finally there is the temperament, training, and ability of the white observer to take into account. It is therefore not to be wondered at that the published accounts of American Indians, and indeed of all native peoples who are investigated in a similar manner, are liable to vary and to be of varying reliability. . . .

The district which we visited is occupied by the Piegan branch of the Blackfoot nation. Originally the Blackfeet were a Canadian tribe living in the woodlands about the Red River country, where, according to the Rev. J. McLean, from the nature of the soil which blackened their moccasins they were called Blackfeet. Mr. Horatio Hale believes that "the westward movement of the Blackfeet has probably been due to the pressure of the Crees [who, in turn, originally dwelt much further east]. This will explain the deadly hostility which has always existed between the Crees and the Blackfeet. . . ."

Mr. G. B. Grinnell adduces evidence in support of the view that their original home was in the country north of the Lesser Slave Lake and next south of the Beaver Indians. At all events . . . they came from the Province [sic] of Athabaska, and were the most northern representatives of the Algonkin stock. . . .

About a quarter of a mile from our camp on the alluvial plain of the [valley of Two Medicine River, immediately above a spot where it is joined by Little Beaver Creek] is the home of Little Plume, and his youngest brother lives beyond. In the

opposite direction, across the creek, are the houses of Red Plume and his son Yellow Owl. Otherwise the Indians live scattered far away, but as it was essential to the object Mr. Curtis had in view to be in close contact with Indians, he invited a number to come and pitch their tipis close to our camp, one inducement being the promise of a feast. The earliest comer was our first interpreter, Billy Russell, a mixed blood of European-Negro-Indian parentage.

. . . In a well-equipped tipi the outer covering does not quite reach the ground, and a painted screen of dressed skins lines the interior to a height of about five feet: this is close to the ground below, and its upper edge is not in contact with the outer covering. This arrangement enables fresh air to enter the tipi in any direction and at the same time excludes draughts.

The place of honor is in the west, and it is here that the sacred bundle and other ceremonial and "medicine" objects are hung. In fine weather the bundles are usually suspended from a tripod of poles outside of and behind (i.e. to the west of) the tipi.

The spaces along the screen between the sacred bundle and the entrance in a well-furnished tipi are occupied by couches which are peculiar to the Plains Indians. These consist of a pair of light frameworks of the shape of isosceles triangles with truncated apices, which are supported by decorated posts. The frameworks afford admirable back-rests, and between each pair of rests are rugs, blankets and pillows.

Tipis are often painted with various devices, which are frequently due to the inspiration of dreams.

Towards the end of our stay a number of Indians arrived at our camp, most of whom brought their tipis, which were arranged in an irregular circle. It was a pretty sight to see the plain and painted tipis on the prairie and the Indians stalking around—especially so in the evening, when the tipis glowed with the rosy hues of the fires and the smoke curled out through the apical orifice. Besides the tipis owned respectively by Wild Gun, Yellow Kidney, Little Plume, Billy Russell, Red Plume, Chief Crow, Running Owl, and [Phillip] Flat Tail, there were tents of various kinds owned by other visitors.

One day we went down Two Medicine river to the point where it opens out into a much wider valley owing to the confluence of Beaver Creek. At this point surrounded by a large number of trees and well supplied with water is the Holy Family Mission. At the northern entrance into the broad alluvial valley is a fissured bluff rearing about one hundred feet above a grass-clad, stony talus which reaches a height of some three hundred feet above the general level of the valley. At one spot the bluff has weathered into a small crescentic bay, which was formerly the scene of great buffalo drives. Converging to this spot on the prairie above are long low lines of stones.

According to Clark Wissler, "the Blackfeet claim that the leaders of the buffalo herd, when running, were always disposed to follow some line, mark, or trail, and that those rows of stones guided the herd towards the edge of the cliff. When the buffalo were grazing within several miles of the drive, some young men would be sent out on foot to work quietly around the herd, causing them to move towards the drive. When they came near the lines of stones all the men in the camp came out and surrounded the herd, approaching them from the rear and side rushed in whooping and shouting." As the course became narrower the buffalo became more panic stricken and stampeded to their destruction. The buffalo appear to have been stupid animals and even a low ridge over which a child could step was sufficient to deflect their course. It must have been a wonderful sight to see the massive brutes hurling headlong into space over the beetling crag, to hear the dull thuds of their fall and the yells of the spectators on the slopes.[31] The slopes below the cliff are still littered with bones of slaughtered buffalo, and one of our party picked up a flint implement which probably had been employed for cutting meat off bones or for scraping fat off the hides of flayed beasts.

One afternoon Little Plume and his wife made a sweat-house for a very old man named Tearing Lodge [see fig. 14]. This consisted of a framework of stripped willow boughs arching across an oval area not exceeding eight feet in length by six feet in width, the height being about four feet in the center. A shallow triangular depression was cut out of the turf, and a broad layer of sage grass was placed on the ground close to the wall. The framework was covered with several cloths and blankets. Near by a number of small boulders had been placed close together and a fierce wood-fire was built over them, which made the stones extremely hot.

Before going in Tearing Lodge sat outside the house and made a long prayer. Mr. Curtis and I were invited to sweat, and we went in with five Indians about 6 P.M., all having divested ourselves of clothing, save for a loin cloth. The entrance of the house was to the east and Tearing Lodge sat in the west facing the entrance.

When we had all sat down on the layer of sage grass a piece of hot charcoal was placed in front of Tearing Lodge, who broke off fragments from a plait of sweet grass and placed them on the coal to make incense. Little Plume, who remained outside, handed in a pipe which was passed to Tearing Lodge; he repeatedly fumigated each end and passed his hand along the pipe and then held it stem upwards. He handed the pipe to the man on his left hand who smoked it, then he passed it on to the next man, and so it was handed on, each taking a few puffs, till it reached the man at the entrance to the house as a pipe may not be passed across a doorway, it was returned in the opposite direction. When all had smoked the last man gave it to

Little Plume. The latter, assisted by his wife conveyed the heated stones from the fire on an extemporized long-handled spatula made of willow boughs. The first four stones were placed around the central depression and a fifth in the center. After Tearing Lodge had put a pinch of sweet grass on each to make incense, the four stones were pushed into the hollow, and other stones were brought in and heaped up. A bucket of water and a small round tin were brought into the house; we bathed our heads with the water and some drank of it. Finally, the entrance to the house was closed, the bucket was placed in front of Tearing Lodge, who ladled water on to the hot stove, and clouds of steam arose.

It was a novel sensation to be one of seven nude men squatting closely side by side in the dark, streaming with perspiration, and being continually parboiled by puffs of steam.

Tearing Lodge had been praying at intervals since he entered the sweat-house, but the prayers became continuous when the sweating began: again and again he put more water on the stones which further increased the temperature. Other Indians then prayed, and the heat became intense. After what seemed a long time a little fresh air was let in and cool water was given us to drink.

The orifice was closed again, the prayers were resumed and more water thrown on the stones. Once more the heat became almost insufferable, but relief could be had by holding the head low down, several of the Indians laying theirs on the ground. After all had prayed once more, air was again let in and I retired. Mr. Curtis and one Indian withdrew after the next round, and all the rest came out shortly afterwards.

Mr. Curtis and I bathed in the adjacent stream according to Little Plume's advice, but the Indians sat in a practically nude condition in the open in order to cool off—praying all the while. The after effects of this bath were very pleasing.

This form of sweat-bath is universal in North America, and was very widely spread in old times in Europe and Asia. Among the North American Indians the sweat-bath was usually—perhaps invariably—a ceremonial affair, it being employed to purify the spirit as well as the body, and if what I saw is characteristic there is no doubt that it is at the same time a devout religious exercise.

In former days there were very numerous ceremonies on various occasions and for different purposes. With the coming of the white man many of these became more or less modified and some entirely disappeared. There were formerly several societies of age or rank grades. [Some] of these societies died a natural death about thirty years ago, [including] the Catchers or Soldiers. These societies had ceremonial paraphernalia which were kept in a sacred bundle, in addition each

individual member had personal adornments proper to the society, which he sold to a novitiate when passing to a higher grade. . . . [Detailed description of the Medicine Pipe ceremony, as witnessed by Haddon.]

The sacred bundle to which I have alluded are collections of religious, magical and ritual objects, each of which is usually separately wrapped up, the whole being securely bound round with dressed skin coverings. The bundles may be small or large, and may contain the "medicine" and ceremonial trinkets of an individual, or the sacred objects and ritual paraphernalia of a society.

Among the great variety of objects which are treasured by the Blackfeet some of the most interesting are the "buffalo stones." These are for the most part portions of Baculites and Ammonites, or rarely other fossil shells, by far the most common being internal casts of the chambers of Baculites. They are picked up in the Rocky Mountains.

According to a northern legend related by Wissler and Duvall, Weasel Woman found the first "buffalo stone," or iniskim, at a curved cut bank at a place called Elbow-on-the-other-Side in Canada.

The people were starving and Weasel Woman had come to pick up wood when she heard something singing. She looked about and found an iniskim sitting on a bed of buffalo hair and sage grass in a cavity at the end of a broken log. The words the buffalo sang were:

> *Yonder woman, you must take me*
> *I am powerful,*
> *Yonder woman, you must take me,*
> *You must hear me.*
> *Where I sit I am powerful.*

The stone taught her the songs and ceremonial procedure, and promised abundance to her people. She took the stone home, and said to her husband: "Now you are to hand this iniskim. Men are always better at it than women. Such things are not in keeping with the way we live. It will give you dreams (visions). We will use it for a long time (live long)." "Yes, you are right," said her husband. While the husband was making medicine smoke, or incense, the woman painted the face of a young unmarried man who had been chosen to lead the buffalo over the drive, and taught him how to sing a magical song when the buffalo were being rounded up, and told him how he should stand at the edge of the declivity over which the buffalo were to be driven.

Man says, "Woman, iniskim, man,
They are powerful."
Man says, "Those rocks, I move them around,
It is powerful."
Woman says, "Those rocks, I move them around,
It is powerful."
Good running of the buffalo,
The driver is coming with them,
We have fallen them,
We are happy.

The rocks here referred to are the stones or boulders marking the lines leading up to the buffalo fall or to the corral or pound. . . .

The Indians are too prone to dwell upon their former freedom from restraint, to dream away the precious present in regret for the irrevocable past.

Much material parallel to Haddon's observations duly appeared in the Piegan section of The North American Indian *(volume 6, published in 1911), including verbal and pictorial portraits of some of the figures such as Tearing Lodge, frequent references to sweat lodge practices, a description of the Medicine Pipe ceremony very similar to Haddon's (not reprinted here), and a probing passage on sacred bundles. At the same time, some of it did not appear. The reasons for this are sometimes obvious. For example, Haddon went into great detail on the building of lodges, but such information would already have been familiar or available to readers of* The North American Indian. *The same would have been true of the sweat lodge material, also originally presented by Haddon with even more attention to minutiae than in its reproduced form here. The lack of correspondence between Haddon and* The North American Indian *on such matters as the sacred stones is more puzzling. A possible simple reason for the omission of such seemingly valuable material is that it was not passed on to Myers and was therefore not available for inclusion.[32]*

4 In the Northwest

I. ON THE COLUMBIA RIVER AND PLATEAU

The peoples who traditionally shared the life-ways of the Plateau culture area—from the Flatheads on the eastern side of the Rocky Mountains to the Yakimas, Klikitats, and others who lived quite far down the Pacific-bound Columbia River—mostly spoke a variety of the Salishan and Shahaptian languages. In the era of contact with whites, however, they also communicated in the Chinook jargon, a lingua franca *composed of Chinookan language roots, elements of Wakashan linguistic features taken from the Nootkas, and an admixture of English and French expressions. Since Curtis's first serious photographic fieldwork was conducted in the Pacific Northwest, within reach of his Seattle studio, he made portraits of Plateau people almost from the outset of his photographic career; for example, as early as 1899 there are studies of Shahaptian-speaking Nez Perces, who originally lived near the present intersection of borders between the states of Washington, Oregon, and Idaho. Curtis and W. W. Phillips visited the Colville Reservation in the Big Bend of the Columbia River in 1905. There they photographed and collected data from such local indigenous people as the Nespelems, who lived near the Agency headquarters (see fig. 15). They also worked with the Colvilles and the Columbias of Chief Moses's band, a group dumped on the reservation for riddance. And they participated in reburial ceremonies for the Nez Perce leader, Chief Joseph, which were attended by representatives from several other Plateau peoples such as the Umatillas, the Palouses, and the Cayuses.*[1] *As this latter assemblage of tribal names—with all their horse associations—indicates, some aspects of Plateau culture were adopted from patterns followed by the Plains groups they encountered when they ventured eastward over the Rockies to hunt buffalo. After the establishment of* The North American Indian *as a publication project there were repeated brief visits to places in the interior of the Pacific Northwest and on the Columbia River, most notably in 1908, 1909, and 1910.*

Letter by Edward S. Curtis to Gifford Pinchot, 1909

Gifford Pinchot was both a patrician and a leading Progressive. During the presidency of his friend, Theodore Roosevelt, Pinchot was appointed chief of the U.S. Forest Service and established himself as a significant political force. He later became governor of Pennsylvania. Curtis first met Pinchot in the late 1890s; they were both members of the Harriman Alaska Expedition of 1899; and Pinchot was a leading patron and supporter of the project until about 1915. The following letter, written in November 1909, although addressed personally to Pinchot, was a form letter sent to actual and potential subscribers to The North American Indian.[2]

Believing that you will be interested in knowing how work on "The North American Indian" is progressing, I will briefly review the activities of the past season.

Detailed work connected with the publication of Volumes III, IV and V was closed in March. Mr. Myers, who had spent the fall and winter months in Cambridge [Massachusetts], looking after all the detail of publication, went first to New Mexico to assist Mr. Strong in some difficult investigations in that region; thence he went to Seattle, where he was met by the writer, and preparations for the camp work of the season were made. Mr. Dalby and Mr. Allen, who were already among the tribes on Puget Sound, came in for conference.

The writer's personal party, consisting of Messrs. Myers, Crump and Upshaw, first went into camp on the Yakima Reservation, the present home of the Klikitat, Yakima and Wishram, the latter being of Chinookan stock, and in reality Columbia River Indians.[3] The tribes of this region have depended greatly on roots for subsistence. The visit having been made during the height of the root-digging season, a trip was conducted into the mountains where many of the Indians were encamped, thus making it possible to obtain a number of fine pictures.

From the Yakima Reservation we went to the Columbia River to continue our Wishram and Klikitat studies. The first camp there was established at The Dalles, whence we continued to work down the river as far as Portland. From the Columbia River region we returned to the Yakima Reservation to gather further information from an old man who was ill at the time of our former visit.

Our next field of research was the Spokan[e] Reservation, with the view of finishing the work commenced some years ago. Word was sent to our old friends to visit and feast with us, and within forty-eight hours we had the best members of the tribe in our camp overlooking the Spokane River [see fig. 1]. Being virtually a re-union of old friends, a great deal of work was accomplished in a short time.

Our next studies were with the "Moses" band on the Colville Reservation; these also closed the work of previous years. While the party was encamped at this point, I made a hurried trip into Montana. . . . My party in the mean time had moved to the Umatilla Reservation, but finding that we had selected an unprofitable time for our visit, I decided to pass on and to return when the chance presented to accomplish satisfactory results.

Our next camp was with the Nez Perces, among whom we settled for several weeks of delightful work, bringing to a close, as among other tribes, the studies commenced in former years.

From the Nez Perces we moved to the Blackfoot Reservation in Montana. In the meantime Dr. A. C. Haddon, F. R. S., of Cambridge, England, had joined our party. We were now beginning to feel the summer's approaching end. Our first Yakima camp had been pitched amid the snow and frost of spring; now the wheat harvest of the Nez Perces was past, and our Blackfoot camp found us in search of more blankets, for again the nights had become crisp and frosty. Here again, we were among old friends. Some years had passed since my former visit and many of the old men had answered the last call. Our camp was on the historic Two Medicine Creek and our work proved very satisfactory.

We next found ourselves among the Kutenai, on beautiful Flathead Lake, a field that afforded the opportunity for making some exceptionally fine pictures. Mr. Myers had previously conducted some researches among the Kutenai, so that theirs was not a strange field.

At the close of our work on the lake, we moved to the Jocko to continue our studies among the Flatheads, who were by no means strangers to us. Our camp among the pines on the Jocko was one of the most beautiful of all the year's work, and it was with great reluctance that we turned our backs on these Indian friends, who had moved in with their lodges and encamped all about us. As we were leaving, I asked some of the men why they also did not begin to move, when one of them answered that they did not want to take down any of their tipis until we had gone. "We want your last look to be on the camp as it has been," he said [see fig. 16].

From the Jocko we went to the Crow country, expecting to find the Northern Cheyenne in camp with the Crows at their annual fair, thus affording a good opportunity for the collection of data. But the Cheyenne had suddenly changed their minds and remained at home, having decided to hold a great convoy of their own and bring all their tribe together. For this reason our stay among the Crows was cut short, and we moved on to the camp of the Northern Cheyenne on Tongue River.

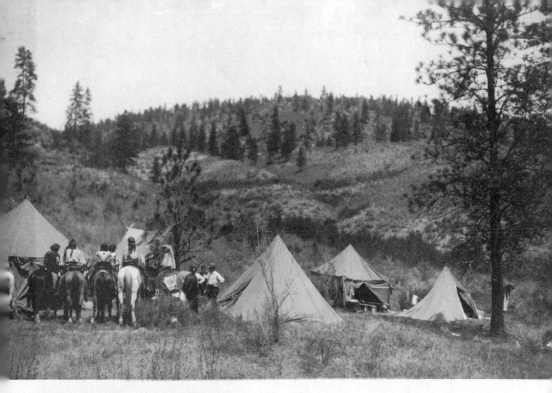

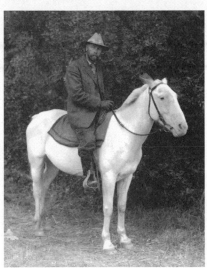

Fig. 1. Author's Camp among the Spokan, 1909. Photographer unknown. This image, probably made by Edmund August Schwinke, shows Curtis (standing, in hat) and other project workers greeting Indian visitors to their camp on the Spokan Reservation in eastern Washington. Library of Congress, Prints and Photographs Division, LC lot 12327-A, Curtis 2997-10.

Fig. 2. Edward S. Curtis, 1909. By Joseph Kossuth Dixon. Dixon mounted "expeditions," funded by the family behind the Wanamaker department stores in Philadelphia and New York, to publicize to Indians—people he too thought of as "vanishing"—the benefits of loyalty to the United States. (For further information on Dixon's activities see Trachtenberg 1998). This image, of Curtis in his best field outfit, was made at the Crow Agency in Montana. Courtesy Indiana University Museum, W 1996.

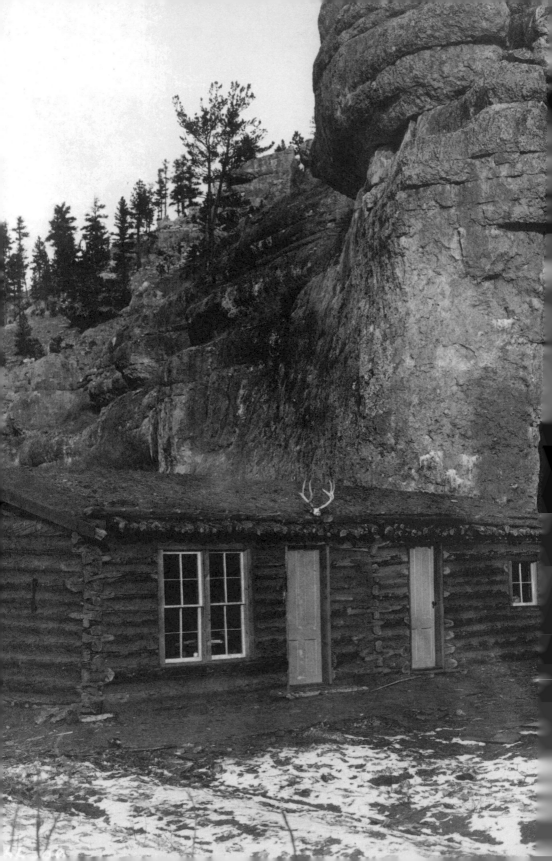

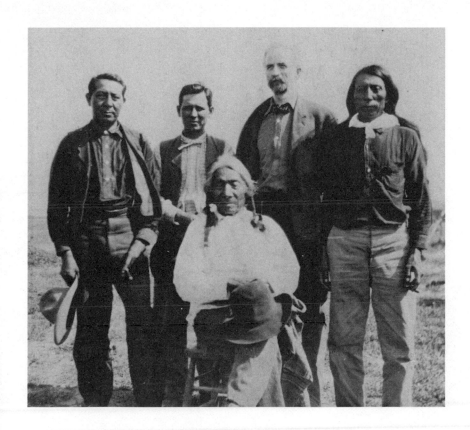

Fig. 3. Camp Curtis, 1908. Partly through A. B. Upshaw, the project's Crow helper, Curtis and his associates had particularly close ties to the Crow reservation. William E. Myers, Curtis, and others spent at least part of the winter of 1907–8 in this cabin, located in Pryor Cañon, Montana, writing up volumes of *The North American Indian*. Library of Congress, Prints and Photographs Division, LC lot 12320, Curtis 2766-08.

Fig. 4. Red Cloud, Edmond S. Meany, and others, 1907. By Fred R. Meyer. Red Cloud was a prominent Sioux leader during the nineteenth century, first by leading military actions against U.S. Army incursions, then in seeking accommodations with white settlement. He died, blind and somewhat embittered, in 1909. Meany (tall and bearded), together with other project members—including, on the far left, A. B. Upshaw—met him in the summer of 1907. The figure between Meany and Upshaw is probably William E. Myers, the project's principal ethnologist and writer. Fred Meyer, an amateur photographer, met Meany in the field at the Pine Ridge Sioux reservation and later sent him this photograph. Courtesy MSCUA, University of Washington Libraries, UW 17995.

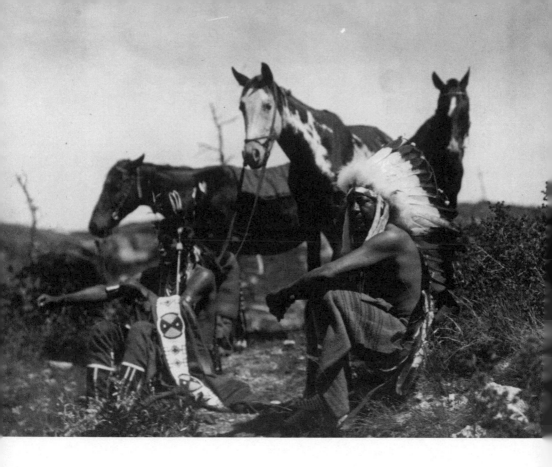

Fig. 5. The Talk (Crow), 1905. This image
depicts A. B. Upshaw in traditional costume
participating in a pictorial reconstruction of
prereservation war party scenes. Library of
Congress, Prints and Photographs Division,
LC lot 12320, Curtis 1281-05.

Fig. 6. The Village Herald (Oglala), 1907. This image was made during reconstructions of traditional prereservation life mounted for Curtis's camera near Wounded Knee on the Pine Ridge Reservation. Edmond S. Meany described the ceremonial tipi depicted here—with its "scalp" top (actually a horse's tail) and attached scalps—in various articles he wrote to publicize the project's activities (for example, Meany 1907). Library of Congress, Prints and Photographs Division, LC USZ 62-48432.

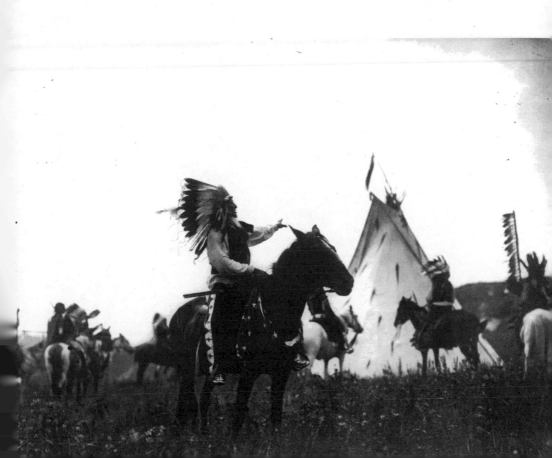

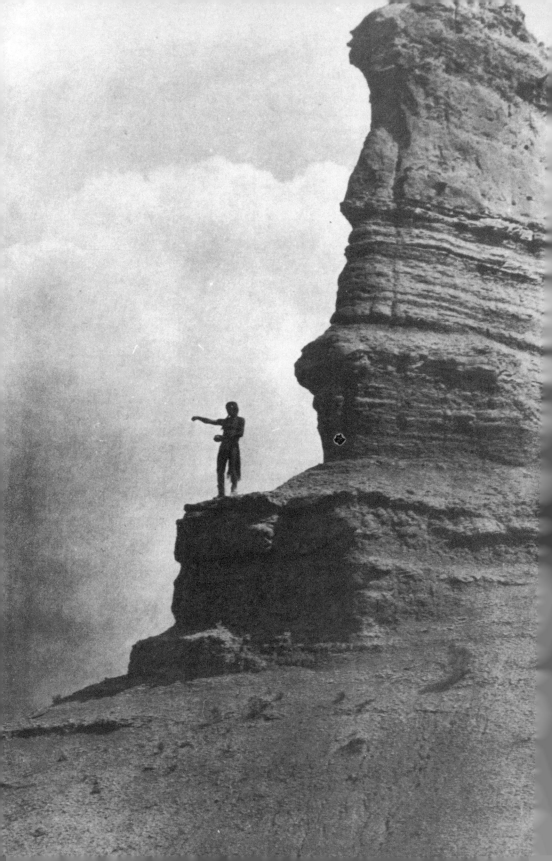

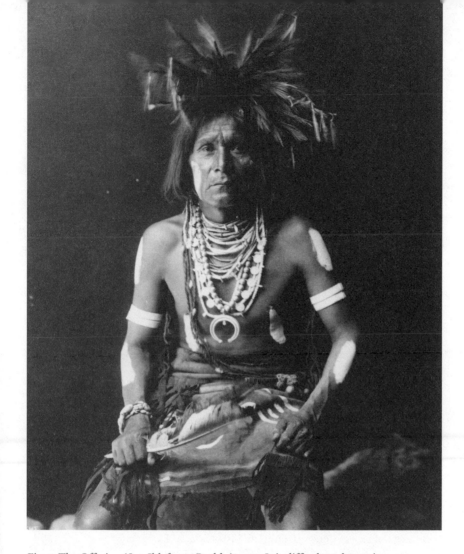

Fig. 7. The Offering (San Ildefonso Pueblo), 1925. It is difficult to determine whether or not the morning prayer depicted here—during which ground corn or pollen was sprinkled to the air—was specifically enacted for the camera. From a photogravure in *The North American Indian*, collection of the author.

Fig. 8. Hopi Snake Priest, 1900. Over time Curtis witnessed Snake Dances at several of the Hopi pueblos and, at some point in the years after this image was made, may have been allowed to participate in the rite. The feather held in the priest's hand was used to hypnotize the snakes so that they could be handled with ease during the dance. As Curtis realized, the rite constituted an elaborate prayer for a right relationship between people and the earth, one that would be blessed with rain. Library of Congress, Prints and Photographs Division, LC USZ 62-97091.

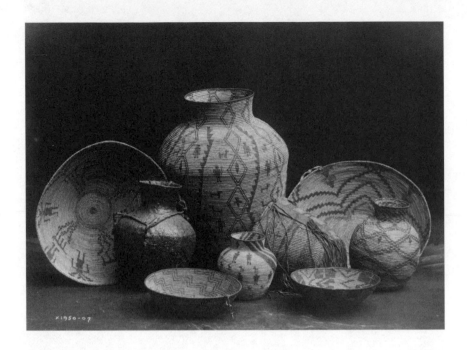

Fig. 9. Apache Still Life, 1907. Curtis habitually arranged primary constituents of a people's material culture into picturesque patterns for the camera. Library of Congress, Prints and Photographs Division, LC lot 12310-A, Curtis 1950-07.

Fig. 10. Women at Camp Fire (Jicarilla?), 1903. This study of an everyday scene is notable precisely because it is composed relatively informally. Library of Congress, Prints and Photographs Division, LC USZ 62-101172.

Fig. 11. San Ildefonso Tablita Dance, 1905. Curtis and W. W. Phillips witnessed this Pueblo dance relatively early in the life of the project, even though a description of it did not appear in *The North American Indian* until volume 18 was published in 1926. The dance, a prayer for rain, was named for the tablet-like headgear worn by the female dancers (some of which are *almost* visible in this image). It was probably because the image does not actually show off this item of costume that the photograph was not used in *The North American Indian*. Library of Congress, Prints and Photographs Division, LC lot 12314-D, Curtis 1734-05.

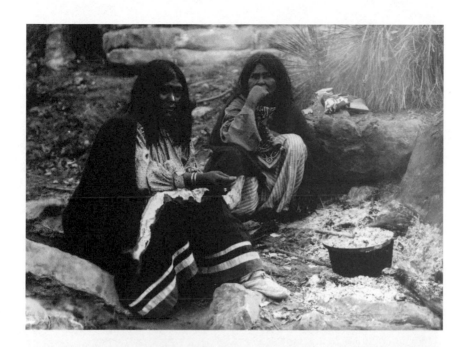

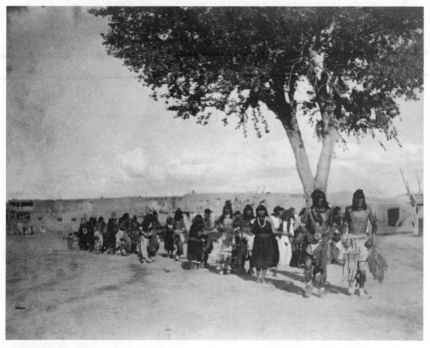

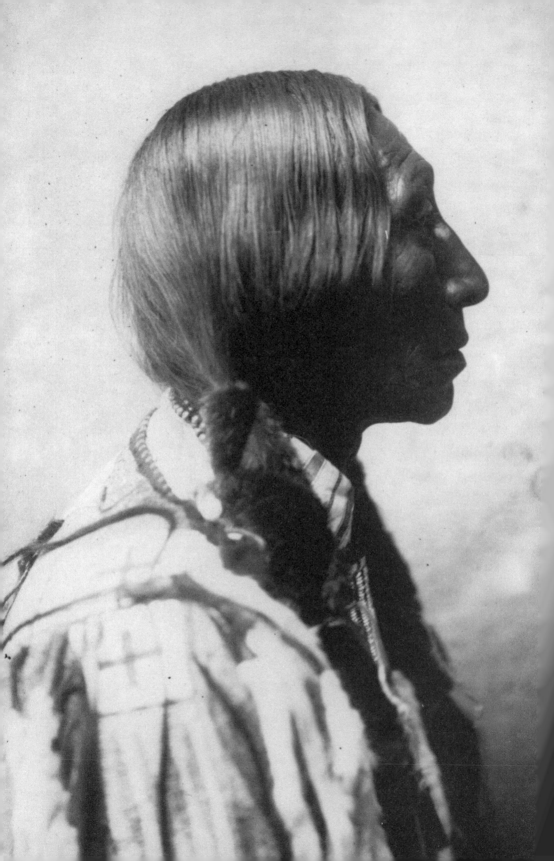

Fig. 12. Bear Black (Cheyenne), 1905. This is a likeness of the Cheyenne medicine man encountered by W. W. Phillips. Library of Congress, Prints and Photographs Division, LC lot 12322-D, Curtis 1413-05.

Fig. 13. Hunka Ceremony (Oglala), 1907. Curtis took many sequenced images of the *Hunkalowampi*, or Foster Parent Chant, only some of which were used in *The North American Indian*. This one—which depicts the ceremony's celebrants, Saliva and (in the background) Slow Bull—has an unusual snapshot quality, most acutely registered by the intrusive arm of the third priest, Picket Pin, as he brings forward the buffalo skull in the assemblage of the altar. Library of Congress, Prints and Photographs Division, LC lot 12319, Curtis 2517-07.

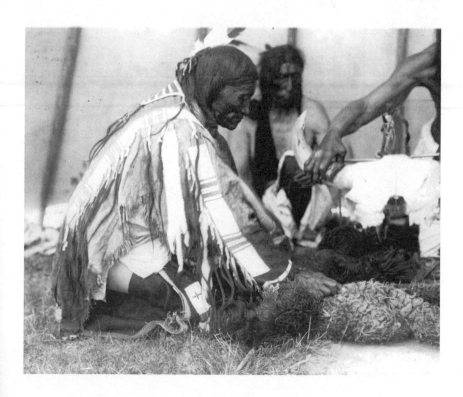

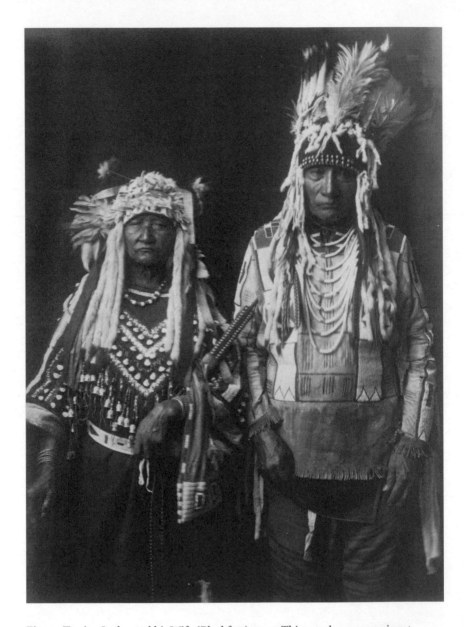

Fig. 14. Tearing Lodge and his Wife (Blackfeet), 1909. This couple was prominent among those who hosted Curtis and A. C. Haddon during their visit to the Blackfeet in northern Montana. Library of Congress, Prints and Photographs Division, LC USZ 62-117602.

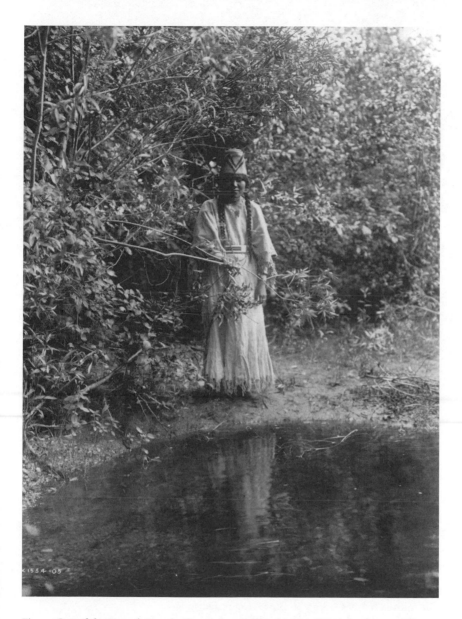

Fig. 15. Out of the Forest's Depths Stepped an Indian Maiden (Nespelem), 1905. The rather fanciful title for this view of a highly costumed young woman on the Colville Reservation, photographed with telling reflection, is typical in both style and content of much of Curtis's pictorialist representation of Indian cultures. Library of Congress, Prints and Photographs Division, LC lot 12327-A, Curtis 1554-05.

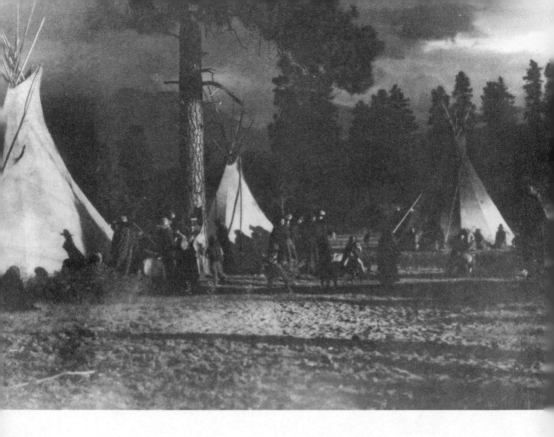

Fig. 16. Stormy Day (Flathead), 1909. This image, published in volume 7 of *The North American Indian*, was made at a Flathead camp on the Jocko River in western Montana that Curtis found particularly beautiful. From a photogravure in *The North American Indian*, collection of the author.

Fig. 17. On Quamichan Lake (Cowichan), 1910. Lake Quamichan is near Duncans in British Columbia, in an area frequently visited by Myers, Curtis, and Edwin J. Dalby in preparation for the Northwest Coast volumes of *The North American Indian*. The Cowichan people gathered tule reeds there. Library of Congress, Prints and Photographs Division, LC lot 12327-B, Curtis 3336-10.

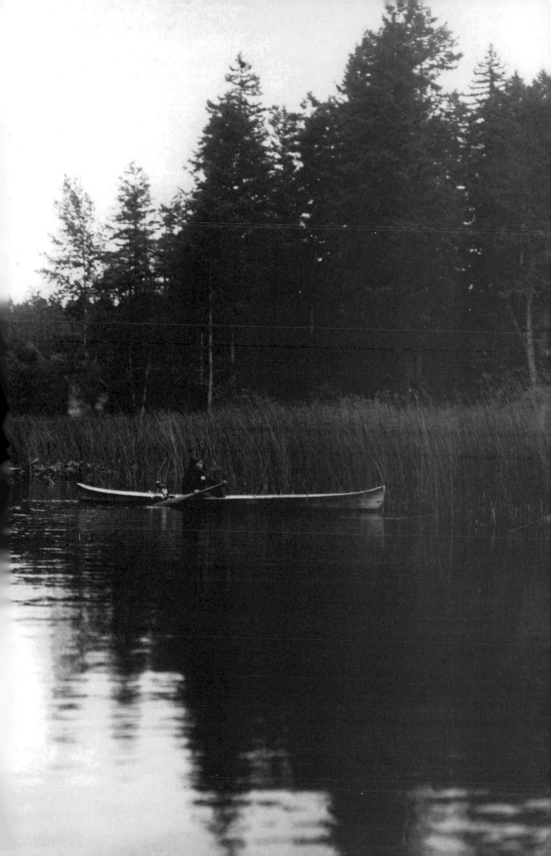

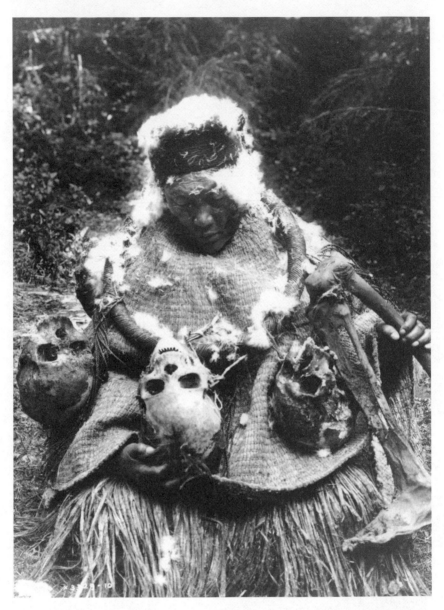

Fig. 18. *Kominaka* Dancer (Kwakiutl), 1910. This image is one from several sequences Curtis made of reconstructions of Kwakiutl winter ceremonies. These ceremonies involved a symbolic coming to terms with the dead and a great deal of theatrical deception, including the supposed cannibal consumption of mummified remains. Library of Congress, Prints and Photographs Division, LC USZ 62-96724.

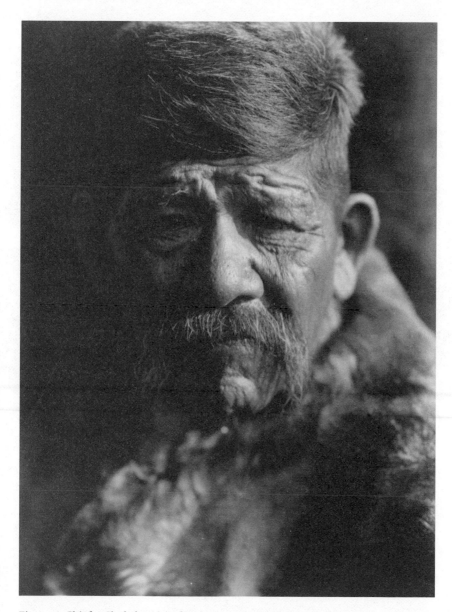

Fig. 19. A Chief—Chukchansi (Yokuts), 1924. The Chukchansi were a northern branch of the Yokuts people, a California culture area group that lived near the headwaters of the Fresno River in Madera County. In California Curtis found few people *looking* as "traditional" as he would have wished; hence a view like this of a chief with shorn hair. Library of Congress, Prints and Photographs Division, LC lot 12318-D, Curtis 4017.

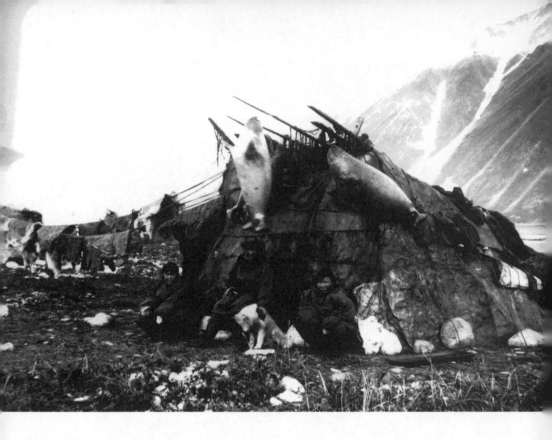

Fig. 20. Eskimos at Plover Bay, Siberia, 1899. This image was made during Curtis's employment as official photographer to the Harriman Alaska Expedition, and was copyrighted by the expedition's funder and captain, railroad tycoon E. H. Harriman. Library of Congress, Prints and Photographs Division, LC USZ 62-101338.

Fig.21. *Kenowun* (Nunivak), 1927. This image, which was published in the final volume of *The North American Indian*, depicts a woman wearing full ceremonial dress. From a photogravure in *The North American Indian*, collection of the author.

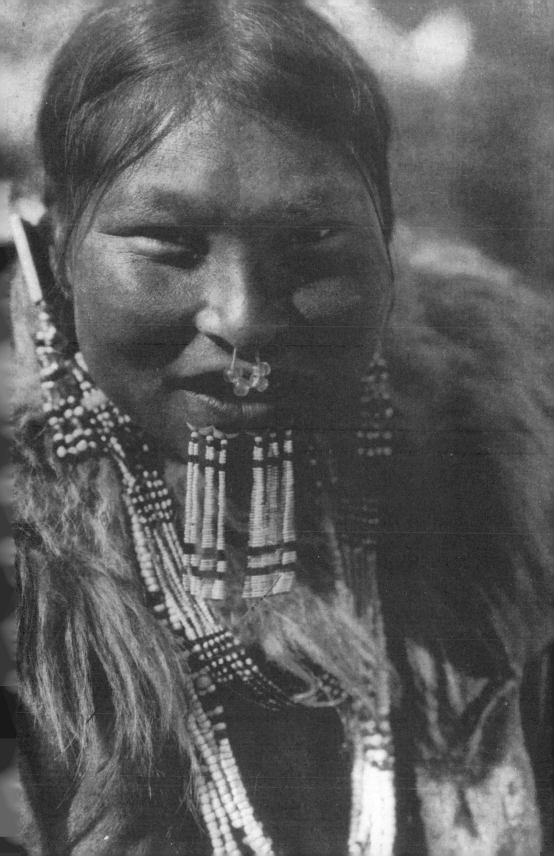

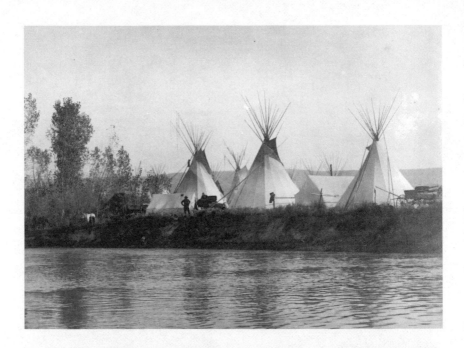

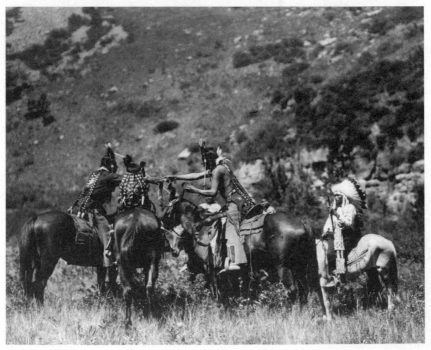

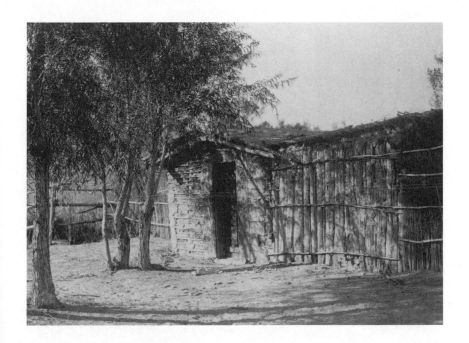

Fig. 22. On the River's Edge, 1908. This image was probably
made on the banks of the Little Big Horn, most likely in
1907 when Curtis employed former Crow scouts to help him
retrace the course of the Custer defeat of 1876. It appears to
depict the project's own encampment. Library of Congress,
Prints and Photographs Division, LC lot 12320 Curtis 2741-08

Fig. 23. A Swap (Crow), 1905. This view was made when
Curtis employed a group of Crows to ride to scenic Black
Cañon and reconstruct prereservation war parties. Library
of Congress, Prints and Photographs Division, LC lot 12320,
Curtis 1273-05.

Fig. 24. Modern Chemehuevi Home, 1906. Curtis made a
visit to the desert-dwelling Chemehuevis of the southern
California–Arizona border in 1906. Even as early as that,
partly because he had no choice if he was to photograph re-
quired dwellings at all, he made images of "modern" houses.
Library of Congress, Prints and Photographs Division, LC lot
12318-B, Curtis 2399-07.

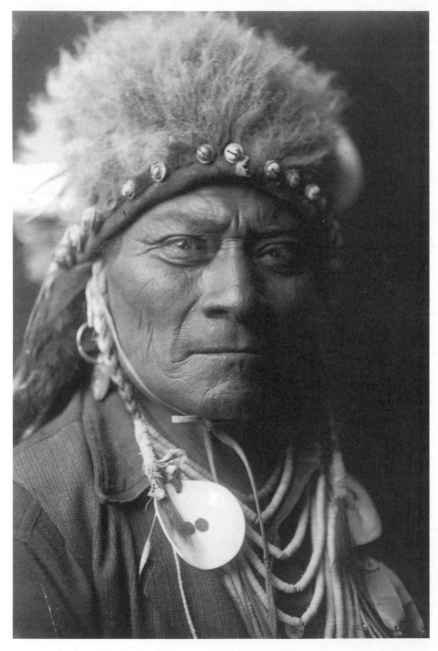

Fig. 25. One Blue Bead (Crow), 1908. A powerful portrait of a Crow man. Library of Congress, Prints and Photographs Division, LC lot 12320, Curtis 2650-08.

The ceremony to which the Cheyenne were devoting attention was the old-time Sun Dance, called by them the "Willow Dance," and I was most fortunate in having a chance to witness it and to obtain pictures of all its interesting features. With the Cheyenne we were also continuing the investigation of former years.

At this camp I left my party and proceeded to New York for the purpose of attending to business affairs. Mr. Myers has since departed for Wyoming to work among the Arapaho and Shoshoni tribes, and will continue in camp until the 1st of December. Soon we will be settled in a cabin on Puget Sound, almost the only reminder of civilization being the fortnightly mail, for a few months of final work on the manuscripts for Volumes VI, VII, VIII, IX and X.[4]

The field season of the two detached parties, whose object is the gathering of preliminary ethnological material, has been nearly as active as my own, Messrs. Dalby and Allen working among the numerous tribes of Puget Sound, Vancouver Island and other parts of the British Columbia coast, Mr. Strong continuing researches among the Pueblos of the upper Rio Grande in New Mexico.

Mr. Myers and the writer have worked among Indians representing eight linguistic stocks and twice as many tribes, at the same time keeping constantly in touch with the members of the other field parties, who have had fully half as many stocks and tribes with which to deal. Geographically, the activities of the three parties have included tribes in Arizona, New Mexico, Oregon, Washington, British Columbia, Idaho, Montana, Wyoming and Nevada. . . .

It is with keenest regret that I speak of the loss of one of my field helpers, Mr. A. B. Upshaw, an educated Crow Indian. He has been an enthusiastic helper and close companion in my fieldwork for a number of years; yet, as greatly as I feel his loss, to his tribe his death will prove an affliction indeed.[5]

From a Newspaper Item, "E. S. Curtis Here to Handle Exhibit," 1909

This extract is taken from a report in the May 28, 1909, issue of the Seattle Times *about Curtis's preparations for his contribution to the Alaska-Yukon-Pacific Exposition. The article concerns the Yakima Reservation that borders the Columbia in the south of Washington state. Its focus on the revivalist religion of Indian Shakerism—which had no real connection to the predominantly white utopian sect founded by Mother Ann Lee—was characteristic of the project's concerns. Interestingly, the published version of the work on the Yakima Reservation in volume 7 contained no reference at all to Shakerism. The next two volumes, however, which focused on other Pacific Northwest peoples both of the interior and the coast, did: volume 8 suggested that Shakerism was essentially an outgrowth of long-standing indigenous hypnotic religious practices of*

the Northwest, and volume 9 contained the results of what Curtis referred to as the "preliminary study," which was two pages of information very similar to that given in the newspaper interview but explaining that the founder of the cult was said to be not a Puyallup but a Squaxon, John Slocum.[6]

That he might be present at the opening of the Alaska-Yukon-Pacific Exposition next Tuesday, . . . Edward S. Curtis . . . has returned to the City from a month's visit with his party of ethnologists now collecting data on the Yakima Indian Reservation. . . . "Owing to the conglomerate make-up of the Indians of the Yakima reservation, the work there is exceedingly complicated," said Mr. Curtis yesterday. . . . "The two principal stocks are the Shahaptian and the Chinookan. Of the former linguistic stock, the dominating element is Klikitat, and of the same stock there are many small bands bearing the name of a stream locality forming their natural habitat. So far our serious ethnological work has been principally with the Wishams of the Chinookan stock.

While on the Yakima Reservation I gave some time to a preliminary study of the so-called Shaker religion. The brief time I have been able to give to the subject has developed some exceedingly interesting material. At every point one finds the blending of the Christian and primitive religions. It is monotheistic, accepting the general teaching of the Christian religion without question or analysis. Their creed demands an exceedingly moral life. It shows much of the sympathy and direct thought of the primitive religion, with the addition of moral teaching, which practically all primitive religions lack.

The birth of this movement was the vision of a Puyallup Indian. In his vision he claimed to have had revealed to him this creed and was instructed to become a teacher of his people. As observed now, it is evident that this man's knowledge of the Christian religion was principally Catholicism. It must be understood that beyond a few of the fundamental facts of Christianity, they entirely disregard the Bible and depend wholly on revelation. Each song whether with or without words is one revealed to the individual who sings it and is known as So-and-So's song. Each prayer is like a personal revelation, and in each exhortation the man speaks as directed in his dreams. As can be expected, the music of the song is more like a medicine song than a Christian hymn. Healing of the sick is an important part of their belief and is wholly a mental treatment.

Perhaps they are insane, as some have said, but so far as I have been able to observe of these people, it is a form of insanity that is decidedly helpful to the Indian. It changes the worst renegades of the reservation to men who are leading

commendable lives. They use no liquor or tobacco and many of them do not even drink coffee. They take care of themselves and their families and make leaders in the community, and for this reason they are doubly interesting from the student's viewpoint, inasmuch as we are given a religious cult to study at its inception and one brought forth by people who possess but a slight knowledge of Christianity and who are at the same time, completely wrapped in their primitive beliefs."

From "Traveling the Route of Lewis and Clark—One Hundred Years Later" by Edward S. Curtis, n.d. (1910)

This document is taken from a typescript of an undated memoir written by Curtis during his later life. His daughter, Florence, provided it for the use of her coauthor, Victor Boesen, when they were working on the two books they devoted to the Indian project, especially Visions of a Vanishing Race *(which in fact contains a shorter revised version of the memoir).*[7]

In the autumn of 1805 the Lewis and Clark party, travel-worn, hungry, their clothes in rags, reached the Columbia River and in canoes followed its course to the Ocean. It was the last leg of their incomparable march of exploration through unknown and trackless wilds of western America from the Mandan villages on the Missouri River to the Pacific Ocean. . . .

On the banks of the River, from the Dalles to the ocean, they had found populous villages of flatten-headed, fish eating Indians. Many were treacherous and hostile. Their houses of great size were built of cedar planks. These villages of a primitive people living largely on salmon and other fish reeked with a nauseating stench.

Through the Lewis and Clark Journals I had followed in my mind that great exploration on the Columbia River. I had long envisioned such a trip. I wanted to see and study the region from the water, as had the Lewis and Clark party more than a hundred years before; also to make a final check of ancient and present Indian village sites. I wanted to camp where they camped and approach the Pacific through the eyes of those intrepid explorers. . . .

The boat in which I set forth in the spring of 1910 was a nondescript, flat-bottomed one, square at the stern and pointed at the bow. In it was installed a small gas engine with sufficient power to give us steerage way. . . . A large Indian canoe served as a supplementary cargo carrier.

Our party consisted of Myers, my field helper of many years; [Edmund August] Schwinke, a stenographer; Noggie, the Japanese cook, and an old Columbia River pilot. The previous year I had consulted him as to the feasibility of such a trip and

he expressed a great desire to accompany us, stating: "I would like to make one more trip on the old River before I fold up." Well, he made most of the trip. . . .

As we moved downstream Myers and I made notes, watched for places to land and checked on old village sites. Schwinke set his typewriter on a packing case and hammered away typing yesterday's notes. Some days swift water and rapids kept us busy just staying right side up. At night we camped on the shore. Sometimes we picked up an old Indian who could give us pertinent information and took him along for a few days. . . .

We approached Celilo Falls in our small craft in some trepidation. Here the great Columbia pours through basalt cliffs dropping some eighty feet into a tumultuous cauldron. Here the Indians fished for the great Chinook salmon. Hanging precariously to the precipices they used dip nets and spears to capture fish. But Celilo was more than a place to fish. Indians from many tribes and from great distances traveled to this trading center. They came from the seacoast and by river; they came over mountains and valleys by horseback laden with goods to barter. I doubt any other location in the country had seen such assemblages of Indians through the years.

It was here we had the problem of portaging our outfit. How much simpler for us than it was for Lewis and Clark. We loaded our boat on a flatcar and a dinky teakettle of a locomotive would pull it to the unloading point below the Falls. Even with such modern facilities it proved quite a task to put our flat-bottomed barge on the car. We had not appreciated its size and weight. The track extended down an incline into the river and the car was let down until partially under water. Freshet season complicated the loading. Since I was the leader of the party and considered the best swimmer, I fell heir to the job. I handled the boat while the men hauled on the lines from shore. The roar of the Falls was so great they could not hear my instructions which forced me to swim ashore to give directions.

Noggie was sitting on the ground crying. On my inquiry: "What in the hell is the matter with you?" he sobbed, "I know you will be drowned!" Undoubtedly I should have appreciated his concern for my welfare, but on the contrary I was annoyed. I suggested quite forcefully to lay off the sobs and give his attention to his line. At least Myers was able to enjoy a laugh over Noggie's tears and my exasperation. One of my vivid recollections was Myers's comment while sitting in the barge and rolling over the steel rails: "Chief, you should take a picture of our outfit and send it to the Explorer's Club, entitled: 'Hardships of exploring in the wild west'."

In portaging the Falls and rapids of Celilo we passed old friends, the Wishrams, living on the north shore of the river. The Wishram village was one of the oldest

and strongest on the Columbia River, and it would have been a great pleasure to visit our old friends, but time did not permit. . . .

Our down stream cruise soon brought us to the great Falls of the Columbia. Here the mighty river on its way to the Pacific Ocean makes its final plunge through the Cascade Range of mountains. Here was the legendary "Bridge of the Gods." . . . The Lewis and Clark party encountered considerable trouble here on both the downstream and return trips. They portaged their goods and roped their canoes through the cascading waters. Besides the difficulty of making the portage with canoes and equipment, they were in grave danger from the natives. . . .

The government locks, which controlled to a degree the worst of the great rapids, were an aid to our river travel, yet below them there is a few miles of tumultuous water in freshet season that is no place for amateurs in a clumsy, overladen boat. On emerging from the locks we tied up to the side of the concrete spillway for a brief chat with the lock crew. Several of them knew the old captain, and those who did not, knew of his reputation as the most daring and successful of the old river captains.

The lock keeper urged him not to attempt the rapids at this season. "The river is at its highest and worst stage and no man alive could make it with that tub. We hate to see you drowned in the old river you have licked so many times. The currents have changed some since your day." While they talked I listened and tuned the gas engine. The boiling water below was not encouraging and I almost hoped the captain would take their advice. However his only answer was a few grunts. He looked at me and wanted to know if I had the d—d teakettle boiling. Like all steamboat captains he had utter contempt for department store gas engines. "If you have, let's be on our way." The lock keeper's departing words were: "Well, Captain, it's your funeral. Tell St. Peter we will be seeing him soon." Little did he realize how soon the captain would be delivering their message.

In rough water it was our practice for the captain to handle the tiller and shout the orders. I handled the bowsweep. In swift water the man in the bow should have something in his head, a good deal in his back, be quick on his feet and quite indifferent as to the future. Before we drifted out of the still water the captain gave me his instructions: "Boy, this ain't navigation. This is a boxing match. If the old river gets in one blow we are through. Ride 'em high; keep her on the ridges. Don't let a whirlpool get us." Then he indicated our general course. At the first plunge into the breakers she bucked like a wild Cayuse in the Pendleton Round-up. She stood on her hind legs. She pitched head first into a yawning pit. She shot sideways with a lurch which almost threw me overboard. We rode a long high crest which seemed

like a mountain ridge; whirlpools were to the right of us and while dodging them we barely missed one on the left. Then a second yawned on the left. As we plunged by it there was another on the right large enough to swallow three such boats. As we sped by a tree was caught in the swirl, stood on end and disappeared from sight. Another long ridge swept us on. Then came the realization we were through the worst of the rapids. Soon the water was less turbulent and we pulled ashore to relax. Schwinke informed me the ride lasted seven minutes. I could not have told whether it was ten seconds or an hour. The captain with a grin chuckled: "And those d—d land lubbers said we couldn't do it."

As a celebration that night we bought a huge chinook salmon from a fisherman and had a salmon feast. It was the fattest, juiciest salmon I've ever tasted. We ate until there was nothing left but the bones.

Contrary winds, rough water, rains and many villages later, made our progress slow. Arriving near the mouth of the Willamette River Noggie decided that he had lost his taste for cooking in the blowing sand and rain. In fact he was fed up with the great outdoors so he folded his bedroll and departed. The fine old captain decided that while we were working near the Willamette he would have a visit with his old cronies in Portland. City life proved too much for him and he embarked on that last journey to Unknown Ports. At least he had a last thrilling trip together down the "Old River." Our party of five was reduced to three and I became both captain and cook. As we neared our goal, the Pacific, and summed up the existing native life from the Dalles to the Ocean, we were greatly impressed [that] scores of populous villages and many sub tribes had passed from existence. The Chinook tribes on the river, which were often spoken of by Lewis and Clark, were practically extinct with the exception of the Wishrams of the Dalles. . . . In that hundred year period there was a ninety-five percent decrease in population and no doubt that is a conservative estimate. (Statement made in 1910)

Introduced diseases, uncared for and unchecked, are the foremost cause of their destruction. Small pox, measles and cholera had ravaged them. Whiskey, too, had done its part. On the north bank just above the Cascades, or Great Falls, was one of the largest villages. Opposite the village on the south bank traders sold liquor. The result was that canoe loads of drunken Indians on returning to their homes were caught in the strong current and carried over the Falls.

On the south bank at Hood River was located one of the most important Chinook villages on the river. As late as 1825 the closely placed houses extended from Hood River to Indian Creek and well up the mountain side. Of that large populous village we found only two descendants. In this case the whiskey dealers were on the north

bank, and it was a case of drowning. Large canoes loaded with whole families capsized. At the time of the Lewis and Clark expedition the Indians had not acquired a taste for liquor. This fact was mentioned by the explorers several times. . . .

Nearing the ocean we turned our worthy but nondescript craft adrift that it might float out to meet the ocean breakers and be battered to fragments.

Much of the data collected on this voyage was deployed in The North American Indian, *volume 8, most notably a catalog of village sites along the Columbia; as the volume's preface put it, "considerable labor was involved in this research, as it required detailed study of the entire stretch of river and the interviewing of every aged Indian to be found on its shores." The* North American Indian *account—minus, of course, the adventure element—foreshadowed material deployed here in Curtis's personal record.*[8]

An aide-mémoire by Edmund August Schwinke, n.d. (1909–1914)

Other aspects of Curtis's reminiscence of the Columbia River voyage were borne out by an aide-mémoire kept by the stenographer on this voyage, Edmund Schwinke. Schwinke, who joined the North American Indian project earlier in 1910, was born in 1888 in Warren, Minnesota, of German immigrant parents. He worked for Curtis for a number of years before settling in Oak Hill, Ohio. As this mémoire, written on two index cards, indicates, it seems that the party started down the Columbia River from Pasco, and that the "old Columbia River pilot" was Captain [Michelle?] Martineau, a steamboat master born in 1848 to an Indian mother and a pioneer father. Martineau had traveled to the Yukon in 1898, had "retired" in the early 1900s to farm, but had continued to sail the Columbia from time to time—until, that is, his death soon after he left the Curtis party. The cook, dubbed Noggie by Curtis, was named Nakamoto by Schwinke. Schwinke's notes were presumably intended to form the basis of a continuous narrative of his Northwest experiences, for they took the story onward to Quinault, Seattle, and points north, including Alert Bay in Kwakiutl territory—all locations of Schwinke's later work for the North American Indian project. In fact, he was a key figure in the making of the film In the Land of the Head-Hunters *in Kwakiutl country. We do not know when he jotted down these headings, several of which are granted further elucidation in the notes.*[9]

Seattle. 1909
Jebson & Ostrander
 Ed Morgan
 Ella and Erna

Panama & S. America
 French products
 Cigarettes, Cigars, wines[10]
Jan 10, 1910
 Attorney
 Wm. Phillips
 Questions asked
 Bears, Indians, Snakes, Kit
Edward S. Curtis—studio
 Describe him and his work and connections
 Immediate plans
Trip to Camp and location
 Ferry. Bremerton. Upset
 Myers, Wm. E—Northwestern
 Nakamoto
Until last of May
 Government Tender
 Killer whales[11]
First trip: Lewis & Clark
 Pasco—Dust storm
 Our boat—Indian canoe
 Capt. Martineau
First stop—Desert Flat
 Our Equipment
Second stop
 Hellgate
Celilo. Dalles—Rapids Present Dam
 Flat Car
 Next morning
Third stop. Nihlwidich Desert
 Pug dogs
 Salmon wheels. Welsh
Fourth stop
 Mountains. Cascade Range
 <illegible>
Portland & Fort Vancouver
 Nakamoto—New cook

West Coast—Oregon & Wash.
 Summer Resort. Ground glass
 Quinault. Wagon Road
Back to Seattle
 Schooner Holt
 Victoria. New cook
 Dark—Harbor
 Parliament Buildings
 Aluminum Wash Pan
 Cowichan
 Fishing
 Dogs
 Seymour Narrows
 Steamers
Alert Bay
 Indian Village
 Cannery—Salmon
 Indian Agent
 Boarding House
 Ling Cod
 Grave Yard
 Totems
 Construction of House[12]

Newspaper Item, "Survivors of Wreck at Mouth of River—Edward S. Curtis Believes They Were Killed by Snake River Indians While Striving to Reach Atlantic," 1912

This rather fanciful account of the discovery of some "stone heads" at the home of the railroad tycoon Samuel Hill, located just north of the Columbia River near Goldendale, Washington, appeared in the Seattle Sunday Times *in October 1912. Since Hill was a friend and patron of Curtis, and the musicale or "picture opera" is mentioned in it, the story may have been circulated at that particular time partly to generate publicity for a presentation of Curtis's musicale in Seattle.*[13]

Buried deep below the surface of the earth at the ranch of Samuel Hill, near Maryhill, Wash. workmen employed by Mr. Hill not long ago found two stone heads. Edward S. Curtis feels confident as a result of investigations, that they are relics of the presence, on the Columbia River long before the days of Lewis and Clark, of two

white men, who according to Indian tradition, were shipwrecked not far from what is now Astoria. After living a nomadic life with the natives of that region the men were slain by hostile tribes of the Snake River country in Idaho, while trying to work their way overland to the Atlantic Coast. . . .

Curtis ascertained the prevalence of a well defined and doubtless authentic tradition to the effect that, more than a century ago, a ship manned by white men was wrecked near the mouth of the Columbia River. Four men survived the disaster. Two of these were found by the Indians popping corn before a fire on the beach. One married the daughter of a Clatsop Indian chief and lived there for some years. His name, according to traditions of the Indians was Kunupi, which Mr. Curtis believes is a corruption of a Spanish name.

An old woman, now living not far from Maryhill, told Mr. Curtis of a tribal legend . . . of two strange men with beards. Because of the ornamental bits of brass which one of them, whom she called Soto (another Spanish name) wore, the Indians received them kindly, and gave them food, lodging and wives.

In this village, the old squaw said, the strangers lived for some years. Then they departed eastward and no trace of them thereafter exists among the tribal records or lore of that country. Mr. Curtis believes the men were Spaniards, that they were the first whites to view the Columbia River and that, when striving to cross to the Atlantic Coast, they were murdered by the hostile Snake River Indians, who were at war with the Columbia River tribes.

"The old woman who told me this story," Mr. Curtis said, "exhibited some of the brass ornaments made by Soto and inherited from her father, who received them from the strange white man. This woman's father was a Cascade chief who was hanged during the Indian war of 1856. . . .

To return to the sculptured heads. They were found within thirty miles of the place where Soto, and after him his halfbreed son, lived in the Cascade Indian village, and it does not seem improbable that some Indian artist or priest carved them in an effort to depict the strange visitors of whom the old woman told me.

Indian priests were apt to fashion from wood, bone or stone figures representing creatures whom they associated with the supernatural. These white men were strange in appearance and could do many things inexplicable to the natives. Associating them with the supernatural, it would be perfectly natural for the Indian sculptor to carve these heads and consider them a part of his collection of sacred objects, the possession of which would bring their owner strength and assistance and perhaps some of the powers of these strange men. The heads are undeniably of Indian workmanship, very old and representing the Caucasian type."

Mr. Curtis, who is to produce his wonderful "Indian Picture Opera" here early in December, has made many photographs of the heads and has sent them to museums and scientific authorities here and abroad in an effort to find, if possible, any like them and to gather information and opinions . . . as to their probable origin.[14]

II. ALONG THE NORTHWEST COAST

The fact that Curtis began his photographic career on the shores of Puget Sound inevitably meant that the Coastal Salish peoples of the area—usually described, like other Northwest Indians, as "Siwashes" by local whites—became prominent subject matter even before The North American Indian *itself was conceived. Nevertheless, partly because of this assumed familiarity, the project did not concentrate its efforts in the Northwest Coast culture area to any marked degree until 1910. When it did so it confronted, of course, a very distinctive yet varied set of features. The region was rich in marine life—from great whales to salmon to king mollusks—and well supplied with timber, so that throughout its extent there was an excellent subsistence base. The people lived in villages at the back of the beaches or beside streams, in plank-clad wooden structures of varying sizes that often housed a number of families. Some groups, such as the tiny group of Willapa but also including once vastly more numerous peoples like the tribes that constituted the coastal Salish around Puget Sound, were decimated by the velocity and destructiveness of white settlement. But the fieldwork did yield collections of baskets and folklore. The Nootkas of the west coast of Vancouver Island and the Makahs, their Nootkan-speaking relatives near Cape Flattery in Washington, were remote enough for the project staff to spend significant amounts of time with them, attempting to absorb their characteristically highly stratified social systems. The Wakashan-speaking Cowichan (see fig. 17) and the Kwakiutl people of northeastern Vancouver Island and the British Columbia coast northeast of the island had a particularly complex ceremonial cycle and associated mythology that had already attracted the attention of such anthropologists as Franz Boas. These people became the primary preoccupation on the Northwest coast of the North American Indian project. Further still to the north were the Tsimshian, Haida, and Tlingit peoples, whose domain, dotted with massive carved totem poles, extended into southeastern Alaska.*

Fieldnotes on the Willapas by W. E. Myers, 1910

The Willapas (now often known as the Kwalhioqua) of western Washington State on the Pacific coast, but spreading inland north of the mouth of the Columbia River, occupy less than two pages of volume 9 of The North American Indian. *This is not surprising*

in that, as a sentence on one of those two pages indicates, when Myers conducted his fieldwork in 1910 only two members of the tribe had survived. There was almost nothing written about them and most authorities, including Frederick Webb Hodge in his authoritative Handbook of American Indians North of Mexico *(1910), then thought (as some still do) that the Willapas were a Chinookan-speaking people like the populous tribes around the mouth of the Columbia, whose language helped to form one of the bases of the Chinook jargon. The Willapas were actually an isolated pocket of Athapascan speakers with a unique language of their own. Myers, along with one or two other ethnologists of the time, such as James Teit, was responsible for collecting some of the last evidence available on the Willapa language and traditions. Since what there was proved scanty, almost all of it was transcribed into a narrative for volume 9 of* The North American Indian *(1913). The only account of the Willapas that gives a slightly fuller vocabulary than that found in* The North American Indian—*and which omits any reference to* The North American Indian—*was compiled from Teit's notes and published in 1924.* [15]

WILLAPA
Informant, Sam Millett and Esther Millett.
(Salish speakers)

The people dwelling along Willapa river from about Raymond to Pe Ell were called by the persons speaking the Chehalis dialect Swilaumsh, the river being Hwilápah. According to the above informants the principal settlements were these: Ta-lá-ln, site of Pe Ell, Wash. (Pe Ell is the name given by white men, probably under the mistaken notion that it was an Indian word. In fact it is an Indian pronunciation of the name of a French half-breed, Pierre, a one-eyed fellow who used to pasture horses in this prairie.) The name refers to a spring which it is said would rise when the tide came into the Columbia river. When Esther Millett, whose mother was half Talaln and half Wakaiakum, was a girl—that is, about 1845—there were 16 houses here. Mrs. Tonimahl on Nisqualli reservation is from this village.

Hathatu (hathat, mallard duck), about a mile from preceding. About 20 houses.

Puhph, on Willapa river about a mile below preceding. About 14 houses.

Nihsna, about a mile below preceding. About 12 houses.

Kamakum, about a mile below preceding. Ten houses.

Tsahwa'sn, six or more miles south of Talaln, not on Willapa river. A trail led to the head of the river. About 20 houses.

Other villages were formerly located on the river as far down as Raymond, but

when informant was a girl the people were all dead and she does not recall the place-names. Yakawits, at Rochester, is said to know them.

Sam Millett heard the following tradition from Ktlumin, chief of the Hlatskanai village south of the Columbia:

Nichiuh was a village in a prairie next to Puhph, south of that place. Some hunters living there tracked an elk clear to the Columbia river and followed it across on a raft. They found a country full of elk. From people living on the south side of the river they borrowed a canoe, in which the [sic] recrossed to the north. After reaching home, they told the people of what a good country they had found, and the entire village moved south across the river to the place now called Hlatskanai (Clatscanie, Wash.).

Most of this data, such as that on village names, was clearly cross-checked by Myers against the following data he obtained from Mrs. Tonimahl and Saishimulut, and— minus Sam Millett's story—it appears in shortened form in volume 9 of The North American Indian.

Informant, Tonimahl

The following places are named as communities of the Athapascan Willapa:

Tálaln, a Cowlitz word.

Slaghá, inhabited by the Slaghátani. A Willapa word.

Nômakum, a Cowlitz word.

Tápahl, a Willapa word.

Metcha, a Willapa word.

Tsahwásin, northwest of Talaln. The Chehalis called this place Qaláwits:

Nachántakatsi

Tsihuwi, a Willapa word.

Suwál, A Cowlitz word.

These Athapascans called themselves, and the place where now stands the town of Willapa, Wilápahiu. The Chehalis word is Ohwílaph.

Informant, Saishimulut, born at Kwalawits (Pe Ell), now living near Rochester, Wn.

Villages

O-hwilaph was the name of the village and vicinity at what is now Willapa, Washington. Above this a sort distance was Tsih-ú-wi, where the same dialect was used. Kwa-lá-wits was at the site of Pe Ell, and Nô-ma-kum at the site of Boisfort.

Letter from Mr. James Teit: "I then thought I would take down some words of

her (Tónamahl, an old Willapa woman) language to see if I could detect any special relationship between it, and the Athapascan tongue formerly spoken in Nicola & Similkameen Valleys, B.C. [The rest of the letter recalls the evidence.]

Regarding the separation of the Hlatskanai, the old woman at Rochester says: At Puhpuh, where lived some of the people speaking the language of Kwaláwits, was an old medicine-man, whose medicine was the fire-drill. (That is, he was presumably the first to use this instrument among this band.) He was very old. Some young men asked for his dril [sic] to take out on an elk hunt. He gave it to them, but told them not to use it for fun, but only after killing an elk. They went out and killed a grouse, then tried to use the drill in making a fire. It wore down to a stump, and the young men in disgust thrust the remnant into the ground. The party went on. The stump of the drill soon glowed and blazed, and the forest country burned for two years, and thus all the elk were driven away. After five years grass began to grow again, and some people went out to hunt. They came on the track of an elk and followed it across the Columbia river, and then a message was sent back for the people, who moved to that country. This was long long ago. These people became the Kihlátskanaiyu. . . .

Nômakum was the prairie between the two creeks which are called Tápahl (on the north side) and Metcha (on the south side of the prairie). This prairie was also known as Tálaln, and is near the site of Boisfort."

This material, with acknowledgement to Teit, also appears in published form, together with virtually verbatim transcriptions of vocabularies collected from Saishimulut, in volume 9 of The North American Indian.

Letter by Edward S. Curtis to Frederick Webb Hodge, 1909

Edwin Dalby was at work along the Northwest coast in 1909. Haddon, before joining him for a short while during that year, stated his own belief that "the kinship system has been almost wholly ignored since [Henry Lewis] Morgan wrote," adding "he [Morgan] knew very little about the kinship system of the N. W. Coast and I believe very little indeed has been written since." It is clear from the following letter that Curtis wrote to his editor in June 1909, that Curtis and Myers would probably have agreed.[16]

We have worked along the Columbia river and Willapa harbor and Quiniault [sic], and now we will start for Vancouver island, to be gone some two months. Preliminary information available does not seem particularly illuminating. I take it our hind-sight will be more valuable than our fore-knowledge in this case. Myers made a trip to Victoria in hopes of getting an outline of the field. Those about

the town seem to be wholly lacking in knowledge or information bearing on the island. He had quite a talk with Emmons, who was there, and who assured him that ethnologically he knew nothing about the island—neither did anyone else.[17]

They tell us that it is a bad season of the year owing to the Indians all being absent. I trust we will find a little material here and there and at least have an outline of the subject by our return.

Myers will go east at once on the close of our Vancouver Island expedition, and will be ready to take up the book making, so do your best on manuscripts. We should be ready to begin reading proofs in early September.

We met and became quite well acquainted with Tait [sic], who was at Quiniault [sic] doing some work for Boaz [sic] on Salish territory, or, to be exact, determining the boundaries of different Salish groups. . . .
ps. Have spent the day with Tait [sic] and he has helped a great deal in outlining our BC trip.

The project, and especially Myers, did benefit from meetings with the linguist and ethnologist James Teit. Myers remained in touch with Teit the following year—and he probably maintained the relationship thereafter. During the remainder of the 1909 field season and, as it happened, for the next few years, they did travel "here and there" on the Northwest Coast, largely by boat in a vessel known as the Elsie Allan, *but as well as conducting a broad survey for "an outline" they also collected material. By July 21, 1910, Curtis was able to report to Hodge from Alert Bay that work was progressing, and by August 18, 1910, that it was "going well" but would require "another season." Two days later he wrote to one of his patrons, Charlotte Bowditch: "The season has been largely spent in the north Pacific country, among tribes of which we possess little intimate knowledge. These tribes who were universally head-hunters, and largely cannibalistic, furnish such a wealth of material that one is almost encouraged with the thought of an adequate treatment in the available space. . . . From the cream of this vast harvest of extraordinary pictures and material," he promised, "I shall later prepare two volumes, which should be of unusual interest." In 1913, when Curtis compiled a long general report for the North American Indian, Inc., he summarized the 1910 season as follows: "We had a long season. . . . The work was largely by boat; first, a trip down the Columbia River; then along the coast of Washington and finally in British Columbia. A season of hard effort with good results."[18]*

In the 1913 report Curtis could not resist elaborating upon his own role in 1910: "The work was particularly hard for me as I had to handle my own boat, do my own work in regular picture making, collecting; and, to add further to my task, I found long before

the end of the season that money was so scarce that I could not afford a cook, so I sent the cook home and did that part of the work myself." "Our breakfast hour was usually 4.00," he claimed, "and supper 8.00 to 10.00."[19]

From a Reminiscence by Edward S. Curtis, n.d. (1910–1914)

Various members of the project spent parts of the next four years, from 1910 to 1914, working with the Kwakiutl people, and volume 10, published in 1915, was not the only result: In the Land of the Head-Hunters *(1914), the first narrative documentary, was produced and, based upon it, in 1915 Curtis published a short "supplementary reader" with the same title. In all of these activities the project team was both augmented by and greatly indebted to George Hunt, the principal Indian informant among the northern Northwest Coast peoples. The following document is the bulk of an undated Curtis memoir. Like other similar memoir material it was passed by Curtis's daughter Florence to Victor Boesen for use in the preparation of their jointly authored books on Curtis. Most of the Kwakiutl data here was included, with fewer personal opinions and much elaboration, in volume 10 of* The North American Indian.[20]

The tribal population here were the Clayoquots. A short distance to the north at Nootka Sound were the Nootkas. Still farther north and close to the northern extremity of the Island, were the Quatsinos at Quatsino Sound. Linguistically they were the same stock, the Wakeshan [*sic*]. In their customs, life and manners the three groups were strikingly similar and it could scarcely be otherwise as their home surroundings, climate, food supplies were the same. Yet there was constant quarreling and warfare between the tribes.

Extending along the shores to the north and south were the recognized tribal fishing and hunting grounds. It was not considered good form to "mooch" on their neighbor's territory. Nature provided a strong protection from distant tribes. Their homeland was the storm-swept western shore of the Island and the entranceway to the different water courses was at all times difficult. While these coast natives were master seamen, they had no illusions as to what might happen to a fleet of canoes caught by a storm on that rugged coast of the Pacific Ocean. The Haida, from the north, usually confined their war raids to the inland waters east of the island. It was the Makah and Clallam who were the most apt to raid the west coast villages.

By neighboring tribes the Clayoquot were considered the most arrogant of the west coast natives. [John] Meares, who first visited them in 1788 described in interesting detail the chief's house which he visited. [Description from Meares's *Voyages Made in Years 1788 and 1789*, no particular edition cited, quoted at length.]

From Meares's description of the entrance to Chief Wicanish's house as the mouth of a huge animal or monster, undoubtedly it was either a thunderbird or a whale. Among the Kwakiutl we observed an elaborate house front decorated with the thunderbird motif. Across the entire front were the painted outstretched wings of the mythic bird with its beak forming the entrance. The upper half of the beak extended out an equal distance and worked on a pivot causing the mouth to open and close on entry. The base of the opening was some feet from the ground and this lower beak was hinged permitting the point to rest on the ground, thus forming an incline on which to walk. In operation it gave the appearance of a monster bird swallowing those who entered. Both upper and lower portions of the beak were beautifully carved from huge blocks of cedar, and so thinly carved they produced a sounding board. When the beak closed the sound was comparable to that of the blow on a giant drum and the sound could be heard for a considerable distance.

As we dropped anchor in the shoal bay on which is located the Kwakiutl village we saw below the single line of dwellings comprising the settlement. They were largely rough board structures with their gable ends facing the shore. There were also a few scattered totem poles and carved house posts. Many large and beautifully decorated canoes were drawn up on the beach. Flanking the village from the rear was a heavy forest of spruce, fir, yew and cedar. Except the slight clearing for the houses, the forest was untouched.

George [Hunt], surrounded by curious natives, met us on the beach. We walked with him to his house to make plans for the season's work. He proved trying yet the most valuable interpreter and informant encountered in our thirty-two years of research. He was tall, powerful, rawboned, grizzled by the passing of more than sixty years of hard knocks, intrigue, dissipation, and the efforts of the "short life bringers." His voice and manner of speech was slow and studied. . . .

The homeland of the Kwakiutl is dark and gloomy. Dense forests extend to the water's edge. The winters bring almost ceaseless rain beginning in October and moderating in May. The rainfall varies from one hundred to one hundred and twenty inches. Winds whip the waters of the ocean, sound and fjords to a wild fury. The people are impregnated with the somber nature of their homeland. They are morose and surly. Their struggle for existence has been a constant battle with stormy seas and death always "walks with them." Perhaps this has developed their fatalism for they believe when one's time comes to die, he [sic] will die regardless of any effort on his part. Thus why should they give thought to death.

Sorcery saturated every fiber of their existence and its working hung like a pall over the head of every adult. A common term for the sorcerers was "short life

bringers" and an expression constantly used was "short life to you." Belief in the potency of sorcery was ingrown, and witless indeed was the man who did not know that some sorcerer was trying to shorten his life by incantation. Their dispositions were as gloomy as the physical background of their environment.[21]

Constant was the struggle for tribal eminence, termed by them "highness." Never ending was the fight of the individual to pyramid his "highness." Observance of caste was pronounced. There were the nobles, the common people and the slaves. It was unthinkable that by any act of the individual he might progress to the class above. However, in rare cases where nobles took wives from the common people the offspring was classed with one of noble blood with a slight interrogation attached. In [a] case [in which] a woman was known to have a child by a slave or [by one] of the common people, the child was considered lower than a slave.

Sea otter garments were the primitive dress of both men and women of the noble-class. In fact the women of the upper class were not permitted to wear fur other than otter. Informal dress of the common people and slaves was woven from the inner bark of the cedar. For the men it was made like a blanket. For the women it was a cape, apron or blanket of shredded bark. Men on certain ceremonial occasions wore robes of bear skin.

In their ceremonies they used a large and striking variety of masks. They were usually carved from cedar and many so large it required a strong man to carry one. The masks were painted in conventionalized designs with great variety of color. Many were operated by concealed strings in the hands of the wearer. They were fashioned to represent all the beasts of the land, the birds of the sky and the creatures of the sea. Many were mythical apparitions that might have been evolved from nightmares. In this art and handicraft they excelled a hundredfold all other American Indians.

Their homes were large. A representative house was about forty by eighty feet. The posts and supporting timbers were massive logs. The sides and roof were built of adzed planks. In some cases the planks were eight feet wide. The homes of the noble caste had supporting posts elaborately carved depicting grotesque heraldic figures. Often the two supporting posts at the rear of the building were surmounted by mythic birds with great outstretched wings. A description of these carvings would read much like the biblical description of the cherubins [sic] in King Solomon's Temple. "The wings of these cherubins spread themselves forth twenty cubits and they stood on their feet and their faces inward."

To my knowledge the only early explorer to note the Kwakiutl houses was Vancouver who visited the Mimkish village in 1792. The drawing in Vancouver's

Journal shows that many of the house fronts were decorated, a practice which was observed in 1910. These large structures housed an entire family including relatives and slaves. Cooking was done over a row of fires extending through the center of the building and the smoke exit was through holes in the roof. Consequently, the walls of these houses were thoroughly smoke blackened. Greasy lampblack in gobs and tendrils hung from the roof boards and supporting timbers.

Dishes for food and cooking utensils were carved from wood. Spoons were of either horn or wood and beautifully carved. The wooden dishes were often quite large. A grease trough holding fifty gallons was not unusual. At grease feasts participants dipped into this trough with quart sized spoons and drank the contents with much gusto. It required a sturdy man to drink two or three gallons of rancid seal oil or oulachon grease.

The most striking feature of the house is the smell. There is a solid, basic odor emanating from congested, unwashed, fish eating people; fish fresh, dried and decayed. Added is the aroma of seal blubber and rancid seal oil. Include also a fifty gallon community urinal near the door, which is added to, and taken from, but never emptied. In addition to this conglomeration of smells was one which had the kick of a Missouri mule. It is the world's worst stench, oulachon grease. With the Kwakiutl, as well as with a majority of tribes of the North Pacific Coast, it is an appetizer, relish, or salad oil. From the Caucasian viewpoint it is just a very bad smell. If there is any other item of food used by humans which is equally offensively odoriferous, I have yet to contact it.

Perhaps it is scarcely unnecessary to say that Vol. 10 of *The North American Indian* could not have been published while George Hunt was still alive. To have done so would have meant short life to him. Without his extraordinary assistance the material could never have been collected. Through it we gain a glimpse of a strange tangential development of the human brain. No comparable material has ever been collected.[22]

A Reminiscence of George Hunt, by Edward S. Curtis, c. 1930s (c. 1912)

In this brief piece, George Hunt—who was, in fact, still alive in 1915 when the Kwakiutl volume of The North American Indian *was published—appears in a more jocular light. This undated document was taken from a one-page typescript in The North American Indian manuscript materials in the Los Angeles County Museum of Natural History. Since it was found with other short pieces on Northwest Coast history, it may have formed part of a book Curtis compiled in the thirties on aspects of the region.[23]*

The Indians seldom try to hoodwink the man whose manner unconsciously shows that he understands them. But once let them become aware that you are gullible and you are doomed to hear all the absurdities their active imagination can invent. I believe no man was ever imposed upon to such an extent as a certain missionary in British Columbia.

My interpreter, a sober-minded man of fifty-eight, one day entered my tent, dropped to the floor, and held his sides while his body shook with silent laughter. To see gray-haired George Hunt overcome was most unusual, and I awaited his explanation with smiling anticipation.

"Do you know the meaning of the totem pole in front of the house at the other end of the village?" he asked solemnly.

"Why, yes. We talked about it yesterday."

"Well," he said, "we have it all wrong. I just now found the truth about it."

He went on to tell me that as he sat on a drift log on the beach in front of the pole, the missionary, swinging his morning school bell, had approached and entered into conversation by inquiring if Hunt knew the significations of the grotesque carved figures. One above another they represented respectively the legendary, moustached ancestor of the clan, two mythical creatures in the form of a man and a woman, and, at the top of the pole, an eagle which, if the truth must be told, more resembled a goose than the king of birds. All this Hunt knew as well as the owner of the pole; but with a suspicion of what was coming he answered in the negative.

"Then I will tell you about it," volunteered the missionary, "since you are collecting such stories. The man at the bottom, the one with the moustache, is the first Spanish explorer whom these Indians saw. Above him that naked figure is Adam, and the woman is Eve." Here Hunt burst into laughter, which he checked with an effort as he gasped for breath to deliver the climax.

"And the bird at the top," continued the missionary, "represents—the *Holy Ghost!*" And Hunt threw himself bodily on the ground, feebly wagging his head.

Newspaper Item, "How the Indian Composes Songs," by Edward S. Curtis, 1914

This piece, in fact an oblique publicity item for Curtis's film, appeared in a Tacoma, Washington, newspaper in December 1914. [24]

My long acquaintance with the Indians has shown me that he does, without imitation, many things exactly as the white man does, and nothing more strikingly so than the composing of songs. The American publisher of the popular songs has one important qualification to consider before he places a new song on the

market, and that is, is it "whistleable"? Can it be easily remembered? Now that is the very plan the Indian adopts. In filming my first photo-play among the Alaskan Indians [sic], "In the Land of the Head Hunters" to be seen [now] at the Tacoma theater, . . . I watched an Indian songmaker at work. He was a strange, visionary old man. He was sitting by a running stream listening intently. He told me that the sound of the water was his inspiration. He kept humming broken strains to himself. Then, an occasional bird cry would give him another musical idea and the strain would become more complete. He used no words, but a strange vocable which sounded like "Hammamama." Having fixed upon a melody, I next heard him carrying it into many apt and ingenious variations. He seemed, however, to feel the lack of something. He explained that he needed a "tail," an ending for his song. He dreamed on for a time until it came. Then he left the falling water and the birds and met the song-passer, who had been waiting nearby for the master to get his inspiration. To him the song was repeated, and he added words. If he could not readily catch the melody, the song was rejected by the songmaker, who set to work upon another more readily caught up.

Song making among the Indians is a profession and they are sold for the equivalent of from $1 to $16. The songmaker teaches a song to the purchaser, but is shrewd enough to exact payment in advance. If it is a winter dance song, the purchaser is taught to sing it in a low pitch, with a powerful vibration; if a love song, he must sing it in a high falsetto, not unlike the method of the drawing room tenor of advanced years singing "Oh That We Two Were Maying."

Letter by Edward S. Curtis to Gifford Pinchot, 1915

This letter, written in May 1915, while seemingly a personal one was actually sent to many subscribers. [25]

Volume and portfolio X of *The North American Indian* [1915] is now being sent to Yale University Library. . . . I feel that this volume is in many respects worthy of special consideration. The Indian life of the region covered presents many unique and even startling phases. These hardy, sea-going people had developed the ceremonial life until it was a veritable pageant [see fig. 18]. It is, perhaps, safe to say that nowhere else in North America had the natives developed so far towards a distinctive drama.

With these people we have our best opportunity to study ceremonial cannibalism in America, also it is here that head-hunting seemed to have reached its height. Taking the head as evidence of success in war or plunder was common along the shores of the Pacific, from the Columbia River to the region of the Eskimo; but the

Kwakiutl and their neighbors, the Haida, appear to have excelled in this practice. Strange as it may seem, the further the coast tribes had developed in culture which tended towards civilization and the greater their vigor, the more pronounced their warfare and the taking of heads. The poor and lowly tribes could scarce risk war raids, whereas the more powerful and aggressive tribes rich in canoes and slaves could well take the hazard of warfare and thus add further to the wealth of their chiefs, by securing more slaves, and, at the same time, add to their tribal standing by the taking of heads.

No volume of the series has required an equal amount of labor in the collecting of data, and in few places have I been so fortunate in securing information needed. The book is, in bulk, somewhat thicker than the average, while in actual words, it contains double the amount of material as in former volumes. Deeming the data collected of the utmost importance and not wishing to be noticeably thicker, we have had special paper made, which is thinner than that formerly used.

The pageant-like ceremonies of the life, their great canoes and ocean-shore homeland, have afforded rare material for pictures. Again, their rich ceremonial life combined with their skill in carving and fertile imagination in the designing of ceremonial paraphernalia, furnishes costume material not found elsewhere.

Quite aside from the extraordinary features of the volume, I feel that it occupies an unusual position in that it is the half-way goal in our undertaking. I believe every subscriber of the work will share in the feeling of satisfaction. We have reached this point, and we know that each volume, as far as material permitted, has grown stronger than the previous one.

Volume XI is ready for publication and it is hoped it can be completed by the end of the year. There is but little further work to do in the preparation of volume XII and its publication can be taken on as soon as volume XI is free from the press.

Obviously, an important issue broached by this letter is the veracity (or lack of it) of Curtis's comments on cannibalism and head-hunting. To some degree they may be considered as deliberate sensationalism, meant to provoke interest in the volume. To some degree they echo the dominant culture's common view of "primitives" at that time—and, regrettably, since—even if phrased a little more titillatingly than other such views that might be quoted here. In informal comments Myers, who conducted much fieldwork toward the Kwakiutl volume, was more circumspect. In 1913 he told C. F. Newcombe, another Northwest Coast expert, that, "Next spring I am going to get at the bottom of this alleged cannibalism," and his actual text in The North American Indian *presents the cannibalistic effects of the so-called "cannibal feast" as theatrical rather*

than real. The existence of cannibalism, as many items in the current popular press indicate, is still a contentious issue, and there is no point in rehearsing the arguments here. Most scholars now agree that actual cannibalism was not practiced by Northwest Coast peoples. Rather, cannibalism was a theme *of their discourse. Also, there were theatrical simulations of cannibal acts, the significance of which was misunderstood by early observers, rather as if a stranger to the Christian Eucharist were to believe that it commemorated the actual eating of Christ's body. The heads of slain enemies were taken, but with much less frequency than Curtis's comments here imply.*[26]

With reference to the more mundane matters of Curtis's final paragraph, it should be said that volume 12, which was devoted to the Hopi people, did not appear as rapidly as Curtis envisaged when he composed this letter to his subscribers. Partly because of paper shortages caused by World War One, but mainly due to something of a hiatus in project activity on Curtis's part, the Hopi volume was not published until 1922.

5 Up and Down the West Coast

I. CRISS-CROSSING CALIFORNIA

The aboriginal peoples of the California culture area were a strikingly diverse group. Among these peoples, living in relatively close proximity one to another, numerous totally different linguistic families were represented: Athapascan, Algonkian, Yukian, Penutian, and so on. Since the landscape was also quite varied, in parts heavily forested and relatively wet, in others arid and treeless, and with every nuance in between, diets were extremely varied. Within a broadly similar pattern diverse social customs, lore, and ceremonies were also found. All the tribal groups in the culture area were small, in some cases only slightly larger than two or three extended families, which made them particularly vulnerable to white expansion. They lived in small villages. Those living in desert or semi-arid areas were hunter-gatherers, they were at least partly nomadic, and they dwelt in easily erected shelters of brush or matting. Other groups close to the sea or the fast-flowing rivers in the northern half of the region lived in plank houses and subsisted largely on the rich fish yields. Many peoples were proficient in basketry, some in wood carving, and, except for the Klamath, placed little emphasis on warrior values. They developed elaborate codes governing interpersonal relations and, for the most part, did not rely on an obviously hierarchical system of chieftainship. Each tribe had at least one shaman, and in the north many of these were women. Those possessing the materials to do so built sweat lodges for both medicinal and religious purposes. Most groups seem to have had complex mythologies and ceremonies, but only a small fraction of these, like their languages, survived the destructive incursions of whites—first with the arrival of Spanish missionaries but particularly at the onset of the California gold rush in the mid-nineteenth century.

Considering these circumstances it is a little surprising that the North American Indian project did not join other anthropological salvage efforts in the culture area

sooner than it did. As early as January 1908 Curtis, in thanking Charlotte Bowditch for taking out a subscription to The North American Indian *and in response to a specific "mention" of "the mission Indians," said, "Yes, I shall later take up that part of the work and devote a volume to their life." W. E. Myers did much ethnological fieldwork among the California tribes in the middle years of the second decade of the twentieth century, and both he and Curtis were in touch with Alfred Kroeber, author of the comprehensive* Handbook of the California Indians, *which was first published in 1919. However, despite isolated forays into California, such as to the Cahuillas of Palm Cañon near Palm Springs early in the century and to Chemehuevi territory in the Mojave Desert in 1906 (see fig. 24), Curtis was not able to undertake serious photographic activity in the region until 1922. By this time many "traditional" aspects of Native clothing, customs, and habitation could no longer be captured (see fig. 19). The varied fieldwork results, including considerably less than the promised "volume" on the mission Indians, were published as volumes 13, 14, and 15 of* The North American Indian *in 1924 and 1926.*[1]

Letter by Edward S. Curtis to Edmond S. Meany, 1922

On August 30, 1922, Curtis wrote from Ukiah, California, to his old friend, Edmond S. Meany, saying, "I am certain you will be glad to know I am in the field working with the Indians. . . . I am out on a three or four months trip with the Indians of northern California. . . . Florence is with me", he continued, "other than that I am alone. Had expected Myers to be with me but he was otherwise tied up and could not manage it. I will make a map with check marks showing where some of the seasons [sic] work is."[2] *As the letter went on to assert, Curtis was confident that the season's work would lead to publication of a further volume of* The North American Indian *(the publishing schedule of which had experienced something of a hiatus), and he outlined plans for the volumes up to and including number 17. As it happened and as the letter's postscript explained, he was unable to include a map of his journey. The letter that follows, written some months later in October 1922, was his way of providing a report on the promised work.*

I believe you will be interested in a few details of my summers [sic] work among the California tribes.

As you know the principal work of this season's trip is the making of the pictures for Volumes XIII and XIV. As a popular title for the trip it might be called "Gathering Up The Fragments." The two volumes in question will cover the many small groups in California north of San Francisco and the Klamath Lake region of Southern Oregon.

This, you see, covers a tremendous area and a great diversity of life. The Coast line from Golden Gate to the Oregon line is a precipitous one with a jungle like forest of spruce, redwood and fir coming to the water's edge. In the old days many small groups lived along the coast principally at the mouth of the rivers. These tribes lived much as did the Puget Sound natives in the old days.

The great majority of the California tribes can well be termed a mountain people. Their home grounds were along the countless mountain slopes where fish could be had from the streams and game and acorns from the mountain sides. So steep are the mountain sides that the natives could only find village sites at rare intervals and in many cases to locate a house they had to dig a niche in the mountain side itself.

This limited ground space has in some places brought about a unique and interesting grave yard location. The graves can truly be said to be a part of the domestic establishment, and here the people certainly always have the dead with them. In many cases the graves are within ten feet of the house. To one not accustomed to living in a cemetery one of these old villages does not seem over attractive as here for generations they have buried their dead, and those buried during the last fifty years are enclosed in a whitewashed picket fence. Over the graves and on the fence are placed all sorts of domestic junk. One village visited seemed fully half covered with graves and naturally the graves of the present generation were dug among the bones of the former generations.

One of the difficulties of this California work is the great number of groups to be visited, and the further fact of their being so scattered and last but not least the isolation. The season's work will cover over fifty working places and to reach some of these is no small task. The majority of the places we reached or almost reached with our car, and in the early part of the trip we christened it "Nanny," as nothing but a goat could get over the mountain trails our work has taken us. Northern California has mountains enough to supply the world and still have plenty for home consumption, and motoring into the out of the way niches among these mountains can be termed a sport. So far we have met with no serious mishap but plenty of close shaves. On one occasion while creeping around a mountain side the ground gave way and the car started to roll over. Once in a lifetime one uses good judgment in what seems to be the last moment of existence. This was one of the times. When the car started over I lacked three feet of [distance from] a life saving oak on the mountain side. I gave the car all the gas at once, and it shot ahead far enough to reach the tree, and then toppled over against it. Sitting in the seat I could have tossed my still burning cigarette two hundred feet down to the first ledge of the gorge. . . .

So far the summers [sic] work has given us six crossings of the coast range and

there will be six to eight weeks more work before I am through. . . . To-day we are camped near the mouth of the Smith River. Our tent is under a spruce and so near the ocean that we are almost in its spray. It is a day of constant rain, and no work can be done. Otherwise I would have no time for this letter.

A week from now we should be at Crater Lake. Then down to Klamath Lake where Florence will leave for home and the balance of the trip I will be alone. Some of the main points to be touches [sic] on the southward leg of the trip will be Alturas, Shasta, Redding, Lassen, Susanville, Pyramid Lake, Nevada, Lake Tahoe, Oroville, Yosemite, and Tulare Lake. These, however, are but highway points and the real work will be on the by-paths.

In a technical way the seasons [sic] work covers some most interesting material. I am working with a different linguistic group at every move. At one point where I worked with a large number of Indians gathered for work in the bean fields, there were six languages in the one camp.

At this point we have the Tolowa, a branch of the Athapascan stock. On the Klamath River, . . . we had the Karok, and the Yurok, the latter belonging to the Algonquin linguistic stock [and so on, through the Hupa, the Wailaki and Yuki, the Kato, the Pomo, and the Shasta]. Many other stocks and groups will be touched but I think I have given you enough of the linguistic groups to indicate some of the technical problems involved in these two volumes now at hand.

While the majority of the groups have changed materially through contact with the white race and mixed bloods predominate, there is still fine picture material and I am confident that the volumes will be rich in illustrations.

I cannot refrain from touching upon the treatment of the California Indians by the early settlers of the state. While practically all Indians suffered seriously at the hands of the settlers and the government, the Indians of this state suffered beyond comparison. The principal outdoor sport of the settlers during the 50's and 60's seemingly was the killing of Indians. There is nothing else in the history of the United States which approaches the inhuman and brutal treatment of the California tribes. Men desiring women, merely went to the village or camp, killed the men and took such women as they desired. Seemingly feeling that the Indians might later be given some protection and rights they killed them off as fast as they could. Camps were raided for men to serve as laborers. Such Indian workers were worse than slaves. The food furnished them being so poor and scanty that they died of hunger. One would think that self interest would have caused them to feed the enslaved men, but apparently there was a feeling that others could be caught when those at hand were dead.

In 1851 a treaty was made with the California tribes but the settlers fearing that some of the land might contain gold, prevented the ratification of the treaty. Thus the Indians became a people without even camping places which they could call their own. No story can ever be written which can overstate the inhuman treatment accorded the California tribes.

It is only fair to say that all early settlers did not join in the brutal treatment of the native as in some cases individual settlers treated the Indians about them with every consideration.

Enough of all this. I will let you know how the trip ends.[3]

From a Memoir by Florence Curtis Graybill, n.d. (1922)

Florence Curtis Graybill, who was born in December 1898 and died in July 1987, was the third of Edward and Clara's offspring. As her own writing on her father's life attests, she was probably the child most interested in his Indian work. This memoir records some of her experiences during the same fieldtrip as that evoked by her father's 1922 letter to Edmond Meany.[4]

I left Seattle by train the summer of 1923 [*sic*] and met Dad at Williams [in California]. We set forth in a small car loaded with camping equipment, food supplies, cameras and personnel [*sic*] necessities. In the cool of the morning we began our westward journey toward the coastal range, a range of mountains we would cross seven times during the summer on trails that had been widened sufficiently to be called roads. . . .

In the vicinity of Ukiah we set up camp near a village of Indians of many tribes who came to the area to pick beans. All ages, from small children to grandparents, sought this means of earning a small wage. In the heat of the day it was well over the hundred degree mark. It amazed me to learn there were six different languages spoken by the Indians camped nearby.

According to the usual plan Dad worked with an Indian interpreter, one with authority, a chief or medicine man. His assistant, Mr. Myers, had already gathered material in the area. Dad would add to it and make photographs. It was interesting to watch him at work. He was friendly but not in the least demonstrative, yet the Indians seemed to instinctively sense his sincerity. . . .[5]

I had another glimpse and understanding of Dad that was interesting to me. We were invited to dinner in town at the home of a doctor and his wife. The doctor was also an ethnologist and delighted to "talk shop" with Dad. In their home they had the most beautiful collection of finely woven Indian baskets I had ever seen.

Photographs were made for *The North American Indian*. While visiting with my hostess I overheard part of the men's conversation. After we had expressed our thanks for their hospitality and said goodnight I could hardly wait to ask a burning question as we went to our car. "When the doctor asked you about that special religious rite which he said he had been endeavoring to learn, wasn't it the one you secured today?" He was startled with my question. "How did you know?" "Just a hunch, no doubt, but you did return to camp today looking like the cat that swallowed the canary . . . apparently mighty pleased with your day's work."

"Well, the doctor had tried for some years without success and no doubt I just happened to be lucky."

"I understand, and you were too modest lest it might sound like you were bragging a bit." And we had a good laugh together. . . .[6]

One of our mountain travelling trips over narrow roads in our car we were forced off the road on a soft shoulder. An oak tree, which was growing in the right place at the right time for us, prevented a disastrous accident. . . . While car repairs were being made it seemed the logical time to make a canoe trip down the Klamath River to an Indian village otherwise inaccessible. It sounded like a wonderful idea to me for a love of boats and fast water is part of the family heritage. Two Indians, who knew the river, accompanied us.

When we were in the throes of that white water Dad looked at me and a wordless exchange of joy was transmitted. We both loved it. . . . We were working our way northward along the coast of California. [With] the Smith River Indians . . . [there] was moisture from sky and sea. I wondered how Father would be able to make pictures, but he did, which never ceased to amaze me.

A couple of years later, when Edmond Meany renewed his links with Curtis to offer condolences over the death of Clara, Curtis's estranged wife, Curtis told him, "No, you are not intruding," but then rapidly deflected attention from his personal life to "the work": "About the only thing my friends can do is to hold a little belief in me. . . . The problems are many, however the real work moves on." He then gave an update on the California fieldwork, stressing the extreme eastern region of the culture area: "I am just in from a short trip up the Owens River Valley and Nevada county. To-morrow I am starting out on a trip of a few weeks in the southern counties of this state. With this southern county trip finished, and later in the season a week spent at Pyramid Lake and the California work will be finished. . . . One California volume is on [sic] the press at the present time," he continued. "The one which we are just finishing will be published as soon as the mechanical work can be carried through." These plans, outlined here

and later in the letter so as to drive home the point that publication of "the work" truly was proceeding apace, did materialize much as Curtis predicted.[7]

II. VOYAGING TO ALASKA

The peoples usually called Eskimos at the time of the project were members of three separate but related linguistic groups: the Yup'ik, the Aleut, and the Inuit-Inupiak. These three are scattered across the vast ice-bound and tundra region of North America, from Greenland in the east to the tip of Siberia in the west. Within each linguistic area they speak dialects of the same language, although when their cultures are examined closely they present quite considerable diversity. Yet they are, in general terms, unified in patterns of life. With obvious variations in aspects of material life such as housing— igloos in the north central parts of Canada, dugout earth houses along much of the Alaskan coast, and hide tents in other regions—they traditionally shared substantially the same cultural patterns. All of life was conditioned by the harshness of the arctic and subarctic climate and landscape. Except for some interior tribal groups, most gained their subsistence based on the sea, hunting whales, fish, walruses, seals, and polar bears, and, where possible, on the gathering of berries and the tracking of caribou and other animals of the tundra. Social organization consisted of little more than large family units, especially for those peoples constrained to travel far afield in search of food. These peoples were expert in the use of available materials for carving, in the making of tightly sewn skin garments for winter insulation, and, most spectacularly, in the fashioning of kayaks and umiaks. During the long inhospitable winters as much time as possible was dedicated to eating and the transmission of songs, stories, and myths.

In 1899, prior to the inception of the North American Indian project, Curtis visited parts of the Yup'ik, Aleut, and Inuit territories with the Harriman Alaska Expedition. The Harriman ship, the George W. Elder, *put in at various villages from just west of Yakutat Bay, through the eastern Aleutian islands, up to Plover Bay on the Siberian side of the Bering Strait (see fig. 20). For* The North American Indian, *parts of which had already been devoted to Northwest Coast peoples who lived as far north as southeastern Alaska and various peoples of the Subarctic culture area domiciled in northern Canada, something different seemed required. The notion of including Arctic peoples at all in the volumes arose very late in the day. According to Frederick Webb Hodge, Myers, while he was still involved in the project, planned to devote the final volume of the series to the tribes of "Eastern Canada," and as late as May 19, 1927, Hodge was still urging Curtis to stick to this original plan, even hinting that it had the approval of the Morgan employees in "the office." But Curtis was not to be deterred. On November 17,*

1926, he outlined his plans for the volume, which was to treat "the Eskimo and one or two of the tribes of Northwestern Alaska, including the natives of Yakatat [sic] Bay." "This will round out the work, adding variety," he claimed, and would be achievable in one season of fieldwork, whereas, he said, "the Indians of Central Canada" would take more that one season of fieldwork, "owing to the isolation of the mongrel groups of that region."[8]

As it happened, Curtis's actual voyage to Alaska in the summer of 1927, in the company of Stewart Eastwood, a young ethnologist then embarked on his second year of fieldwork for the project, and his daughter, Beth Curtis Magnuson, started at Nome, much further north of Yakutat Bay, and continued onward through northerly Arctic groups, such as those living at Nunivak (see fig. 21), King Island, Little Diomede Island, Cape Prince of Wales, and Kotzebue. Each of the three left accounts of their travels, from which the following passages have been excerpted.

In reading these accounts it is impossible to ignore the almost obsessive preoccupation that each writer displays with the alleged "filth" of the Eskimos (as everyone quoted here referred to them). Mary Louise Pratt has pointed out that such observations are a frequent trope of travel writing by whites and constitute part of the cultural work of that genre to reinvent places such as Hooper Bay as "backward and neglected," as "manifestly in need of the rationalized exploitation that Europeans bring" as part of the "white civilizing mission"—a sense particularly evident in Eastwood's formulation. This points to a further paradox in the project's approaches: in almost the same breath Curtis celebrated Eskimo lack of contact with missionaries because it allowed the perpetuation of the people's innocence![9]

From Beth Curtis Magnuson's Log of Her Alaskan Voyage, 1927

Beth Curtis Magnuson, Curtis's second child and oldest daughter, was born on May 5, 1896, and died on September 2, 1973. After the dissolution of Curtis's marriage and the transfer of his studio activities from Seattle to Los Angeles, she became the manager of the Curtis studio. By 1927 it was located in the lobby of the Biltmore Hotel and her husband, Manford E. Magnuson, also worked for the business. Her log, handwritten on Alaska Steamship Company note paper, was addressed to "My Dear Studio" as "a letter" intended to convey some of the details on a "day to day" basis. The version here consists of a very brief selection from the whole.[10]

On that day [June 7] I started down early so as to get all my luggage on board [the Victoria] there being quite an accumulation of same despite Dads [sic] warning. But even at 9 AM the dock was crowded and it seemed as though half of Seattle as well

as every Alaskan was drawn to see the boat off for Nome. It was raining needless to say but a number of my friends were there so it was a jolly departure. . . .

Nome

Words are inadequate and I feel at a loss to attempt it. But picture if you can houses, hotels, stores, shops, saloons, gambling dens etc. to accommodate fifty thousand people left deserted—then these same buildings after time, weather & storm have played havoc with them for 20 years. The streets are dirt which is mud in winter— the side walks are narrow and go [drawing of a wavy line] most of the boards are broken & out. [Drawing of collapsing buildings captioned as follows:] Nome. Formerly 50,000 now 750 (and half of these Eskimos).

Thursday

We have our boat—by name "Jewel Guard" and our skipper who is the former owner is called "Harry the Fish." He is a swede [sic] and hates liquor, tobacco & women. Even so we are courageous & plan to set sail Saturday for St. Michaels—Hooper Bay & Nunivak Island. The boat is not so bad—about 40 feet long—a small cabin in which we hope to store our food luggage & also put our bodies to sleep at nights.

And so it really seems that at last I am about to realize a life long ambition. A trip into the Indian country with Dad—only more than I expected for it is to be on a boat. So all aboard for parts unknown. . . .

Tuesday

It was quite rough as soon as we got outside & being uncertain as to just what kind of a sailor I was I put on the sheepskin & assisted Harry the Fish to steer the boat. . . . In the afternoon we struck ice so we attempted going out to sea and straight to Nunivak. But the storm increased and we soon changed our minds & took refuge in the ice. It is such slow going that we made but 60 miles & finally decided to make for Golovin Bay & get out of the storm. After steadily going we made it at 11:30 A.M. Wed & we were glad to be alive. The waves were ten times as great as our boat & we were shipping much water. Oh boy it was good to beach down! All of us piled into our bunks & slept till late in the afternoon. . . .

In the evening we went ashore to look over the town. There are three white residents, the balance natives. The store is a [Lohman] enterprise & we found more storm delayed people, some whom we knew on the Victoria. So we organized a party . . . and had an enjoyable evening. . . .

July 9th—

Land near Nash Harbor & go ashore. One small Eskimo tries to talk to us & we ask

for Paul—At last he points to the right and we get on board our boat & go on. At last we sight what must be Etolin at 5.30. There seems to be a small village on the sand spit. Some of the Eskimos paddle out in their kyaks. All are dressed in fur parques & have large nose rings. We ask about Paul—they shake their heads smile & mutter in their own language. At last we give them [an] American flag & one man seems to understand & raises it on the flag pole as a signal to Paul to come over.

After dinner Dad & I go ashore to explore the Fifth Avenue of Nunivak island. All of the Eskimos follow us around & laugh & talk like children. We buy a few baskets & look over the village.

July 11th

About 10 A.M. a Kyak draws alongside and in it is Paul. He is half Eskimo & Russian, wonderfully handsome & always smiling. We all have breakfast & then the men go ashore. The waters are so high that I stay on board.

July 12th

The weather is still terrible so I stay on board & get meals while the boys work. Dad is real pleased with the amount of primitive material here. And Paul is ideal as an interpreter and helper. In the afternoon I go ashore & watch them work & make pictures. . . .

Wednesday July 14th

We all arose early the men going ashore at eight to start work. I cleaned up the dishes & prepared lunch and dinner so as to be able to go to the village in the afternoon. It was our first bright day, the sun actually shone despite a severe cold wind—so we started making pictures.

The Eskimos themselves seemed to appreciate the good weather for the Igloos and all space around was covered with Parkees, skins, dried fish & roots to be aired. We photographed quite a good many including one group who were departing to their summer camp paddling off in their Bedarky towing three Kyaks.

Paul suggested that we might like to see the mens [sic] quarters, womens [sic] quarters etc. so we started in. The men have one large Igloo built something in this fashion. It is earth & grass over a framework of logs. [Section drawing of house]. You go down a few steps, then down a few more & up (all of these on hands & knees). The main room is about 16ft. square & there is a large whole [sic] in the center for the fire. Around this are grass mats, one for each man. Here he sleeps, carves ivory or does whatever handicraft he needs. His tools are in a box at his side. The boys stay here with the men. And the women carry in their food to them.

The womens [*sic*] Igloo is similar with the exception of a large crude stove & much fish, seal etc. Around the edge of the igloo is a raised platform with grass mats for each to sleep on. When we entered their [*sic*] were four women in there, two of them weaving baskets and a third sewing skins. They all smiled & laughed at us—Such a happy crowd. The little girls sleep here with the women. [11]

Most of the seal oil, fish & roots are in at present & have been stored in pits for next winters [*sic*] use. Within a few days they all will be gone from this camp and we will have to pursue them to their summer quarters.

We paid them in silver and they look at it in a strange way. Paul says they have seldom have [*sic*] ever seen silver and would have been as pleased if we had given them chewing gum. The one & only place in the world where money has no value.

I looked over the furs at the traders and they have beautiful ones. It seems they get a good many foxes on this Island.

Tonight is beautiful. The sun is setting behind the hill on which our little village is perched. Most of the Eskimos are on the top gazing off across the Ocean. . . .

July 15th

We left Etolin for the winter village and Paul's home. After dinner we go ashore & meet Mrs. Paul and the children. Mrs. Paul is charming, quite bashful & shy. . . .

July 21

The men go ashore & get in splendid work. I go ashore in late afternoon and visit Mrs. Bird [the teacher]. She has wonderful dinner for us. Mr. Harold the birdman & Mr. Collins the boneman are present.

July 22

Men work on shore but it is too rough for me & I stay on ship. At about 5 P.M. we left . . . after piling Mr. Harold, Collins and Stewart on board together with all their bones and birds. [12]

We hardly get out of Nash Harbor when a northeaster starts & we are in a fearful storm. Our new passengers all are ill—the storm is so bad we decide to go up river and strike the bar on the way in—We soon get off & finally anchor awhile. . . .

July 26

We arose at 3:30 & had breakfast & pulled anchor at 5—Waved goodbye to Mrs. Paul. We stopped at the spring village & unloaded the men & the bones. Then we went ashore to get our things & say goodbye to our old friends. Paul returned with us for lunch & then we said goodbye. Surely hated to leave him for he is a real friend. We will miss him terribly. At 11:30 we set sail & headed for Hooper Bay. . . .

Hooper Bay Village—July 27

After a beautiful day on the ocean en route from Nunivak to Hooper Bay we came in sight of a huge bluff. We had not hoped to reach our destination so early & were somewhat puzzled too for the charts indicated Hooper Bay to be mud flats a few feet above the high water. By the time we were fairly near the cliffs it was too dark to venture further so we anchored. At about 3 A.M. we came to and found our cliffs were Romanzoff & are still at a loss to figure how we made such good time.

We went back to the edge of the sandspit & about 5 A.M. a Kyak came alongside, and in a few moments a launch with Mr. [Micha] Ivanoff. They had been whaling & were waiting till high water to go into the Bay. We waited with them & about 10 AM slowly wound our way in—the bay is only a few feet deep in many places & the village is located on a muddy bank on the edge of the river.

Slowly moving up the river we passed numerous tents & drying racks. Everywhere one could see dirty children dogs etc. We had not dropped anchor before we realized that the reputation of this village was justified—it being considered the dirtiest & filthiest in existence.[13]

We had no more than stopped when the Eskimos literally swarmed on the boat until no one could move—We got lunch and ate it while fifty of them looked on.

Dad wandered out to make a few pictures but returned in half an hour too disgusted with the dirt to go further. We made a few pictures of those on the ship then with Eastwood & I to back him up we started to see the village. Some of them lived in tents, others in the usual mud house. The soil here is clay mud which oozes in all directions & at high tide it is a mass of small waterways.

Unlike Nunivak they each have their own hut which serves as living, eating & sleeping quarters for all the family & also as storage for seal & food. It is positively the most disgusting place I have ever seen & the women & children have never bathed or combed their hair. The men have the customary sweat baths so they except for the muddy & ragged clothing look fairly clean.

In the afternoon we had dinner with the Ivanoffs. Mrs. Ivanoff is full Eskimo from the North and he is half Eskimo. Their home & school is spotless & we had a very enjoyable time.

All returned to the ship early & I had to close down all hatches & cover the portholes to get enough privacy to go to bed. There wasn't a spare inch on board ship without an Eskimo. We arose early Thursday & by the time we started breakfast the whole village had arrived. Despite that we went ahead with the Day.

Dad left at noon with Mr. Ivanoff on a whaling expedition. The rest of us stayed

on board. Mrs. Ivanoff came down for tea in the afternoon & we had a lovely visit. She is utterly discouraged with the situation & I can't blame her.

After dinner we pulled anchor & went out to anchor & await Dad.

Eastwood celebrated by going for a swim which has so shocked us all that there are no further words.

From "A Rambling Log of the Field Season of the Summer of 1927" by Edward S. Curtis, 1927

Beth was unable to complete the full summer with her father. She returned to Los Angeles while Curtis and Eastwood struggled through repeated storms to visit other isolated Inuit communities. As in Beth's account, the primary preoccupations of the log are the weather: storms, ice, fog, swells, wind, currents, and so on, and the means by which they inhibited progress to places selected for fieldwork. In both logs, therefore, the highest point of all, at least from this vantage point, was when the Jewel Guard *ran aground on a sand bar twenty miles from shore. Another high point for Curtis was the smell from a whaling station in the Aleutian Islands which "brought back thoughts of the old days" when he was "out on the boats chasing whales." It gave him, as he said, "the longing to once more be out on one of those small boats in a raging sea chasing a whale." Curtis also presented in the log much commentary on Alaska in general, as if he might have half thought of publishing at least some of the log as a kind of travelogue. The following are typical observations: "It is impossible for the outsider to comprehend the extent of Alaska. When Russia sold us that land of snow and tundra she was careful to see that we got all of it." And: "The Seward Peninsula is not a white man's country and the white man's invasion of it must of necessity be short lived." Such a remark, like this one, is virtually an aphorism: "For the native it is all right, he knows no other land or life. He lives from the sea and the land, his wants are few. Where there are natives there will always be traders to buy his furs and sell him such of the white man's goods as he must have. Hence the future of the Northwest corner of Alaska is the native and the trader." When Curtis re-read his log in 1948, the evocation of so many dangerous moments and frontier speculations seemed profoundly interesting to him, and he told Harriet Leitch, his correspondent from the Seattle Public Library, that he couldn't put it down until he had finished it. In this selection, however, the emphasis falls more on relations with the indigenous Arctic peoples they encountered.*[14]

June 28th. Sailed from Nome at 7:30 A.M. Our party aboard is Beth, Eastwood, Harry the fish, and myself. Our boat is no palatial yacht, 40 feet in length, 12 foot beam, drawing 3 1/2 feet. Not much of a craft for navigating the stormy seas of the North. . . .

July 10th. . . . 9:30 P.M. We are at anchor at the outer cole of Cape Atoline [i.e., Etolin] Bay. Plan to go on in early tomorrow. Have secured a native to pilot us in; that is, I think we have; as he speaks no english [sic] I am not quite certain he knows what we want him to do.

We reached the island at 1:30 P.M. Could not tell what point it was. Sighted small native camp and went ashore. Found a small boy who knew a few words of our talk. Learned we were in Nash Harbor about six miles from the native village. As we expected to find Paul Ivanoff at Cape Atoline we headed for there without going into Nash Harbor Village. Ran on East thirty miles to this point. As we neared this village the natives all climbed a high sand dune and watched us as though they had never seen a boat before. They were certainly a picturesque lot gathered there on the grass grown sand dune. Beth and I have been ashore and exchanged smiles with the natives. They are certainly a happy looking lot. I tried in every way to learn where Ivanoff could be found. At last Beth showed wit I lacked and said "Paul," then every native was awake. The natives know Paul but naturally no one knows that the rest of his name is Ivanoff. At once the natives indicated that Paul was at the Winter Village at the inner bay, and they would raise a flag and Paul would come in the morning. It took a great many motions to get this settled. It is certainly good to be here. We are twelve days out from Nome and the distance is but 300 miles. It has certainly been twelve days of grief and some trying moments. Out of the twelve days we had ten days of storm.

At anchor Cape Atoline. At 5:00 A.M. Paul came aboard and brought a happy smile with him. We are going to like Paul. Paul is part native and part Ivanoff. He is here on the Island in charge of the reindeer herd for the Lohman Reindeer Corporation. He has been here for four years; has a small store, it being the only one on the island. At present there is about nothing in this store but he expects to receive goods in October and this is only July. We brought him a few hundred pounds of food sent by the Company. There is a tradition that they get one mail a year at the Island. They get this one mail by luck and the grace of God. This year it fell to us to bring the mail. Who will bring it next year God knows and he wont [sic] tell. . . .

We worked ashore all day and made a good start. The natives here are perhaps the most primitive on the North American Continent. We should get some good material. We know now our decision to visit this island regardless of the problems was a wise one. Think of it. At last, and for the first time in all my thirty years [sic] work with natives, I have found a place where no missionary has worked. I hesitate to mention it for fear that some over-zealous sky pilot will feel called upon to "labor" with these unspoiled people. They are so happy and contented as they are

that it would be a crime to bring upsetting discord to them. Should any misguided missionary start for this island I trust the sea will do its duty. . . .[15]

July 11th. Anchored at Cape Atoline. Weather raining. Worked with natives all day and until 10:00 P.M. Secured lot of good material. Present informant is a hunchback medicine man. We hear that there is on the island—probably at Night Harbor—two men collecting for the National Museum. We brought mail for two men, names, Collins and Stewart, if here, they must have been on the island for six weeks, landed by the school boat Boxer. Nash Harbor is but thirty miles away. It seems odd that if they are there the natives at this point do not know of them. Paul has heard nothing.

July 12th. At anchor at Cape Atoline. Rain all day. Work ashore in Paul's cabin. We are certainly fortunate here, Paul is a good interpreter and is good enough to drop all his work and help us. He is about King of the Island, has the confidence of the natives and can get almost anyone to talk with us. Worked on text until noon, the afternoon being sunny I made pictures. . . .

July 15th. At anchor Winter Village, Cape Atoline. A fine sunny day. Spent good part of day making pictures. Paul had the reindeer herd driven in and I made pictures of it. Paul is proud of his herd, insists it is the best in Alaska. One great problem of the reindeer business is ticks. For some strange reason the animals on the island are free from this pest, also the herd is being bred with Caribou bulls. . . .

July 20th. Anchored at Nash Harbor at 3:30 A.M. Went to shore at 6:00. Paul found an informant and we started work at once. Made a few pictures. Stewart and Collins are here, also a bird collector, Harold. Harold was landed by the revenue cutter and the other two by the school boat Boxer. They want us to move them to Cape Atoline. . . .

July 22nd. Finished our work at Nash Harbor at 5:00 P.M. I have taken on task of moving Collins, Stewart, and Harold to Cape Atoline. It took some hours to get all their equipment and plunder aboard. They are like a bunch of infants and should be home in the hands of a wet nurse. Why are such inefficient men sent out? While their work is presumably supported by the Bureau of American Ethnology, the US National Museum, the American Association for the Advancement of Science, and the American Council of Learned Societies, they are working on limited funds and their getting about must depend on charity transportation of school boat, revenue cutter, trader, school teacher, etc. Hoboing in the name of science.

At Nunivak they used nickels for money. The natives here did not know one coin from another. Great was their disgust when they reached Paul's store with their nickels. A nickel in Alaska is about on a par with a German mark anywhere. Their plunder consists largely of skulls and bones, about a ton of said human bones in

sacks. A skull or two as types might be all right but what in the hell do they want with tons of the stuff. . . .

July 24th. Wind dropping. Kept busy all day gathering text material. Hope the weather will permit our moving on high tide tomorrow. . . .

July 26th. 11:30 Just sailed from Cape Atoline. We were all up at 3:00 A.M. preparing to leave our anchorage at the inner harbor. Sailed at 5:00 A.M. An hour and a half took us to our old anchorage at Atoline. It took us a couple of hours to get the bone hunters and all their plunder ashore.

Closed up all matters with Paul and then took him aboard for a farewell lunch. Paul has been one of the best helpers I ever had. It was hard to say "Goodbye" to him. In fact, we all left Nunivak and our friends there with a real heart ache. I suspect that much of our liking for the island is our deep regard for Paul and through his help our work on the island has been a great success. . . .

July 27th. 6:00 A.M. Sighted Hooper Bay Village six miles away. Natives came out to meet us. All shoal water between us and village. Must wait until high tide to go in. Micha Ivanoff, the school teacher here and a cousin of Paul, came out to greet us; had been expecting us for some time.

At 10:00 A.M. Native piloted us in. Did not touch bottom but once going in. Ran up river a short distance to the camp and village. In the past three weeks the natives here have killed sixty eight small white whale. Drying racks are filled with black bloody looking meat. The Hooper Bay natives have the reputation of being the filthiest human beings on the Globe. I have not seen all the world's dirty natives but I can say that no human can carry more filth than those here. The dirt and filth is beyond description. The smell, we will just pass by.

July 28th. In the mud at Hooper Bay. A warm sunny day. The tide is low and all the gooey mud is in sight. Natives could not be clean and live in such sticky, slimy slush. Spent the day making pictures and arranged to go out with the natives on a beluga hunt—white whale—I certainly hope we catch a whale and that I get a few pictures. . . .

August 4th. We tied up [in Nome] at 6:00 A.M. and went up town for breakfast. Beth was greatly worried with the problem of getting out. At the restaurant we learned that there was a plane in from Fairbanks and as he had no passenger back perhaps we could make a deal with him to take Beth to Fairbanks. . . .

August 7th. 10:30 A.M. Met the Schooner Trader coming from Diomides and Teller. The deck was crowded with passengers, mostly natives. The Trader is the first boat of any kind that we have met since we started on the cruise. This is a striking illustration of how little traffic there is in this Bering Sea and Arctic Ocean Country.

One swimming about here waiting for a passing craft to pick him up would have a long wait.

5:40 P.M. Sighting King Island, just a pin head spot on the horizon line. Position due west. Weather condition fair. All going well we should reach the island about midnight. This is the darkest and worst hour but we must make the best of the situation.

August 8th. Anchored at King Island at midnight. . . . All up at 3:00 A.M. Calm quiet day. Went ashore at 5:00 A.M. Sea quieting and no trouble in landing. Great luck this time as it is rare that one can make a landing on this storm beaten rock. Finished work at 10:30 and sailed. No time lost doing this island. As time passes we feel more than ever that our work is a race against time. By the middle of September the winter storms will be on and then getting about in a small boat will be out of the question. From now on storm conditions will be worse every week.

King Island is one of the most picturesque spots in all the North. The island is but a rock pinnacle standing out of the sea. The village is like no other village on the continent. Small box like huts built on stilts clinging to the precipitous cliffs. These people can well be called North Sea Cliff Dwellers. On all the island there is but one spot where boats or canoes can land and that spot is but 150 feet wide. At no place at or about the island is there even the slightest anchorage protection from storms. Truly humans pick strange places in which to exist. There is, however, a good reason for the King Islanders clinging to this isolated spot. The island is directly in the route of the walrus herd on its migration to and from the Arctic, so with the King Islanders walrus hunting is but a harvest. The walrus come North in the early Spring with the first break-up of the ice. The killing lasts but a few days as the herd soon passes. Of late years the natives leave the island as soon as the walrus season is over, and go to Nome for the Summer. At our visit there was not a human on the island. We expect—at least hope—to get back to Nome before the people have returned to the Island, and get our text material from some of the old men there.[16]

What the island lacks in humans was more that made up in dogs, countless numbers of them, all one type, large wolf-like beasts. As we anchored the pack set up such a howl that we feared landing might be a problem, but as our boat reached shore we found that there was no ground for fear. Rather than being cross they were so glad to see a human that they almost crushed us with their affection. . . .

It is now noon. We are through at King Island and almost exploding with joy at our success in getting our pictures of the village. We will sail from King Island to Cape Prince of Wales where we expect to pick up an interpreter and then sale [sic]

at once for Little Diomide. We are informed that we will find no interpreter on the Island.

5:30 P.M. We are at anchor at Cape Prince of Wales. We caught a fair wind and a fair tidal current and, for us, made great speed. Some miles out a skin boat with a party of walrus hunters boarded us and came in tow. As we anchored, two other large skin boats came out to greet us. When all the mob had climbed aboard to look us over I feared we would sink with the load. Fully fifty of them were on the deck. Arthur, the native we were looking for as an interpreter, was in the second boat. Talked with him and he is to go with us. He has gone ashore for his bed and we will pull out for Diomides as soon as he returns. We are certainly in good luck so far on this leg of the cruise. The day is perfect and no sea to speak of. Matters are going so well that I am suspicious of what may come next. Such weather is not right but the barometer is still up. . . .

August 9th. Anchored at Little Diomides last night at 10:30. Arranged anchor watch so that I came on at 3:00 and started breakfast. All but Harry ashore at 4:30. Lost no time in getting to work, Eastwood gathering text material, I making pictures. Certainly a good start. The day has been fine. The wife of a missionary tells us it is the only perfect day this year. In fact, the best day she has seen in the four years she has been on the island. The island has the reputation of being the home of bad weather. Here they tell us that at one time the Boxer had school supplies on board for three years before she finally managed to reach here at a time when they could be landed. We are certainly close to the edge of the United States, as it is but three miles across to Siberia. Five days here should give us what material we need. . . .

August 18th. 10:30 P.M. We are at Kotzebue. Reached the Sound early this morning and picked up a native to pilot us in. He made a poor job of it. He insists that he knows all about driving dogs but does not know much about piloting big boats. We fought the mud flats all day. Ran in every direction looking for water deep enough to keep us afloat. We reached the village at 6:00 tonight. Have been ashore. Sam Magids is here. He was expecting us and will do all he can to get us started on our work. He is a prince of a fellow. We are anchored in front of his store and about 100 feet from shore, so here goes for some work. I am going to bed at once and hope to get some real sleep. Over sixty hours of hard work and but four and a half hours in bed, that following our sleepless days at Diomides, has me numb from both ends to the middle. Tonight I sleep. Tomorrow at midnight I start on a whaling trip with the natives. I am told they killed six today, the same white whales which they get at Hooper Bay.

August 19th. Spent the day at work with the natives. Meeting considerable opposition from the missionaries.

August 20th. Worked ashore. Raining; storm too bad for whaling trip.

August 21st. Worked ashore. Still too stormy for whaling.

August 22nd. Worked ashore until 4:00 P.M., then pulled anchor and started on trip up the Noatak River. The Noatak natives were camped at Kotzebue for some weeks but the day before we arrived they started up river to their inland village. They will travel slowly and we expect to overhaul them and get pictures of the skin boat fleet on its way up river. Our boat draws too much water to go all the way to the village and we will take a Peterborough with us and make the final part of the trip in the canoe. We ran until 10:30 and anchored awaiting daylight.

August 23rd. Started at 4:00 A.M. Overtook Noatakers in camp at 8:00 A.M. Made pictures of camp, then started up river. Took one boat in tow. An old man from that boat came aboard with us and told stories until we reached shoal water at 3:30 P.M. then loaded small outfit in Peterborough and followed natives up river. Camped with our old man that night and he talked until midnight. Bad weather, rained all night and we had no tents.

August 24th. Talked with old man until 3:00 P.M., then started up river. At 8:00 P.M. overtook Joe Nashalek, the school teacher at Noatak Village. His gasoline boat was hard aground. We had a cup of coffee with him and his crew and then took him in our canoe and started up the river. Cold night, the first real freezing night we have had. Reached the Noatak Village at midnight. It was good to be in a warm house. Mrs. Joe cooked us a fine supper, mostly of salmon trout. Regardless of my keen appetite, I can testify as to the fine flavor of the Noatak salmon trout, nothing equal to them in the salmon family except the small blue salmon of a small stream on the West Coast of Washington.

August 25th. Nice morning. Up early and looking over village. Spent the day making pictures; Eastwood talking with old man. Worked with old man until midnight.

August 26th. Day stormy. Worked with old man. Made some pictures.

August 27th. Worked with natives on both text and pictures until 4:00 P.M. then said goodbye to our friends and started down river. Reached our boat at 8:00 P.M. and started down river at once. Being a clear day it was not necessary to anchor.

August 28th. We are back at Kotzebue and at work. . . .

August 31st. Up at 3:30 and starting on trip up Seliwik River. Fine day. At 9:30 P.M. we reached entrance of upper Seliwik Lake. The visibility too poor to navigate narrow water ways so anchored until daylight.

September 1st. Up at 3:30 and on our way. Storm, wind, rough water. Arrived at Seliwik Village at 7:30 A.M. Work started badly, too much missionary. Missionary has sent out word to all natives that they must not talk to us. . . .[17]

September 2nd. Moved up stream three miles to be near an old informant. This man had been driven from the village by the missionaries owing to his refusal to be a Christian. The old man is a cripple and a most pathetic case. Missionary will not allow relatives to assist him in any way.

A hard snow storm during the day. This is our first real snow storm and we realize the Summer is over.

September 3rd. Clear day. The world is white with snow. Worked ashore with old man until night then returned to village.

September 4th. Found another "devil man" and worked ashore until late in the afternoon and then started for Kotzebue.

September 5th. Anchored last night at a native camp near the lower end of the Seliwik Lake. The natives brought us a large shea fish. This one weighed about forty pounds. A meal of well cooked shea fish is almost worth a trip to the Arctic. I never heard of this fish until reaching the Kotzebue country and if it is caught elsewhere I do not know of it. It is a fresh water fish and evidently belongs to the white fish family. As caught they range in size from ten to one hundred fifty pounds. During certain seasons they are taken in great numbers. . . . Reached Kotzebue at 11:30 P.M.

September 6th. Worked ashore. Rained all day.

September 7th. Clear day but cold. Worked ashore all day, made a number of pictures. We are almost through at Kotzebue.

September 8th. Worked ashore. Storm all day, snowing hard. I asked one of the white men here if this was not an unusually early winter. His answer was, "No, we usually get some bad weather in early September then it clears up and we have some nice Indian Summer. Of course it is rather cold but seldom gets colder than ten below. . . ."

September 18th. The native boys tell me we are about fifteen miles from Teller. . . . As a member of the Harriman expedition I was on the sand spit at what is now Teller thirty one years ago [sic]. Nothing there at that time but a large summer camp of natives. The Steamer George W. Elder with the Harriman expedition anchored there for a day, then proceeded across to East Cape, Siberia.

12:30 P.M. Anchored at Teller. My problem now is to get back to Wales and pick up Eastwood. I question his being keen about spending a Winter at Wales. To pick him up I must reach there between storms, as the natives could not come out to us in a blow. . . .

September 20th. Reached Wales yesterday a little after 3:00. Went ashore quickly and made pictures until dark. Eastwood was certainly glad to see us back. Spent the evening ashore with Eastwood in closing up text work. Went aboard the boat at

1:00 A.M. Harry was so mad that he was frothing at the mouth. Barometer falling rapidly and storm threatens and he could see no reason why we had not sailed before dark. . . .

As to our work, all we have to do to complete our season is to get our King Island text material and a few King Island portraits. In conclusion, I regret that lack of time prevented my rambling log being more complete. . . . Naturally notes for the book are quite complete but such notes are necessarily formal and countless matters of human interest cannot be included. The outstanding fact is that we have finished the trip without mishap and have the material for a good volume. . . . To successfully secure winter and ice pictures would necessitate wintering in one of the native villages, Nunivak, King Island or Diomides. This would mean an eighteen months trip to the North and a long shut in winter at one of the isolated islands. The thought of such a winter from the picture point of view thrills me, yet it would mean some trying months.

Letter by Stewart Eastwood to Frederick Webb Hodge, 1927

When William E. Myers became unable to conduct fieldwork for The North American Indian *he was replaced by Stewart C. Eastwood, a young graduate of the University of Pennsylvania, the son of a doctor from Brandon, Vermont. Eastwood had successfully completed a number of anthropology courses during his undergraduate years and came to the project highly recommended by Frank G. Speck, an authority on Eastern Woodland Indians, who knew Hodge well. He joined up on May 15, 1926, and within a month, after discussing the project in detail with Hodge in New York and talking to the business managers of The North American Indian, Inc., at the Morgan Bank, he was with Curtis on the plains in Oklahoma. Eastwood's correspondence with Hodge shows that he wrestled with the writing up of his summer 1926 fieldnotes on the Oklahoma peoples, but did eventually produce volume 19 to his editor's satisfaction. Volume 20, on the Alaskan Eskimos, was based on the hard season of fieldwork in 1927 already evoked here by Beth and Curtis, and Eastwood managed to finish his part for it by November 1929. Although he maintained contact with Hodge for some time and even presented the Southwest Museum in Los Angeles, Hodge's museum, with some of the Inuit artifacts he collected during his association with the project, he appears never to have returned to ethnology.*[18]

Now that we're storm bound here [Golovin Bay], I have an opportunity to catch up with my correspondence.

Much water has passed under the bridge since we first landed at Nome. There

we found that the chief obstacle to work was lack of transportation, not only to out of the way places, but anywhere. After much haggling over price, we solved that foremost difficulty by purchasing a boat. . . . The 29th of June we put out to sea for Nunivak Island, and arrived there on the 10th July, after drifting around in the ice block and being hung up on a sand bar. Navigation is uncertain since there is no reliable information on tides, currents, or even charts. We go mostly by guess and God helps us get there eventually.

On Nunivak we had the best of luck since the natives are primitive and unspoiled [see fig. 21]. They were willing to help us in every way so that we have a fine mass of material and a goodly number of pictures—real pictures illustrative of this mode of living, not merely the portraits we had to fall back on last summer.

Our interpreter [Paul Ivanoff] I cannot praise too highly. He is the local representative of the reindeer company, part Russian, mostly Eskimo, speaking not only the Nunivak dialect but several of the mainland tongues. He worked with [Knud] Rasmussen [the Danish colonial administrator and authority on the Inuit]. I note that Rasmussen and other writers speak of Nunivak as a bare land, almost devoid of means of living. That information must have been hearsay, for we found it quite to the contrary. Berries, plants, grasses and edible seaweeds in abundance— many of which we are bringing out to be identified. Birds in profusion—sea animals and fish in any quantity. While there we came across two "Bone-hunters" from the Smithsonian, Collins and Stewart, who are supplementing [Ales] Hrdlicka's [physical anthropology] collection.

From Nunivak we went to Hooper Bay for pictures. The natives there are the filthiest in Alaska—we were only too glad to leave. They have much bird life there but little else. They were kept from starvation by the teacher and the missionary who helped them catch white whales by driving them aground by means of the power boat. Living as they do in mud and dampness, it is estimated that 75% have tuberculosis. Their kyaks and weapons are poor; they have the crudest basketry; no carving in ivory since they don't get it; no wood carving since wood is extremely scarce. And so on. This culture at first glance seems to be a lack of culture.

To be brief. From there we headed North but a stiff blow drove us in here. We intend to re-outfit at Nome for the Diomides, Kotzebue and King Island.

We're looking forward to getting our first mail at Nome. I succeeded in picking up a copy of Nelson [i.e., Edward W. Nelson's *The Eskimo About Bering Strait*, 1897].

Eastwood did not manage to maintain his correspondence with Hodge during the rest of the trip, and this is unfortunate because the experience affected him deeply. In

November 1929, when he was putting the finishing touches to the vocabularies and other supplementary details to volumes 19 and 20—as well as worrying about the effects of the stock market crash on his mortgage and his job prospects—he told Hodge: "Off and on I am digging out an article on Alaska but the progress is slow—about 11,000 words to date. . . . It may see the light of day if some editor will take pity on me," he continued, "If not it will be a mighty good log of the expedition." It appears that he found no editor to take pity on him, but his Alaskan experiences did not go entirely unregarded. On July 24, 1942, after the United States entered World War II, Hodge wrote a glowing reference for Eastwood to secure him a naval commission, and he cited the younger man's experience as a navigator in the treacherous northern waters of Alaska.[19]

6 Generally Speaking

Whereas the letters, fieldnotes, and other items reprinted in the previous chapters arise out of and specifically describe contact between the project's members and Indian peoples, this final chapter includes documents of a more general nature, all of which feature Curtis as their main source: records of his travels, reminiscences of religious observance, lecture notes on Indian population figures, musings on Indians as a "vanishing race," and the like. However, these too have been selected because they bear upon, and to some degree contextualize or actually represent encounters in the field. In both linking passages and at the end I offer some concluding commentary.

From a Student Newspaper Item, "Curtis Tells of Indian Pictures," 1905

At the behest of Edmond S. Meany, Curtis gave a number of public lectures at the University of Washington in Seattle. The following is an extract from a report in the student newspaper, The Pacific Wave, *of one he delivered in November 1905. As is obvious from its content, this lecture was given before the financial agreement Curtis made with J. Pierpont Morgan. Interestingly, Curtis told the students that, as of that time, it would require a total of "eight years endeavor" to complete his task, which was to "classify Indians pictorially."*[1] *Ultimately, as has been seen, the project embraced much more than just the pictorial element and took vastly longer than eight years to complete.*

I have been working on this series of volumes for eight years, and carried it on as rapidly and thoroughly as money will permit. The plans are that the final publication will consist of approximately 3,000 large pictures in twenty portfolios. Twenty volumes of tens [*sic*] will be bound separately and will contain, as additional illustrations, 3,000 full page engravings.

I am going to tell you a little of this season's work. In the early season I went

to Nespelem, where we dragged poor old Chief Joseph from one resting place to another.[2] From there I went to the Crow Agency in the Valley of the Little Big Horn, a region rich in mythology and legend. In my work, the subjects covered are the location of primitive homes; primitive home structures; the nature of home country; origin story; person of miraculous birth; hair dress, male and female; marriage; sacred powder [sic?]; primitive foods; games; principal ceremonies; burial; medicine men; history of tribe; arts and crafts; clan formation; chiefs and religion.

While with the Crows we made a trip across the reservation to what is known as Black Canyon [see fig. 23]. The canyon is a particularly picturesque spot. We had with us a splendid bunch of Indians, old and young. There was Upsham [sic], an educated Indian. Now, I want to repeat that statement. An educated Indian—the most education to a given quantity of pagan avoirdupois that I have ever seen. But don't presume that he was civilized. You can't, in one generation, civilize the Indian. Give him one coat of educational whitewash at Carlisle, let him graduate with great honors there, then graduate from a large Eastern college; add to that a post graduate course, and years of living in white families; let him live in the married state with an educated white woman, and still he is a pagan through and through, and will die so and go to the god of his fathers [see figs. 4 and 5]. . . .

After we left the Crows, we made a visit to the Sioux of Pine Ridge agency and into the heart of the Bad Lands. The great ceremony of the Sioux is the "Hunka" ceremony [see fig. 13]. In its general features it is the great ceremony of many plains tribes.

I began my southwest work among the Cahullia [sic] Indians in their palm canyon in Southwestern California. This is a wonderfully interesting group and region. Their legends are naturally interwoven with the life of the palm. To them the palm is more than a plant or a tree. It has a life, a soul, a hereafter.

From Albuquerque, New Mexico, we started out among the Pueblos of the Upper Rio Grande. The villages visited were San Ildefonso, Poju [sic], Santa Clara, San Juan, all belonging to the same linguistic group, the Tanon. The Pueblo Indians' life is one vast interwoven network of ceremony, all of a religious nature [see fig. 7], and the greater part secret. I am going to tell you a little of the creation story of this group of people.

They think there is but one supreme being, creator of the universe and its populace, whom he created in his own image. He is called Proseyamo [sic]. . . . He is still alive and upon the earth somewhere in the south, living in the center of a great lake, from which place it is confidently hoped he will return to his people. Poseyamo's first home was in a great lake, Sepofina, in the far, far north, where it was

always dark. In the beginning the earth was completely covered with water, in which lived many fish and water animals. Gradually, the water subsided, leaving bare land, until all that was left was the great lake into which the countless fish had collected. From there Poseyamo created all living things in the animal kingdom, from man to reptile. Game and other animals he made first to spread over the land and make food for the people he was to create. Next, he transformed fishes to people, and, dipping trees and cornstalks into the lake for them to grasp, brought them out upon land. Immediately, the various tribes quarreled and fought. Poseyamo, to stop this fighting, separated them. The warlike, roving Indians he scattered here and there over the plains; the quiet, peace-loving Pueblos he sent far to the South. In one of the villages of the Indians every Saturday night they build a beautiful fire in anticipation of Poseyamo's return.[3]

From Lectures on Indian Population by Edward S. Curtis, 1911

When the U.S. Census figures for 1910 were published, showing what appeared to be an increase in the nationwide Indian population, a minor debate ensued as to whether Indians were a "vanishing race." Of course, the issue of "vanishment" was bedeviled by ideological and other factors. In fact, it was downright confused, and—whichever side was taken—certainly could not be settled by recourse to demographic statistics alone. As Russell Thornton and others have shown, the Indian population most likely did reach a nadir in the 1890s, so the statistical rise by 1910 was significant. However, the degree of the increase's significance could hardly have been measured at the time. Since the North American Indian project was so indelibly associated with the notion of Indian vanishment, Curtis felt compelled to enter the fray in print and in his public lectures. The following constitute extracts from scripts of lectures that were probably delivered as part of the 1911 musicale performances or at the same time as those performances. He sent something of this sort—we do not know exactly what—to Frederick Webb Hodge, for Hodge to check the figures. As delivered there would have been an emphasis on their being grounded in Curtis's own travels and experiences, a feature also of the "interview" with Edward Marshall below. As we know from the field materials reproduced here, the project did have experience in all the regions discussed in the lecture. Curtis said in his letter to Hodge that even in the "White Mountain Apache country," one of a number of "localities which we scarcely think of as having been thickly populated by prehistoric people," "day after day" one "can ride along the streams there and scarcely ever be out of sight of pottery fragments or mounds indicative of old houses."[4]

The Sioux, so well known in history through their numbers and hostility, are but

a small fragment of what they were even seventy-five years ago. It is a long jump from the land of the Sioux to the Stone-house region of the Southwest. First in considering that part of the country, glance at a map published by the Bureau of Ethnology, indicating the area covered by the house ruins of these pre-historic dwellers. It will be seen at once that the area in question is very broad indeed. One can ride month after month across the deserts, plateaus, and mountains, and see the thousands, if not tens of thousands of those ruins of home-sites. Who can form an estimate as to how many ages it would take the present population to build these, if they as a whole devoted their entire time to building. Time would need to be reckoned in geological periods rather than in years.

To sum up this matter of population, deep students of the subject, such as Dr. [W. J.] McGee and Prof. [James] Mooney of the Bureau of Ethnology, would consider a million and a half at the time of the discovery a conservative estimate, and of course, all these were full bloods. Now the census gives a total of 335,000. This by counting all degrees of blood blending, even, as Mooney says, to the one sixty-fourth. And then the further enumerating of thousands of white and negro [sic] blood, who have largely joined themselves to the tribes through indolence or greed. If an accurate census as to mixed bloods could be had, there would no doubt be less than a hundred thousand of the pure stock. Statistics as to mortality and fecundity have in the past been entirely lacking. The last census was made under scientific direction and with all possible care, and with it as a basis further enumeration, if done in such a way as to take advantage of the present careful work, should furnish comprehensive data.

Whether the American aborigines are a vanishing race or not, the vital question is one of culture rather than of numbers. The person with one sixty-fourth Indian blood, who knows no word or tradition of the Indian, can scarcely be counted as forming a part of the Indian race.

Let it be presumed that at the same time of the discovery there were a thousand languages in North America. Probably close to half of those have disappeared, and in fifty years the present number will undoubtedly be reduced by more than half. As to tradition, lore, life, and manners, or in other words, racial characteristics, the student knows that it is useless to talk with men less than sixty years old, which proves that as a race they are almost at the vanishing point.

There is scant comprehension of what the passing of the Indian as a race signifies. Ordinarily the Indians are thought of in a vague way as a nondescript lot of tribes, cultureless, godless, linguistically speaking a systemless language which was everywhere much the same. How many outside of ethnologists stop to consider that in the American Indian we have one of the four Races of Man? How many realize

that among them is represented more than seventy-five per cent of the worlds [*sic*] languages—lingual stocks? How many realize that there were probably among these people one hundred and fifty lingual stocks, each differing from the other as much as the Ayrian [*sic*] from the Indo-Semitic? How many realize that California had 4 times as many lingual stocks as Europe, and that California and Oregon together had as many languages as all of the Eastern Hemisphere, and that many of those languages were, to use the words of E. [*sic*] Max Müller, "more perfect in structure than the boasted Ayrian?"[5]

The final answer to the rise or fall of a race is not had in a census report [covering?] twenty years, particularly when the early census research was admittedly but a makeshift. The group of people contending that the present Indian population equals that at the time of the discovery of America is not recruited from historians and ethnologists, but rather is of those who grasp at thoughts which make startling headlines. It is particularly easy to make a convincing argument on the increasing theory through the widespread and almost universal ignorance of the Indian subject. There is probably no important phase of American life of which people know so little. . . .

Careful study will show that hundreds of tribes or bands existing four hundred years ago are extinct. Let any one of those who proclaims the Indian race is not a dying one, give even a month to a careful study of the subject, and he will forever cease to write in that strain. The serious student of the Indian is constantly face to face with the fact that he is dealing with a life of yesterday—not today or tomorrow. That the reader may have a broad glimpse of the subject, let us first glance at a map of the United States. All admit that in most parts of our country—the noticeable exception is in the desert region of the Southwest where the Indians generally pay no attention to streams or extensive bodies of water—the Indians dwelled on the shores of the ocean and the lakes, and along streams. What Indians now dwell along the watercourses east of the Mississippi river? Practically all that there is to show that primitive Americans have lived there are the shell heaps and a few place names, and here and there a fragment of an arrow-point. Speaking in numbers, to make no mention of culture, what has taken the place of the hundreds of fairly populous tribes dwelling in the eastern part of the United States. We all know that the Indians who lived east of that river have, with the exceptions of a handful here and there of mixed bloods, passed from the face of the earth.

Let us take a far journey to the Pacific coast. Dr. C. Hart Merriam, who has given great labor and time to the problem of the early population of California, claims

for that state a population of 2,500,000 (?) at the beginning of the Spanish contact. 250,000 [*sic*] pure blooded Indians in one state, and the present total population of the country, counting [illegible] is 335,000. Next let us consider the most important stream to the north of California, the Columbia. When Lewis and Clark made their journey of discovery down its lower stretches, both banks of the stream from Snake river to the mouth were dotted with populous villages, many of these quite large. That at the Cascades numbered several thousands, and also at the mouth there was a large population. And what remains of all that life? Two small villages near the Dalles with a combined population of less than 200. Let us continue on to the north and consider the west coast of Washington, and Puget Sound. One hundred years ago the tribes claim to have lost the majority of their numbers by the contact with white men, yet there were in the area named fully 75,000 natives, and today there are scarcely 2,000, (?) three fourths of these mixed bloods.[6]

Let us now consider these northern tribes between the Cascades and the Rocky mountains. [Illegible handwritten additional sentence.] Band by band, tribe by tribe, we have in our field research gone over this area, and it is safe to say that the total population is not more than one tenth that of a hundred years ago. As neighbors of these tribes are the Salish, commonly called Flathead. Their number is now about a fifth of what it was when first noted by the Jesuits. (? look up) Their close neighbors, the Kutenai, are but a mere fragment of what they were when first seen by the Hudson's Bay company explorers. The Piegan, the important western extension of the Algonquian stock, is conservatively estimated at 12,000 when first noted, and they now number some 1,700.(?) The Atsina, another branch of the Algonquian stock, once a strong tribe, now number only 500 or so.

To the east we find the Crows. Counting the two bands of this tribe, it is safe to say that they numbered at the height of their existence, which was perhaps a hundred and fifty years ago, 9,000, and their numbers now 1,700. The combined villages on the Missouri of the Mandan, Hidatsa, and Arikara had a population of at least 9,000 and now there is a total of 1,120.

Curtis was right to see that the rise and fall of a "race" could not be decided using census figures. But this is not, as he thought, because the numerical base line was uncertain but rather because population figures, whether sophisticated or not, can give only a numerical account of people as designated by the census. In fact, in both Curtis's writings and the public discourse of the time on these matters there was a fatal confusion over different categories—biological or genetic inheritance, language retention, cultural patterns, and population statistics. Sometimes these elements were

fused together as if they were all the same *thing, and sometimes they would be pried apart as if they had nothing to do with one another. For example, in Curtis's speech at the University of Washington, Upshaw was presented as a walking contradiction, "an educated Indian," and Curtis was insistent that, for all Upshaw's "education" he could not be "civilized" and would at his death go to "the gods of his fathers." It was as if Upshaw's Indianness—in this case, his heathenness—was indelible, biological, and unaffected by such cultural features as education. Certainly in both Curtis and the dominant discourse of the period a notion of genetic inheritance was held to be the basis of "race": hence the stress on the falling numbers of "full-bloods" and the like.*

Yet in Curtis's writing on population there is also, as we have seen, a contradictory belief: the suggestion that "tradition, lore, life, and manners"—or, as he phrased it, "racial characteristics"—could disappear from the younger generation, presumably as a result of the inroads of "white" culture: "the student knows," he said, "that it is useless to talk with men less than sixty years old." This insight was supposed to prove that Indians "as a race" were "almost at the vanishing point." There is, of course, a sense in which this confusion is an all-too-accurate reflection of the nature and caliber of the culture's thought on "race" at that time.[7] In any case, such prophecies, if indeed that is what they are, did not prove true regardless of how they were conceived. Indian population figures rose through the twentieth century. Ideas of a biological basis to "race" have been largely discredited, but insofar as they persist it would be difficult to apply them to demonstrate Indian vanishment. Despite further "losses" of Indian languages, some of them dramatic, significant numbers of such languages, like their speakers, survive. In terms of culture, however, there has been a deep and profound "loss"—but this is so only if we believe that Indian culture has to be the traditional culture practiced by Native Americans before or at the point of encounter with the Europeanized or "white" world. We must return to these points.

From "Indian Religion," a Lecture by Edward S. Curtis, 1911

The 1911 musicale—with its orchestra, slide show, and movie footage—was, as we have seen, mounted as a way to raise funds and to create publicity for The North American Indian *as a multivolume set. The musicale included lecture material that varied from performance to performance. The following are extracts from a typescript of such material entitled "Indian Religion."[8] It combines, in an interesting way, forms of racism typical of both Curtis and his time with what was then—and should be emphasized—a rare reverence for the spirituality of Native American life. This combination—this tension, in fact—is also graphically visible in the project's photographs (see this chapter's end).*

It is my purpose to bring before you certain phases of Indian religious thought and practice. No effort will be made to formulate an argument, but rather to assemble many fragments.

The average conception of the Indian is as a cruel, blood-reeking warrior, a vigorous huntsman, a magnificent, paint and feather bedecked specimen of primitive man. Of such we have no end of mental pictures, but to the wonderful inner and devotional life we are largely strangers. . . .

Let us consider . . . the Apache—a wild, mountain and desert people, possessing perhaps more of the attributes of the animal than any other tribe. A superficial view of these people would convince one that they were too near the cat family to possess religion, but let us see what are the facts in this instance. The true Apache should awaken before the coming of the sun, that when the golden globe appears at the eastern horizon he can stand facing it, to make his first prayer of the day, and through all the day each act must be preceded by supplication.

An interesting feature of Indian religions is the great number of similarities to all other religious thought. For instance, few tribes are found not possessing a fair creation story. Again, deluge stories are without number. And what ethnologists term the "culture hero"—the person of miraculous birth who comes upon the earth as a savior of his people, and then disappears in a miraculous way—is universal. . . . [A long account of the Apache creation myth.][9]

Indian religious observances, and their ceremonies cannot be separated, as primitive ceremonies were but elaborate prayers to please the divine ones. To such ceremonies the priesthood from time to time added dramatic features, with the double purpose of entertaining the people and impressing them with the potency of the gods. Trickery and jugglery were often resorted to by the priests to further impress their followers. Such practices probably reached the greatest development among the natives of the north Pacific coast, where, in plain view of the hundreds of spectators, men or women were beheaded, or in other instances their entrails removed, and again, people were placed in burial boxes, presumably tightly wrapped with cords, and thrown into a great fire, where the box and contents were presumably burned to ashes, and to add realism to the scene, the person in the box could first be heard screeching and crying, and then, as the box crumbled away the sound grew fainter and died out. These were but elaborately planned and executed tricks known only to the priestly order.[10]

Hypnotism or suggestion has from time beyond reckoning been an important feature of their religious practices. Few if any of the priests have grasped the thought that it is but suggestion, but, like the believers in mesmerism, consider it magic, or

the power going from the practitioner. Many of the novices are, in their quests of supernatural power, self-hypnotized.

Let us consider for a minute the acquisition of spiritual power. It is usually through some great act of devotion, at times taking the form of extreme self-torture, or more often attainment is through long fasting and concentration of thought, this bringing about an abnormal mental state making the brain susceptible of impressions, or revelations, if you like—the Indian calls them visions. Fasting assumes countless forms with the different tribes. In some the old men would go about the camp or village, urging the young men while yet pure to go into the high mountains and fast—"make your bodies clean, and go into the high places where the air is pure, that the spirits will come close to you." Following this, the youth would ceremonially sweat and bathe, in preparation for his vigil.

Before passing on, I want to add a word as to the use of the vapor sweat bath, which is common with so many of the tribes. Sweating is a devotional act with the majority, and while it does purify the body, the thought seems to be spiritual purification rather than physical.

Our novice, after such sweating, goes alone into the mountains, taking with him but a scant blanket to wrap about his loins. Probably he reaches the place of his vigil just before the sun goes down, and, taking a position at the selected spot, he will stand with eyes directed to the disappearing sun. When it is gone he makes a rough couch of boughs, and covering himself with his blanket, prepares to spend the night. It may be autumn, or even bitter winter. If the latter, he will make a tiny fire to keep from perishing from the cold. There is scant hope that visions will come to him this first night, as he has not fasted a sufficient time to produce an abnormal mental state. With the approach of day our devotee will be found standing, facing the coming sun, and as it breaks forth, lightening up the mountains or plain, he implores the spirits for strength and knowledge; and all through the day he faces the giver of light and warmth, and continues imploring divine aid.

As the sun sinks, the fervor of prayer has grown to be one great wail, like the cry of lost souls: "O, Great Mystery! Give me this desire of my heart!" and with the disappearance of the sun, he throws himself upon the earth, faint with fasting, yet imploring divine aid. His fasting is now a matter of thirty-six hours, and his night is apt to be a restless one, with slight chance of visions coming to him. Again with the approach of day, he takes his place, waiting to greet the sun, and as the disc appears at the horizon, he breaks into a wail of supplication. Today he must increase the vigor of his prayer, and perhaps with the coming of the sun he will cut a piece of cuticle from his body, and, holding it in his outstretched hands, cry out,

"O, Sun! I give you of my body, that you may answer my prayer!" If he is a man of great courage he may on this day cut many such particles of flesh from his body, as offerings. Again as the sun goes down he will make a powerful plea for spiritual aid. This, the third night, may bring visions, but more likely not. On the third day he is very weak through his long fast and loss of blood, but with all his strength will continue his invocations and self-torture, carrying it so far as to cut off the first joint of a finger and offering this, that the spirits may come close to him. By the fourth night we must presume that a man would be sufficiently delirious to see visions, but such is not always the case, and I have records of individuals who have fasted as long as eleven days.

At the end of a man's fast, whether successful or not, he returns toward the village, but anxious friends have come out close to his place of fasting, to assist him on his return, as he no doubt lacks the strength to walk any considerable distance. Several instances have been found where devotees have died before reaching their homes. Great care must be exercised in giving them food. An interesting feature of his return is that the devotee finds it hard to bear the odor of what he calls "impure bodies," and it takes days to accustom himself to them.

Prominent and ambitious men are apt to fast many times to secure several spiritual protectors, or if a man failed once he would likely go again in hopes of better fortune. We would naturally expect a man to claim a vision whether seeing one or not, but while some may do this, I believe it is rare, as the man would fear angering the gods by his false claim. I know men who tell me that they have fasted many times, but the spirits refused to come to them.

There are countless other forms of self-torture for spiritual attainment. On the north Pacific coast a man might go into the deep forest, and there make himself a bed of skulls, and sleep for months upon it. Again, he might sleep with a mummy tied to his back, as well as upon the bed of skulls. . . . [A longish description of the exterior features of a Nez Perce child's vision quest.][11]

A description of an actual vision is very difficult to obtain from the Nez Perces, or in fact any Indian. Three Eagles, a splendid informant, says however that the vision appears to the youth in the form of a man, who instructs the child, and further says that the little boy, if he could be seen now, would be lying as if dead, and when he awakens he may think, "I met a man." That is all he would remember.

Here are shown two very interesting points: that the boy, when receiving his vision or revelation, is lying as if dead, and that when he awakens there seems but a vague recollection of what occurred. Both of these statements indicate that the visions are not had while in a natural sleep, but while in hypnosis. In fact, the Indians

continually repeat that it is not in a normal sleep that visions are experienced, but ever state that "I lay as if dead."

This remarkable phase of fasting brings us back to hypnotism. We see here that the child is sent out with definite instructions, and following such instructions, receives the visions as suggested. In other words, the impression or vision received is during an abnormal mental state, and on resuming the normal state there is but the vaguest idea of what occurred while in the trance.

Now let us take up the second phase of this remarkable matter. Our child has now grown to maturity, and by chance or intent enters one of the ceremonial lodges during the great long-house winter ceremony. One of the priests sings a song, which may in a cryptic way refer to the object of the early fasting, and suddenly the youth is powerless to withdraw, and in the briefest time drops down in a cataleptic or hypnotic state. Then, while coming from this state, he is able to recall the former state, and give forth the impressions received in youth.

It is often said of certain tribes that they are sun-worshipers. To call them sun-worshipers is, I believe, in most instances about as nearly right as it would be to call all Christian people cross-worshipers. In other words, the sun is but the symbol of the power. With the Crow Indians of Montana—who possess a wonderfully descriptive language—we find, when analyzing the name of the principal character of their pantheon, that it is "He who sees all things, he who hears all things, he who does all things," and to these people all things, animate or inanimate, possess a spirit counterpart, or, to be exact, it is animism in full flower. The insect, so small that it can scarcely be seen with the naked eye, possesses a soul, and is a part of the great order of the universe. And the same can be said of every plant which springs from the ground, or even the pebble at the brook side.

From "The Vanishing Red Man . . . Discussed by Edward S. Curtis," an Interview by Edward Marshall, 1912

Edward Marshall (1870–1933), who also wrote under the name Davis Edward and whose full name was Davis Edward Marshall, was a friend of Theodore Roosevelt's and one of the earliest to commend the future president's "rough rider" activities in the Spanish-American War. He was a respected Progressive figure, and this aura of Progressivism would have colored the initial reception of the following article-cum-interview. The article appeared in The Hampton Magazine, *a journal partly sponsored by the Hampton Institute, a college established after the Civil War to give a craft education to the sons and daughters of former slaves, together with a number of Indians. In October 1911, in the same letter as the one in which he discussed population*

figures, Curtis told Frederick Webb Hodge that some written material he had asked
his editor to comment upon would be "blocked out . . . in the form of an interview,"
probably for "the New York Herald." He was most likely referring to the textual matter
that follows. [12]

The man who knows him [the North American Indian] in all the intimacy of his
inner life, his one competent historian, critic, admirer and memorialist, the artist
who has fixed his features and his wigwams, his ceremonies and the homely habits
of his daily life imperishably on the photographic plate so that he may not by future
generations be forgotten, misconstrued, too much idealized or too greatly underesti-
mated, has, for this number and the next issue of THE HAMPTON MAGAZINE, told the
story of the Indian and provided for its illustration many of the marvelous pictures
he has made beside the red man's campfires, in the dim shadows of his wigwams,
amidst the tall grass of his hunting grounds, upon the banks of the swift-rushing
rivers which he loves. These contributions must be looked upon as memorable. . . .

The interview which follows accurately summarizes Mr. Curtis's conclusions as
to the Indian's relations to the continent and to the white man, and the white man's
to the red man's.

I asked Mr. Curtis four great questions, the first three of which I shall repeat
at once, with summaries of his replies, as an introduction to the more elaborate
statements following.

"Whence came the Indian?" was my first question.

"That no man living knows, though many have had theories," said Mr. Curtis.

"What was he when we found him?"

"A fine race, in the usual sense of the term, developing along worthy lines in
certain sections of his country, nowhere without his noble traits; perhaps the most
admirable primitive of the world."

"What might we have made of him?"

"An ingredient of great value in the foundation of a new American race."

"What did we make of him?"

"We destroyed his tribal entity and scattered his people to the winds; we weakened
him by introducing disease and drink, and made him largely useless to himself, to
us and to the world at large."

And as my first question had been "Whence came he?" I made my last one
"Whither goes he?"

I cannot summarize his answer. It was, itself, a summary—a terse, dramatic,
dreadful summary. I shall reserve it for the last line on my final page.

[Marshall then quoted Curtis's full response to his question about Indian origins, concluding with a brief summary of Indian "progress" at the point of European discovery of the New World, first South, then North America.]

Turning from Southern to Northern America, we find that, at the time of the discovery, the important Atlantic Coast tribes of the Algonquian stocks were both agriculturists and hunters. The Seminoles, of Florida, were wearing tunic-like garments, reminding us of Roman costumes.

Branches of the Siouan stock had migrated from their early southern habitat to the North Atlantic Coast, thence reached into the region of the Great Lakes, and later passed southward and westward to the buffalo plains beyond the Mississippi River. The Mandans, another branch of the Siouan stock, and the first to reach the upper Missouri plains, were well established there, dwelling in earth-and-timber houses, cultivating crops and hunting buffalo. They were worshipers not alone of the divine ones who ruled over game, but also of the spirits of plant life.

The tribes of southern Arizona [the Pima, Yuman peoples, and others] lived in massive structures built of kneaded clay and grouped into important villages; they practiced agriculture with the aid of irrigation and had aqueducts miles long, suggesting no mean engineering skill.

The "Stone House People" [the Pueblos, Zunis, and Hopis] of what is now Arizona and New Mexico were agriculturists of marked ability. With shaped stones they had built homes and sanctuaries, sometimes carrying them to several stories in height. Thousands of such substantially built structures had served their day of usefulness, had been abandoned by a dying or migrating people and were already crumbling into ruin on the day of the white man's discovery of the Americas. The people of this "Stone House Region" doubtless possessed a remarkable ceremonial and religious life and were skilled in handicraft.

The coast-dwelling tribes of the North Pacific region [Coastal Salish, Nootkas, Kwakiutls, and other peoples] were, when Columbus first sailed westward, living in large community structures of hewn planks and going out upon the sea in canoes, both large and small, for the capture of fish, seal and whale.

Thus it may be said, in answer to your second inquiry, "What was he when we found him?" that the Indians at the time of the discovery were a fine race, in many ways progressive and progressing; full of great potentialities.

In elaboration of his answer to my third question, "What might we have made of him?" Mr. Curtis, whose long and close association with the Indian has made him his intense admirer, told me: "We might have made of him a racial ingredient of inestimable value to us and to the world, had we not instead, shortsightedly,

sentenced him to death, and, directly or indirectly, put this sentence into operation. We debauched, infected and slaughtered him."[13]

[Curtis, according to Marshall, then elaborated further upon this theme, before closing on his fourth answer.] Mr. Curtis spoke at length and with much feeling. He knows. His contact with the Indian has been sympathetic beyond the possibility of any contact of officialdom with him; he knows him in the North and in the South; knows what is left of him in Middle West and East. . . . He has slept in his tepees and eaten with him, has trusted him, has been trusted by him; he knows his legends, his religions and his music; he has heard his melancholy history intoned at dying council fires through the thin lips of old men, his futile aspirations, his unrealized ideals, the whole somber tale of his tremendous disappointments; he has been behind the scenes the while upon the stage of the sparse, narrowing Indian domain in the United States—domain? ah, no; retreat!—the final act of this extraordinary, harrowing drama has been in course of presentation. It has been this man's pathetic privilege to listen to the last, despairing cry of many a once great but now decaying chief: "Woe! Woe to me and my lost people! Woe!" And more than once has Curtis knelt beside a weary, stoic chieftain as he died.

"We have made of him," he said, "a race totally discouraged. We have robbed him of the last thing which, through ages of association and race-building, he had learned to love. Think of it, the melancholy of it, for the Indian and for his conquerors! He knows well that, as he now is, after the century and more of wrong we have inflicted on him, he cannot adjust himself to the environment we press on him, he has been handled very maladroitly and is perfectly aware of it, and is tortured by it. But forced to the wall with no escape, he has accepted his dull fate with the grim stoicism of his race, and has ceased to try to combat or avert it. Our efforts to extend assistance to him have been insincere and he has known it; linked, unwillingly, with cupidity and stupid lack of understanding, even the work of those few honest men who really have tried to help him has been wasted—has been worse than wasted, for it has been harmful [and so on]."

"We have wronged the Indian from the beginning. The white man's sins against him did not cease with the explosion of the final cartridge in the wars which subjugated him in his own country. Our sins of peace . . . have been far greater than our sins of warfare. . . . This was true at the beginning of our occupation of the country; it was true of the Nez Perce War, fought in the early seventies, and one of our last blows at Indian resistance. This struggle was fomented by crude liquor sold to Indians by white men at a time when those who bought it had already been half-crazed by our injustice. The Indian spirit, as a whole, had long before

been crushed; that forced war crushed the spirit of the great Nez Perces nation. In peace we changed the nature of our weapons, that was all; we stopped killing Indians in more or less fair fight, debauching them, instead, thus slaughtering them by methods which gave them not the slightest chance of retaliation."

"But it is said," I interposed, "that the Indian population of this country is increasing. Official figures show it."

"Facts do not," said Mr. Curtis. "Experts sometimes try to answer the most important question regarding a race without sufficient study. All the early enumerations of the Indians were mere guesswork. Three census reports cover twenty years. Can you get the facts about any people in the span of twenty years when the first count, which must be the basis of investigation, is admitted to have been a mass of errors? Statements that the Indians are increasing, rather than decreasing, in their aggregate of number, have been based upon inaccurate figures." [Curtis continued much in the same vein as the lectures he gave on population statistics.] There are not, in fact, to-day, upon the Continent of North America, 100,000 full-blood Indians, hence it is not difficult for one to draw a conclusion."

(*In the next issue of the* Hampton Magazine, *Mr. Curtis will go into further detail of this tragic story of the rise and the decline of a great race, taking up, among other things, the matter of possible remedies for the great wrongs we have done the Indian. He will discuss the admirable domestic customs of the people whom we have displaced, showing that white men and women might learn something with advantage to American morals, and that white parents might learn something with advantage to American childhood; and he will briefly and dramatically indicate the inevitable nature of the last act of the great tragedy.*)[14]

It is noticeable that all of the images accompanying this "interview" with Edward Marshall seem, in this context, even more freighted with notions of Indians as a disappearing, racially doomed people, than they do in The North American Indian *itself. There is not the space here to go deeply into the ideology of the vanishing race. We have already met a number of versions of Curtis's word-based formulations of it in these final texts. Here is a further one: "The Indian, one of the four Races of Man, is fast disappearing from the earth. In a few brief years he will be but a tradition." The sentiment was, of course, not unique to Curtis; it was a cultural assumption. William Henry Holmes, the artist, anthropologist, and one-time chief of the Bureau of Ethnology, wrote to Curtis using parallel words: "your idea is a grand one—the preservation for the far future of an adequate record of the physical types of one of the four races of men, a race fast losing its typical character and soon destined to pass*

completely away." Suffice it to say that it was not only a common cultural assumption: it also became a visual *trope.*[15]

We see it deployed by a host of photographers of Curtis's time. Indeed, perhaps the most plangent images of Indians as a vanishing race were not produced by Curtis, but by someone who photographed him *(see fig. 2): his acquaintance and stylistic imitator, Joseph Kossuth Dixon. Dixon worked on a series of "expeditions" funded by the heir to the Wanamaker department stores in Philadelphia and New York. In Dixon's "Sunset of a Dying Race" (made at some point after 1908), the be-feathered horseman, his back to the viewer, is still—as any figure in a photograph must be—yet he is also in motion, moving away from us, riding toward the effulgent circle in the sky, as if he will be taken* up *into the heavens. In Marshall's commentary on his interview we read that, at the outset of his project, Curtis "forthwith assumed the additional burden of the preparation of a document which should forever be a monument to the aborigines of North America." The many famous Curtis images accompanying the interview, several of which are given new, unfamiliar titles—including "The Three Chiefs" (1900), "The Potter" (1906), and even "The Fisherman—Wishham" (1909), which shows a powerfully built man outlined against the turbulent Columbia River— are made to seem not at all moments redeemed from the onrush of time but rather as items rescued from a time* already *passed: obituary photographs literally framed in black, as if their subjects were all well and truly dead.*[16]

Marshall's 1912 interview, like the other texts reproduced in this final chapter, shows that at heart Curtis thought that the only true Indians—or, at least, the truest Indians—were those who lived a traditional, precontact lifestyle. Curtis could not bring himself to see Indians as fully part of—certainly not constitutive *of—the modern, bustling world. The final chapter of my earlier Curtis study,* Edward S. Curtis and The North American Indian, Incorporated, *aimed to elaborate just how, and why, they were represented as Other. Yet, as I intimated when I wrote the conclusion there, the Native inhabitants of* The North American Indian *and other products of the project cannot* simply *be consigned to the category of Other. My current view is that Curtis sometimes came to a sort of middle point, acknowledging what we might call Indian antecedents. In the Marshall interview he even speculated on the good Indian characteristics that might have flowed into the new American "race," had widespread white-Indian intermarriage occurred: "We might have made of him [the Indian] a racial ingredient of inestimable value to us and the world, had we not . . . sentenced him to death."*[17] *That is, in a formulation such as this he escaped the full rigidities of his time's biological racialization.*

In this respect a parallel figure in the American twenties was the writer Mary Austin,

who claimed that modernist American poetry could—and should—trace its lineage back to American Indian forms. In effect she and others like her, such as Carl Jung, propounded a kind of geographical determinism which produced some interesting— and some absurd—notions. One such notion was that skyscrapers were a logical and seamless progression from Pueblo multistory dwellings. Another was that "American" faces would gradually become more Indian-like. We could say that for Curtis, as for Austin, Indians were—if I may borrow anthropologist Robert Heizer's neat phrase— "almost ancestors." Curtis continued to believe in the inevitable demise of Indian peoples, even in the 1912 interview. "The Indian," he said, "has accepted his dull fate with the grim stoicism of his race."[18]

However, on another level Curtis probably intuited that this demise was not—and could not be—inevitable, could not be the only tellable story. Some of his images testify to this. At the most mundane level there are pictures such as "Modern Chemehuevi Home (1906; see fig. 24) and "Modern Yurok Home" (1923). When confronting California Indian cultures that had been so terribly decimated, such as the Chemehuevi and Yurok, Curtis had to incorporate "modern" features if he was to photograph at all. But another purpose of such images was, precisely, to register the "loss" of typical traditional Indian "characteristics"—in shelter construction, as in everything else. But of course an image like "Modern Chemehuevi Home" does not show "loss" or, rather, does not show only "loss." It shows dynamic change and acculturation, or what Mary Louise Pratt, in her book Imperial Eyes, calls "transculturation" in the "contact zone."[19]

The portraits are, I think, less ambiguous. Let us look at the depiction of the unnamed Yokuts man in "A Chief—Chuckchansi" (1924; fig. 19). The caption grants him a status among his people, but he is nevertheless anonymous, and his shorn hair could be read adversely as a sign of cultural loss just as easily as it could be read positively as a sign of transculturation. Surely the overwhelming effect of the portrait, something much more important than its ethnographic information as such, is that it counters notions of vanishment by the power with which it evokes a consciousness of being itself that might be taken loosely for "soul." We may bear witness to the same effect in the portraits "One Blue Bead" (1908; fig. 25), the likeness of a middle-aged Crow, and "Kenowun" (1927; fig. 21), the portrait of a young woman from Nunivak in all her finery. These two portraits in particular do not appear to be of figures who were recognized as in possession of social prestige in the world beyond their own tribal territories or, unlike the Chuckchansi chief, even within their respective home territories (Crow country and Nunivak). Indeed, The North American Indian, for which their likenesses were made (even if they were not used, as in the case of One Blue Bead) has nothing to say about them. In one of his essays Curtis claimed that his portraits caught and presented "the

soul of the people."[20] *This was, of course, an unrealizable aspiration for any picture, which must in the end grant us not reality but a representation. Nevertheless, in the haunting intensity of One Blue Bead's image a powerful* presence *is evoked. And a viewer's eyes can hardly not be held by the slightly smiling interest of Kenowun's gaze, which passes literally through her labrets and other facial adornments. These adornments possibly "tell" us something about her cultural practices, but we also see what she shares with others, her common humanity. In the Curtis photographs, as in these written documents of American Indian encounters, Native people frequently vanish, but they also* live.

Notes

PRELIMINARIES

1. The works referred to here are Curtis 1907–1930; Curtis 1997; Gidley 1976; and Hausman and Kapoun 1995. Anne Makepeace was able to capitalize on the success of her film to produce in 2001 a popular biographical study of Curtis that also contains, though without identifying citations, extracts from a number of unpublished documents. The www site referred to is *http://memory.loc.gov/ammem/award98/ienhtml.*

2. *Edward S. Curtis and the North American Indian, Incorporated* is Gidley 1998a.

INTRODUCTION

1. Curtis, *NAI* 1 (1907):preface; subsequent quotations from *NAI* will be referenced only as necessary (e.g., quotations from captions to pictures will be found on the caption list accompanying the relevant volume). For a full analysis of the North American Indian project see Gidley 1998a; uncited information hereafter was taken from this source. There is also relevant information and commentary in earlier accounts, especially Andrews 1962; T. C. McLuhan's biographical essay in Coleman and McLuhan 1972; Graybill and Boesen 1976; Lyman 1982; Davis 1985; and Makepeace 2001. Curtis's film was edited and reissued, with sound, as *In the Land of the War Canoes* in 1973; see Holm and Quimby 1980.

2. A small selection of writing on the literature of encounter would include Asad 1973; Said 1978; Fabian 1983; Gidley 1992; and Pratt 1992. For such writing with particular reference to American Indians see Berkhofer 1979; Dippie 1982; Liebersohn 1998; Murray 1991; Pagden 1993; and Todorov 1984. My own previous work on this aspect of Curtis's work includes the introduction and chap. 9 of Gidley 1998a; and Gidley 2001.

3. On Curtis and pictorialism see DeWall 1980, especially chap. 3; and Gidley 1993. See also Coleman 1998.

4. The account of the Klondike gold rush is Curtis 1898. For more on the Harriman Expedition see Goetzmann and Sloan 1982; the contemporaneous narrative of the expedition is Merriam 1902. For an image of Indians made by Curtis during the Harriman Expedition see fig. 20 here.

5. See, e.g., Grinnell 1892 and 1889. For Curtis family lore see, e.g., Andrews 1962:114–115.

6. Grinnell 1905.

7. Letter from Curtis to Hodge, October 28, 1904, Hodge Collection. The interaction of Curtis, Morgan, and Morris is treated at greater length in Gidley 1998a:chaps. 1 and 4. Later, in 1911, Morgan Bank interests appointed Morris as vice president and one of three directors of The North American Indian, Inc., the company established in 1910 to run the financial affairs of the project.

8. Letter from President Theodore Roosevelt to Curtis, February 6, 1906, Roosevelt Papers.

Much of the unfolding Curtis-Morgan financial relationship is documented in the Curtis materials deposited in the Pierpont Morgan Library, New York City.

9. See Mick Gidley, "Edward S. Curtis's Indian Photographs: A National Enterprise," in Gidley 1992:103–119; and Marshall 1912, especially as excerpted in chap. 6 of this book. For more on the Curtis family relationships see Graybill and Boesen. I am also indebted to the late Billy Curtis Ingram, interviewed in August 1977.

10. Further information on some of these topics may be found in Curtis 1914a and 1915; Gidley 1987; Holm and Quimby 1980; and Gidley 1982a; and scattered through Gidley 1998a.

11. See Hodge 1910. For more on Hodge see Gilb 1956; and Cole 1957. For Hodge's intervention in the production of *NAI* 19 (1930), see Graybill and Boesen:94–95, 106–107.

12. Some of Upshaw's father's deeds are recorded in *NAI* 4 (1909):18–20. Information on Upshaw himself came from Littlefield and Parins 1981:170, 303; Upshaw 1897; from interviews with Florence Curtis Graybill in December 1976, and with Harold P. Curtis in February 1977; and from unpublished data by W. W. Phillips in the Phillips Papers. There is further treatment of Upshaw in Gidley 1994. For appreciations of the ethnographic quality of *The North American Indian* see, e.g., Lowie 1909:185, 192; Lowie 1935:355; and Ewers 1955:109, 234.

13. Upshaw's contribution to the project was acknowledged in *NAI* 7 (1911):preface. The Mandan escapade was remembered by Curtis in a reminiscence quoted fully in Andrews 1962:39–42. The manuscripts of *The North American Indian* were examined in the Los Angeles County Museum of Natural History in 1978. A note on Upshaw's White House visit appeared in the *Washington Post*, March 26, 1909 (reproduced in a Curtis publicity brochure titled *The North American Indian*, n.d. [c.1911], author's collection).

14. For more data on Phillips see chap. 2. Hodge quotation is taken from Gilb 1956:104. Numerous letters from Myers to Hodge can be found in the Hodge Collection, while much evidence of his textual work can be found in the manuscripts of *The North American Indian* housed in the Los Angeles County Museum of Natural History. An interesting theoretical work by Myers is reproduced in Gidley 1998a:160–162.

15. Evidence for many of these statements may be found in Gidley 1998a:chap. 5.

16. Florence's comment is in Graybill and Boesen 1976:30. There are several of Myers's letters to Newcombe in The Newcombe Collection in the Provincial Archives, Victoria, British Columbia, and exchanges of correspondence between Myers and a number of Berkeley anthropologists in the Museum and Department of Anthropology Papers, University Archives, Bancroft Library, Berkeley. Other information gleaned from the *San Francisco City Directory* and San Francisco telephone directories, the *Sonoma County Directory*, the *Petaluma City Directory*, from Myers's death certificate issued by the State of California Bureau of Vital Statistics, and obituaries kindly obtained by Dennis Anderson from the *Santa Rosa Press Democrat* of May 1, 1949, p. 10a, col.3, and p. 10a, col.6.

17. Truettner 1990. See also Gidley 1992:103–119.

18. For relevant ideas of race see Gossett 1965, especially chap. 10, 13–16; Dippie 1982; and, particularly, Gidley 1999. For pictorial effects see Lyman 1982; Gidley 1993; and Gidley 2003.

19. See Momaday's preface to Cardozo 2000. See also chap. 6 here; and Gidley 2003.

20. Sources on Indian resistance to white expansion and the introduction of the reservation system are too numerous to cite adequately. I have used a popular account, Brown 1971, which, supplemented by primary research, is also the source for other uncited points in the following paragraphs. Speckled Snake's speech is reprinted in Turner 1974:249–250.

21. See Brown 1971:331–349; and Sandoz 1953.

22. Royal Commission quotation taken from Kew 1990:160.

23. Material on the Colville Reservation here and in subsequent paragraphs parallels some deployed in Gidley 1979.

24. Information on the reservation experience is extensive; useful studies relied upon here and in subsequent paragraphs include Prucha 1984; Hoxie 1989; and, for conciseness, Washburn 1988:51–81. For specific examples in British Columbia see Kew 1990.

25. Atkins, "Annual Report of the Commissioner for Indian Affairs," as quoted in Gidley 1979:44.

26. Morgan, "Annual Report of the Commissioner for Indian Affairs," as quoted in Gidley 1979:52.

27. Brandon 1964:364.

28. For a discussion of Curtis's essay hostile to Indian ceremonial practices see Gidley 1998a:260–264.

29. Though not treated in this overt way or in this order, there is some discussion of each of these phases scattered throughout Gidley 1998a. For more on the musicale see Gidley 1987. On *In the Land of the Head-Hunters* and Hollywood see Holm and Quimby 1980; and Gidley 1982.

30. Myers to Hodge, n.d. 1926 (received March 26), Hodge Collection.

31. "Village Tribes" is Curtis 1909b, and these peoples are treated in *NAI* 2. For the Hopis see *NAI* 12, and, for extracts from the script of the musicale containing Curtis's reminiscences of the Snake Dance, see Gidley 1987:78, 81–82. Similarly, for the Navajos see *NAI* 1; Gidley 1987:79–80, 82–83; and Faris 1993.

32. From the musicale script, as quoted in Gidley 1987:82.

CHAPTER 2

1. Information on Harold P. Curtis is taken from: an interview with him in January 1977, interviews with Florence Curtis Graybill in August 1977 and thereafter, an interview with Billy Curtis Ingram in August 1977, and a letter from Jim Graybill, Florence's son, to the author, dated August 21, 2000. These personal communications were supplemented by material found in various primary documents and in Boelter and Hull 1966; Andrews 1962; and Graybill and Boesen 1976.

2. The Westerners' publication is Boelter and Hull 1966. Harold's account is from an untitled typescript in the Karl Kernberger private collection; it represents the typed part of a much longer account, the rest handwritten, attributable by internal evidence to Harold P. Curtis.

3. While other documents mention Justo the cook, there is no record of ethnologists named Stewart and Lang ever working for the North American Indian. Either Harold misremembered or he deliberately fictionalized the names of, in all probability, W. E. Myers and W. W. Phillips,

perhaps because, unlike Upshaw, they were believed to be alive at the time of the writing. For further information on Upshaw see the introduction here; and Gidley 1994.

4. The reference here is to John G. Bourke's *On the Border with Crook* (1891). Corydon Eliphalet Cooley was the kind of figure evoked by Harold Curtis. He had been chief of scouts in the 1872 campaign against the Apaches and in 1882 had served as interpreter for Crook. Cooley was married to a daughter of Chief Pedro of the Coyotero Apaches, and his ranch had often served as a haven for Apaches not involved in hostilities. See Worcester 1979:248–259. Cooley was also credited with winning the site of the present Arizona town of Show Low in a poker game—hence its name.

5. Cf. the title ("Hunting Indians with a Camera") of Edmond S. Meany's Curtis-inspired article on the North American Indian project (Meany 1908), partially reprinted in the Plains chapter here. Note that the ages given here, fifteen and forty, were both advanced, that is, either fictionalized or misremembered.

6. Information on Phillips taken from an interview with his son, Wellington S. Phillips, in August 1978 and from correspondence with his grandson, W. W. Phillips III; corroborated by data in the *Seattle City Directory* and University of Washington records. The extract is taken from a typescript in the Phillips Papers.

7. For more on the musicale and its publicity purposes see Gidley 1987. In a section omitted here from this "chapter" of the account of the project, Phillips said the events took place "early in 1906." However, a letter from Phillips to E. S. Meany indicates that he did not enter Apache country until June 1906, well into the season (Phillips to Meany, June 1, 1906, Meany Papers). Also, since there is relatively little mention of Curtis—and none in the portion reproduced here—it is more likely that these events took place in 1905 or 1904; or, again, Phillips may have conflated events from different years.

8. Gray Oliver went unmentioned in *NAI* 1 (1907) itself.

9. Phillips's typescript footnoted *NAI* 1 accounts of each of these topics, as if the data given there was that which had been gained, or partly gained, from Goshonne. This probably was the case— but see also the succeeding account by Curtis. "Messiah Craze" refers to the nativistic Daghodigá movement, which was active among the Apaches between 1903 and 1907.

10. Curtis was evidently pleased with his party's acquisition of data on the Messiah Craze while it was still in full swing (see Curtis's letter to Hodge cited in note 12) and it is strongly featured in *NAI* 1:42–46. However, while Das Lan was rendered fully in that text, Bizhuan went totally unmentioned.

11. This was reproduced, though not attributed to Bizhuan, in *NAI* 1:36–37.

12. The *Scribner's* article is Curtis 1906:513–529. The letter is Curtis to Hodge, July 9, 1906, Hodge Collection (MS.7.NAI.1). The document was taken from an untitled typescript in the North American Indian Papers. This extract, and a number of variations of it, was probably composed as preliminary script material for the musicale tour (see Gidley 1987). The later memoir material appears, for example, in Andrews 1962:28–29 and, especially, Graybill and Boesen 1976:22–26; both of these are reliable versions of extant typescripts.

13. John G. Bourke's writings on Apache religion alone, published the previous decade, run to more than 170 pages (Bourke 1891 and 1892); see also Reagan 1904. I am grateful to Christian Feest for bringing these references to my attention.

14. Unless either Phillips or Curtis was being remarkably cynical, this "dumb" interpreter must have been someone other than Gray Oliver.

15. See *NAI* 1:23–42. Various typescripts in the Kernberger collection titled "Indian Religion" include longer versions of this mythological material; some of the nonmythological data is reproduced here in chap. 6. Aspects of this unseemly trading are treated in Gidley 1994.

16. Curtis, of course, exaggerated in saying that "no further information was gathered on Apache religion," but it is interesting that as late as 1970 Keith Basso pointed out that information on precontact Western Apache religious beliefs was "very incomplete" (Basso 1970:15).

17. Quotation on Strong is taken from an anonymously authored article, "Instructor Leaves about February 8," in the University of Washington student newspaper, *The Pacific Wave*, vol. 16, no. 67 (January 22, 1909), p. 4. In fact, *NAI* 17 (1926), on which Strong worked, does contain many references to Spanish historical documents. For a fuller treatment of the project's relationship with and representation of the Pueblos see Gidley 1998a:chaps. 6 and 11. Myers's comments on the Pueblo people appear in his letters to Hodge of, respectively, June 21, December 12, and September 21, 1924, Hodge Collection.

18. Curtis to Hodge, September 18, 1908, Hodge Collection. The article, much of which is reproduced here, is Curtis 1909.

19. For Cushing and Stevenson on the Zuni, see, respectively, Green 1979 and Stevenson 1904. Cushing and Stevenson were in fact rivals, representing very different approaches to ethnology, an issue clarified by Pandey 1972.

20. Some of the rest of "Among the Tewas" is reproduced in Gidley 1998a:chap. 6. For more on Southwest ruins and population statistics, see the extracts from Curtis's lectures on population in chap. 6 here.

21. Sojero—with whom (as is recorded in another section of the memoir not included here) Phillips struck up an excellent working relationship—went unmentioned in *NAI* 17.

22. In the San Juan Range of the Rocky Mountains there are many ancient Anasazi sites within striking distance of San Juan pueblo. Despite the clearly remarkable extent and good state of preservation of the particular ruins visited by Phillips on this occasion, it has not proved possible to identify them precisely, and *NAI* 17 gives no clue. Following the "discovery" of Cliff Palace at Mesa Verde, Colorado, in 1875 and of other spectacular Anasazi ruins thereafter, there was both genuine archaeological and more journalistic interest in locating further such finds. For a popular account see Ceram 1971, especially 159–165.

23. Unfortunately it has not proved possible to trace any of the Penitente photographs referred to here. For more detailed treatment of the Mexican life of northern New Mexico see Weigle 1976 and the novel *People of the Valley* by Frank Waters (1941).

CHAPTER 3

1. "Did You Ever Try to Photograph an Indian?" *Sunday Call*, October 14, 1900, taken from a clipping in the Southwest Museum, Los Angeles. The Curtis family view, together with a reminiscence of the sun dance written or dictated by Curtis many years later, may be found,

for example, in Andrews 1962:23–24, 114–115. For contemporary corroboration of early Blackfeet experiences see Metcalfe 1904–5:13–19.

2. Curtis did indeed win prizes at such conventions, including the one at Indianapolis in 1900, which also led to a laudatory review by the doyen of San Francisco photographers at the time, Arnold Genthe. See Genthe 1901.

3. The matter of payment for information and pictures is more complicated than the bare bones of this newspaper item suggest. For a detailed commentary on it see chap. 3 of Gidley 1998a.

4. For an extended, illustrated account of the Piegan sun dance, see *NAI* 6 (1911):31–58. White Calf's portrait—wigless and "appropriately" dressed—also appeared there, but Small Leggins went totally unmentioned. However, in a caption for the famous image "The Three Chiefs," when it was printed in Curtis's Plains essay for *Scribner's*, Small Leggins is named one of the chiefs. See Curtis 1906b:663.

5. Phillips, "With the Cheyennes," typescript in the Phillips Papers. Fieldwork was conducted among the Cheyennes over the course of several different years, but 1905 seems the most likely season for these particular incidents.

6. The mention of "Carlisle" here is a reference to the famous Indian boarding school in Carlisle, Pennsylvania, which was also attended by Upshaw. It was run by Richard Henry Pratt in such a manner as to "assimilate" Indians as rapidly as possible, clearly to no avail in the case of this man. It has not proved possible to identify him by name.

7. These healing practices, especially the sucking, seem typical of Cheyenne medicine of the period. See Stands in Timber and Liberty 1998, especially 107–114.

8. The physical hunger of the Cheyennes evoked by Phillips here was not a unique experience during this period. Plains Indians had not yet adjusted to a life of farming rather than hunting, and frequently rations promised by treaty failed to arrive or were confiscated by corrupt agency personnel before reaching their charges. Harold P. Curtis reported in an interview with the author in February 1977 that he, too, remembered starvation on the Plains among the Sioux, in either 1905 or 1907.

9. The extract is taken from Curtis 1906b.

10. For more discussion of Curtis's views on Indian demise see Gidley 1998a, especially 31–32 and 280–83; and chap. 6 here. Needless to say, Curtis was wrong in his predictions about the Crows.

11. In the Sioux volume of *NAI* (*NAI* 3 [1908]:45–50), there is extended treatment of the Custer battle, drawing on work with a variety of Indian informants and probably carried out both before and after the 1906 *Scribner's* article. It conveys the strong implication that Custer both let down his men and wagered for glory. Curtis gave newspaper interviews that reported the same controversial message. For more evidence, and commentary on it, see Gidley 1998a:181–183.

12. Curtis's emphasis on ranking and judging different tribal "types" by physique and cultural attribute, a habit so common among anthropologists of his own time, is now thoroughly discredited.

13. Interestingly, and perhaps because of the perception that more prominent elderly Sioux survived than did the major figures of other groups, *NAI* 3 was given a slight change of format that permitted the printing of a series of orally collected biographies of such figures as Red Cloud (see

NAI 3:187). The material in that oral history, in turn, gives but an intimation of Red Cloud's role in the politics and warfare of Indian-white relations on the Plains; an accessible account may be found in Brown 1971:121–146.

14. Phillips's account, titled "Through the Country of the Crows," is partly reprinted in Gidley 1998a:96–100. Gidley 1998a also contains sustained discussion of the relationship between travelers' tales and ethnography (89, 172–176).

15. For a fuller treatment of Meany see Richards 1975 and Gidley 1981:8 10 and passim. The Meany Papers contain much evidence of Meany's links with and fieldwork for Curtis. The most relevant of Meany's newspaper pieces, originally published in the *Seattle Sunday Times* on August 11, 1907, was found in an advertising brochure for *The North American Indian* (n.d.[c.1910]), author's collection. The article excerpted here is Meany 1908.

16. Many of the photographs and much of the data that the project obtained among Red Hawk and his folk did duly appear in *NAI* 3 later in the same year.

17. Letter from Myers to Hodge, January 14, 1908, Hodge Collection.

18. The Foster Parent Chant account appears in *NAI* 3:71–87. See also a letter from Myers to Hodge dated October 30, 1908, Hodge Collection. Other examples of Myers's ethnological inquisitiveness and ability to assimilate data may be seen in his letters to Hodge dated November 17, 21, 22, 25, and 28, 1908, Hodge Collection.

19. Curtis letter to Meany, July 31, 1908, Meany Papers. In later life Curtis remembered Dalby much less charitably when (without naming the younger man) he told Harriet Leitch of the Seattle Public Library that when Dalby had complained of mosquitoes he had said, "If you can't stand the mosquitoes it won't take you but two days to walk out to the railroad." Edward S. Curtis file, History Department, Seattle Public Library. Dalby's letter to Meany dated August 5, 1908, Meany Papers, and Meany's letter to Dalby, August 13, 1908, Dalby family papers.

20. General information on Dalby is taken mainly from an interview with his son, Fritz Dalby, in August 1978, and from access to the Dalby family papers in his possession. Additional information comes from Gilbert Costello's "Scrapbook of the Seattle Press Club," vol. 23, p. 36, Seattle Public Library; and from "Ed Dalby will Gather Material for Curtis," *Pacific Wave*, vol. 16, no. 59 (January 8, 1909), p. 1. Some of the data collected by Dalby among the peoples mentioned in these exchanges probably did find its way into the relevant volumes of *NAI*, namely vol. 3, published at the end of 1908 (which covered the Yanktonai and the Assiniboin, as well as the Teton Sioux), and vol. 5, published in 1911 (which treats the Mandans, Arikaras or "Rees," and the Atsinas).

21. Curtis letter to Hodge, November 16, 1908, Hodge Collection. Unfortunately Hodge's reply does not appear to have survived. Information on Haddon is taken from Quiggan 1942; Haddon's own summary of his reading and a 1901 journey to the United States (Haddon 1902); an unpublished paper by Haddon titled "The Morning Star Ceremony of the Pawnee," Haddon Papers; and other unpublished items in the Haddon Papers.

22. On Haddon at the AYPE, see Rydell 1984:199. From a letter by Osborn to Haddon of April 11, 1893, Haddon Papers, it is clear the two had known each other well for some time. Curtis to Hodge, November 18, 1908, Hodge Collection. Also, in an undated letter to Dalby, Curtis urged

that they should do their best to please Haddon, adding, "he would be with you but a couple of weeks so it won't seriously interfere with your work" (Dalby family papers). Haddon letter to Wissler, November 17, and Wissler to Haddon, December 2, 1908, File 110, Anthropology Department Archives, American Museum of Natural History.

23. Information from de Brigard 1973:4–5. Also, Haddon's affection for photography was so well known that for his eightieth birthday in 1935 some ten thousand photographs, many of which he had either collected or taken himself, were deposited in the Haddon Library of the Cambridge University Museum. The letter that advocated W. H. R. Rivers's system, undated, is in the Dalby family papers.

24. From a clipping, unidentified, dated July 17, 1909, envelope 14, Haddon Papers. A letter from Curtis to Hodge of July 13, 1909, Hodge Collection, indicated that Haddon was to be with him from July 20 to September 5; also, Dalby confirmed part of this arrangement in a letter from Dalby to Haddon, July 12, 1909, Haddon Papers. See Quiggan 1942:136 for the police raid yarn, corroborated by Fritz Dalby's memories of his father's tales (letter from Fritz Dalby to the author, October 14, 1977). Haddon's help while among the Kutenai was acknowledged in the introduction to vol. 7 of NAI (1911). "Indian Ethnological Expert Begins to Study Blackfeet," *Christian Science Monitor*, September 2, 1909, quoted fully in one of the publicity brochures issued by the North American Indian, Inc. titled *The North American Indian: Extracts from Reviews of the Book, and Comments on the work of its Author, Edward S. Curtis*, n.d., author's collection. This report also says that Haddon was impressed by the "beauty" of Curtis's pictures. If Haddon did take measurements, they have not survived.

25. Curtis letter to Haddon, November 2, 1909, Haddon Papers.

26. McGee's review is McGee 1910. Curtis letter to Haddon, December 23, 1909, Haddon Papers. Hodge was promoted to head the Bureau of American Ethnology and Holmes became director of the National Museum.

27. The "Soul" piece is Haddon 1914. Later contact includes a Curtis letter to Haddon, October 8, 1914, Haddon Papers. For other evidence see Haddon 1911a and 1911b.

28. Haddon's chief sources were: Wissler 1905; Wissler and D. C. Duvall 1908; Hale 1885; Grinnell 1892; various articles by Wissler in publications of the American Museum of Natural History; and articles by Grinnell in the *American Anthropologist*. Haddon's memoir is printed here, in a somewhat shortened form and with his spelling silently Americanized, from a typescript in the Haddon Papers. A fuller version, including a detailed description of a Medicine Pipe ceremony, appears in Gidley 1982b.

29. At this point Curtis's photographic work and the project's ethnological work were virtually unknown in Britain, though in 1907 an autobiographical account of the Indian project by Curtis, "My Work in Indian Photography" (Curtis 1907a), had been reproduced from the American *Photographic Times* in the *British Journal of Photography* as "A Triumph of Record Photography" (Curtis 1907b), with a headnote expressing the hope of mounting a Curtis exhibition in Britain.

30. These sorts of ideas of Indian demise and/or degeneration, as indicated in the introduction

here, were not unique to Haddon. For extended discussions of their genealogy see Berkhofer 1979 and Dippie 1982.

31. This passage indicates a significant change in cultural attitudes, for few present-day Western readers would find mass destruction of any animals, let alone the buffalo, "a wonderful sight."

32. The probing passage on sacred bundles in *The North American Indian* is *NAI* 6:66–79. For more extended discussion of the differences between such reminiscences as Haddon's and the published volumes of the Plains volumes of *The North American Indian* see Gidley 2001.

CHAPTER 4

1. For more on the 1905 visit to the Colville Reservation, with contextual material, see Gidley 1981:74–83.

2. Curtis to Pinchot, November 15, 1909, Pinchot Papers.

3. The identity of Crump is unknown; the other figures mentioned here—whether white, such as Myers and Charles Munro Strong, or Indian, such as Upshaw and Henry B. Allen, who was Skokomish—were regular members of the project.

4. The published volumes of *NAI* both testify to the fact that these visits took place and bear the fruits, both generally and in particulars: for example, the Cheyenne sun dance is indeed treated, both pictorially and verbally, in *NAI* 6 (1911):117–122. However, while "preliminary work" had begun on Northwest Coast peoples and the Pueblos (as the next paragraph states), the writing up of volumes 9 and 10 did not, in fact, take place in the winter of 1909–1910.

5. Apparently Upshaw came to a violent end: he was murdered in a brawl just off the reservation. See Gidley 1998a:96; information from an interview with Florence Curtis Graybill in December 1976.

6. From a *Seattle Times* clipping dated May 28, 1909, in the AYPE Scrapbooks, no. 8 (May 23–June 13, 1909), p. 27, Northwest Collection. *Cf. NAI* 8 (1911):53, and, more important, 9 (1913):116–117. For a short, authoritative account of Indian Shakerism see Amoss 1990.

7. As recorded in the headnote, this travelogue is from a typescript of an undated Curtis memoir. For the published shorter revised version see Graybill and Boesen 1976:57–58. There is some commentary on this voyage and its rhetoric in Gidley 1998a:chap. 6.

8. *NAI* 8:xii. The Chinookan material, devoted almost entirely to the Wishham, appears as pp. 85–107, followed by a collection of myths, and the register of village sites on pp. 180–183.

9. Information on Schwinke is taken from a clipping of his obituary in a local Oak Hill, Ohio, newspaper, which was supplied by Mrs. Walter Davis of the Oak Hill Public Library soon after his death in 1977. Information on Martineau is taken from *An Illustrated History of Klikitat, Yakima, and Kittitas Counties* (1904):477, as indexed by the Northwest Collection. The aide-mémoire itself was transcribed in 1977 from index cards that were in the possession of Schwinke's widow residing in Oak Hill. On Schwinke's role in the Kwakiutl film see Holm and Quimby 1980; and Gidley 1982a.

10. Jebson and Ostrander was an import and export shipping company that specialized in the Far East and South and Central America. Presumably Schwinke first went to Seattle for this company. The identities of Ed Morgan et al. have not been discovered. But "Ella" may refer to Ella

McBride, who worked at the Curtis Studio and with whom Schwinke was to have a close working relationship.

11. Presumably these entries indicate Schwinke's intention to write of his appointment to the North American Indian, in which he ultimately succeeded to a position akin to that held by Phillips. He certainly took Phillips's place in the field. Myers attended Northwestern University and Schwinke's first task was probably to type material for Curtis and Myers in the cabin located across Puget Sound (for which they would have had to take the Bremerton ferry), for they certainly worked there during 1910. Some of the other items here—"whales," for example—were also the subjects of yarns passed down in the Curtis family.

12. Some of these entries may be "explained" as follows: "Nihlwidich" is probably a form of the Chinook name for the principal Wishham village near the Dalles, transliterated in NAI as "Nihhluidih"; "desert" is most likely short for "deserted," since the thrust of the NAI account was that these people had been virtually extinguished; "Pug Dogs" could refer either to the significant number of dogs in Chinookan villages or to their presence in myths; "Salmon wheels" probably indicates one of the many varieties of fish traps developed by the Wishham. On reaching Astoria, at the mouth of the Columbia, where the water may well have been as smooth as "ground glass," the party set off for Quinault and visited interior settlements near Lake Quinault. The remaining entries refer to subsequent events that summer, mostly on Vancouver Island in British Columbia, including a narrow escape from drowning in the Seymour Narrows (recorded elsewhere by Boesen and Graybill 1977:112–113), and fieldwork at Alert Bay among the Kwakiutl, where Schwinke was involved in the construction of houses for the film set of Curtis's *In the Land of the Head-Hunters*. For more on the film see Holm and Quimby 1980; and Gidley 1982a.

13. Clipping held in the Kernberger collection. For data on the musicale see Gidley 1987.

14. It has not been possible to discover other information about these stone carvings, but the relevant volume of NAI does contain references to the way Chinookans possessed carved effigies of birds, animals, or other creatures with supernatural abilities. See, e.g., NAI 8:92.

15. NAI 9:153–154, with vocabularies listed on 199–200. See also Hodge 1910, 2:955–956. The notion that the Willapas were Chinook speakers is perpetuated in, for example, Phillips 1971:160. The project workers, including Myers, met Teit in the Quinault area (see Curtis letter to Hodge, June 18, 1910, Hodge Collection) and Myers also corresponded with him. Teit's data was published by Franz Boas and Pliny Earle Goddard as Boas and Goddard 1924. Myers's fieldnotes themselves were found among the North American Indian papers; as reproduced here a simplified orthography is used.

16. An account of Dalby's plans appeared in "Ed Dalby will Gather Material for E. S. Curtis," in *Pacific Wave*, vol. 16, no. 59 (January 8, 1909), p. 1. Haddon letter to Dalby, n.d., Dalby family papers. Curtis letter to Hodge, June 15, 1909, Hodge Collection.

17. The "Emmons" referred to was George Thornton Emmons (b. 1852), a retired U.S. Navy lieutenant who by then was one of the most revered authorities on Northwest Coast material culture, especially that of southeastern Alaskan peoples. This was evidently written before Myers became well acquainted with C. F. Newcombe of Victoria. Newcombe served as an important resource for the project and for many other anthropologists of Vancouver Island and points north.

18. Curtis letter to Charlotte Bowditch, August 20, 1910, Bowditch Papers. The two volumes were, presumably, 9 and 10, those on the Nootka and Kwakiutl. This general view of the productiveness of the initial Vancouver Island work was corroborated by newspaper accounts, especially "Studying Indians of Province—Mr. Curtis will spend Two Weeks in the Vicinity of Cowichan," *Victoria Times*, June 28, 1910, p. 14, and "Photographing Indians," *Victoria Colonist*, June 29, 1910, p. 6, photocopies of which were kindly supplied by the British Columbia Legislative Library in Victoria. The Curtis comments on the 1910 fieldwork were excerpted from a report enclosed with a letter from Curtis to Belle de Costa Greene, March 21, 1913, Curtis materials in the Morgan Library.

19. This is a further quotation from the report cited in note 18.

20. For more on these topics see Curtis 1915; and Gidley 1982a. The most detailed treatment of the project's relationship with the Kwakiutls, Holm and Quimby 1980, corrects some of the excesses of Curtis's own reminiscences of Hunt, as reproduced in Graybill and Boesen 1976 and elsewhere, to the effect that Hunt suffered homicidal rages and bouts of insanity. For further data on Hunt see also Gidley 1994. Parts of this undated document were reproduced in Graybill and Boesen 1976.

21. The alleged gloominess and superstitious character of the Kwakiutls and its ascription to their natural environment here echoes very closely the sentiments expressed in the introduction to *NAI* 10.

22. Considering the extensive ethnological fieldwork conducted among the Kwakiutls by Franz Boas and other distinguished anthropologists, Curtis characteristically exaggerated the uniqueness of the project's achievements. Nevertheless, other authorities since have expressed appreciation for the quantity and subtlety of the project's Kwakiutl data, including Irving Goldman (Goldman 1975:9–12), and, of course, Bill Holm (in Holm and Quimby 1980, especially 36).

23. As recorded in the text here, this document was found in The North American Indian manuscript materials of the Los Angeles County Museum of Natural History.

24. This item appeared in the *Tacoma Tribune* of December 17, 1914; clipping in Northwest Collection.

25. This letter of May 12, 1915, was taken from the Pinchot Papers; for evidence that it was actually a form letter see, for example, a duplicate sent to Charlotte Bowditch dated April 22, 1915, in Bowditch Papers.

26. Myers's comment is from his letter to Newcombe dated November 10, 1913, Newcombe Collection. Myers's findings about the "cannibal feast" are outlined in *NAI*, 10:221–242. For more recent treatment of Kwakiutl culture, with coverage of alleged cannibalism, see scattered comments in Holm and Quimby 1980, which also casts doubt on the existence of actual cannibalism.

CHAPTER 5

1. Curtis letter to Bowditch, January 4, 1908, Bowditch Papers. For more on Myers's time in California see Gidley 1998a:chap. 5. Curtis's "Before the White Man Came" and other Palm Cañon pictures were copyrighted in 1924, but there is a Curtis family story, told particularly by Edward's youngest daughter, Katherine ("Billy"), that Curtis's life was put in danger when he inadvertently fell asleep while working in Palm Cañon during the early years of the project. From an interview

with Billy Curtis Ingram, August 1977. For more on Curtis's time among the Chemehuevi see Curtis letter to Francis Leupp, November 17, 1906, Letters to the Commissioner, Bureau of Indian Affairs, Record Group 75, National Archives, Washington DC. A portion of *NAI* 15 (1926) was devoted to the missions.

2. Curtis letter to Meany, August 30, 1922, Meany Papers.

3. Curtis letter to Meany, October 8, 1922, Meany Papers. On the treatment of California Indians by the white population see the very similar sentiments expressed in the preface to *NAI* 13 (1924):xi–xii as reprinted in Gidley 1976:59.

4. Taken from a typescript of an undated Florence C. Graybill memoir produced for the use of her coauthor, Victor Boesen, in the writing of their books on Curtis. It was probably written in the 1940s as part of the family effort to encourage Curtis in the composition of his autobiography, which may account for her lapse of memory in dating the events to 1923. Brief extracts from the full memoir were published in Andrews 1962 and, of course, in the two Graybill and Boesen books.

5. Florence goes on to recount the story of the healing of a woman by an Indian medicine man who was their interpreter "in tribal regalia," as in Boesen and Graybill 1977:151.

6. The "doctor" may have been C. Hart Merriam, a Curtis supporter from at least the time when, as scientific leader of the Harriman Expedition in 1899, he had appointed the younger man as the expedition's "official photographer." Merriam often spent summers in California. Alternatively, the individual may have been Dr. John Wilz Napier Hudson, husband of the California artist Grace Hudson and, like Merriam, a major collector of ethnographic information and basketry.

7. Curtis letter to Meany, February 22, 1924, Meany Papers.

8. For the Harriman Expedition see Goetzmann and Sloan 1982. George Bird Grinnell contributed the ethnological chapters to the first volume of the *Harriman Alaska Expedition* (Merriam 1902). Curtis to Hodge, November 17, 1926, and May 11, 1927; Hodge to Curtis, May 19, 1927, Hodge Collection.

9. Pratt 1992:152.

10. The text here was taken from a photocopy of the handwritten log supplied by Florence Curtis Graybill, who used parts of it, often in amended form, in her two books on Curtis. Victor Boesen also kindly supplied a copy of a typewritten version containing some elaborations, presumably derived from Curtis's daughter, Beth, which provided corroboration. The use of but a small portion of the original has necessitated some re-paragraphing. Beth's date of death was kindly supplied by Jim Graybill, her nephew. A coherent account of the voyage may be found in Boesen and Graybill 1977:161–183.

11. This account augments one provided in *NAI* 20 (1930):6–9, though the latter includes an indigenous vocabulary and an excellent diagram. *NAI* 20 also mentions Paul Ivanoff, but only as an informant for the book's map of Native dialects (p. 3).

12. These figures were Henry B. Collins and T. Dale Stewart, employees of the Smithsonian working on a collecting expedition, and an ornithologist it has not been possible to identify. See also Curtis's comments later in this chapter and, for information from Henry Collins's point of view, Joanne Cohan Scherer's extended review of Lyman 1982 (Scherer 1985).

13. A more "objective" account of this filthiness appears in *NAI* 20:97–98.

14. See Boesen and Graybill 1977:164–165. Curtis letter to Harriet Leitch, November 24, 1948, Curtis file, History Department, Seattle Public Library. The text itself is taken from a photocopy of a typescript kindly supplied by Florence C. Graybill; parts of the text were used in the two books by Graybill and Boesen.

15. Though these particular sentiments did not appear in *The North American Indian*, a disproportionate amount of space in volume 20, a full third of the book, was devoted to Nunivak.

16. Although the text of *The North American Indian* does not *explicitly* say so, this was indeed how the ethnological material on King Island was gathered. See *NAI* 20:99–110, especially 100.

17. This anti-missionary sentiment, elaborated at some length in the original log, was not included in *The North American Indian*. Indeed, the text there on the Kotzebue actually states that "the medicine men, who rule the village, supervise ceremonies, advise hunters, treat the sick [etc.]" (*NAI* 20:165), and generally gives the impression that precontact life, a life without missionaries, continued into the then present.

18. Information on Eastwood gathered from Eastwood's correspondence with Hodge, Hodge Collection; and from Watkins 1942. The letter itself is Stewart Eastwood to Hodge, August 1, 1927, Hodge Collection.

19. Eastwood letter to Hodge, November 21, 1929, and Hodge letter to U.S. Navy, July 24, 1942, both Hodge Collection.

CHAPTER 6

1. Taken from *The Pacific Wave*, November 10, 1905, Manuscripts and Archives, University of Washington Libraries. Part of a longer University of Washington speech that Curtis gave is reprinted in Gidley 1998a:77–79.

2. For more on the reburial of Chief Joseph and Curtis's participation in it, which was partly coordinated by Edmond Meany, Curtis's host at the University of Washington, see Gidley 1981:76–82.

3. Data parallel to that briefly recalled here may be found in the relevant volumes of *The North American Indian*. For example, a version of the Pueblo creation myth given here appears in *NAI*17 (1926):170–171.

4. The typescripts are titled "Indian Population" in the Kernberger collection, and are similar in format to others definitely used as lecture scripts for the musicale, sometimes echoing their contents. Thornton's study, appropriately titled *American Indian Holocaust and Survival*, is Thornton 1987. Curtis sent versions of his evidence to Hodge in a letter of October 13, 1911, a letter fully quoted in Gidley 1998a:30.

5. One of the authorities mentioned here, James Mooney, was well-known to Hodge precisely *as* an authority on population; he wrote on the subject for Hodge's *Handbook* (see Hodge 1910, 2:286–287) and elsewhere. Mooney's views are cited and discussed in Thornton 1987:26–28 and passim. McGee, for some years acting director of the Bureau of American Ethnology, also worked for a time for the U.S. Census Bureau. He frequently advanced the view that Indians could not compete

with white "civilization" (see Hoxie 1989:118–125); any work he may have undertaken specifically on population figures has not been traced. Friedrich Max Müller was a professor of German origin who taught oriental languages at the University of Oxford. In the 1860s he propounded the theory that "Aryans" diffused both the Indo-European language *and* "civilization" to Europe. He later recanted, saying that he was concerned only to describe the diffusion of languages. For further information see Gossett 1965:123–126. It has not proved possible to trace the source of the comment on Indians that Curtis attributed to him.

6. Merriam's study is also summarized in Thornton 1987:200–201.

7. There is interesting corroborative scholarship to this effect in the history of ideas of race. See, for example, Gossett 1965.

8. This material was taken from a typescript of the same title apparently prepared for the 1911 musicale (one of several with that title), in the Kernberger collection.

9. The Apache creation myth material in the lecture was probably taken more or less directly from *NAI* 1 (1907):23–42.

10. Data other than that specifically annotated here also appeared in *The North American Indian*. For example, the Kwakiutl volume includes much material on theatrical tricks; see *NAI* 10 (1915):210–214 as reproduced in Gidley 1976:142–144; and see fig. 18 here.

11. This Nez Perce description closely follows that in *NAI* 8 (1911):62–66 (reproduced in Gidley 1976:68–71).

12. This "interview" is excerpted from Marshall 1912. Curtis letter to Hodge, October 13, 1911, Hodge Collection.

13. As the final paragraphs of this chapter underscore, this was not a view Curtis often put forward; his characteristic opinion of "miscegenation" was that which he expressed in the comments on Upshaw's indelible Indianness, despite his mixed-race marriage.

14. In fact, this issue of *The Hampton Magazine* proved to be the journal's very last.

15. William Henry Holmes letter to Curtis, March 9, 1905, E. S. Curtis file, Thomas Burke Papers, Manuscripts and Archives, University of Washington Libraries, Seattle. On the ideology of the vanishing race see Dippie, 1982; and Gidley 1998b.

16. Dixon's photograph is reproduced in Gidley 1998c:152. Definitive treatment of Dixon may be found in Trachtenberg 1998.

17. Marshall 1912:253.

18. Relevant Mary Austin writings include Austin 1921 and Austin 1923. For Carl Jung's see Jung 1930. The Heizer quotation is the title of his edited collection of California Indian photographs. The Marshall quotation is from p. 253.

19. See Pratt 1992.

20. The Curtis quotation is from Curtis 1914b:163.

References Cited

FREQUENTLY CITED MANUSCRIPT AND SPECIAL COLLECTIONS

Bowditch Papers: Charlotte Bowditch Papers, Santa Barbara Museum of Natural History, Santa Barbara.

Dalby family papers: Private collection of papers relating to Edwin J. Dalby.

Haddon Papers: A. C. Haddon Papers, Cambridge University Library, Cambridge, England.

Hodge Collection: Frederick Webb Hodge Collection (MS.7.NAI.1), Braun Research Library, Southwest Museum, Los Angeles.

Kernberger Collection: Karl Kernberger's private collection of Curtis musicale scripts and other typescripts.

Meany Papers: Edmond S. Meany Papers, Manuscripts and University Archives, University of Washington, Seattle.

North American Indian Papers: Edward S. Curtis Collection, No. 1143, Seaver Center for Western History Research, Los Angeles County Museum of Natural History, Los Angeles.

Northwest Collection: Northwest Collection, University of Washington Libraries, Seattle (includes AYPE scrapbooks, miscellaneous newspaper clippings, and specialist indices).

Phillips Papers: Private collection of writings by W. W. Phillips.

OTHER MANUSCRIPT AND SPECIAL COLLECTIONS

American Museum of Natural History, New York: File 110, Anthropology Department Archives (Clark Wissler and other letters)

Author's Collection: *The North American Indian* (advertising brochure), n.d. [c.1910]; North American Indian, Inc., *The North American Indian: Extracts from Reviews of the Book, and Comments on the work of its Author, Edward S. Curtis*, n.d.; copy prints of Curtis photogravures.

Bancroft Library, University Archives, University of California, Berkeley: Museum and Department of Anthropology Papers.

British Columbia Legislative Library, Victoria: Miscellaneous newspaper items.

British Columbia Provincial Archives, Victoria: C. F. Newcomb Collection; miscellaneous newspaper items.

Indiana University Museum, Bloomington: Photographs by Joseph Kossuth Dixon.

Library of Congress, Manuscripts Division, Washington DC: Gifford Pinchot Papers; Theodore Roosevelt Papers.

Library of Congress, Prints and Photographs Division, Washington DC: Curtis copyright photographic prints and negatives.

National Archives, Washington DC: Letter to the Commissioner in Record Group 75.

Pierpont Morgan Library, New York City: E. S. Curtis materials.

Seattle Public Library, History Department: E. S. Curtis File; Gilbert Costello's "Scrapbook of the Seattle Press Club."

State of California Bureau of Vital Statistics, Sacramento: Miscellaneous certificates.

University of Washington, Manuscripts and University Archives, Seattle: Thomas Burke Papers, bound files, c.1900–1910, of *The Pacific Wave* (University of Washington student newspaper).

PUBLISHED WORKS

Amoss, Pamela T. 1990. The Indian Shaker Church. In: Wayne Suttles (ed.) *Northwest Coast* vol. 7, *Handbook of North American Indian*. Washington DC: Smithsonian Institution: 633–639.

Andrews, Ralph W. 1962. *Curtis' Western Indians*. Seattle: Superior.

Asad, Talal, ed. 1973. *Anthropology and the Colonial Encounter*. London: Ithaca Press.

Austin, Mary. 1921. Non-English Writings II: Aboriginal. In: William Peterfield Trent, John Erskine, Stuart P. Sherman, and Carl Van Doren, eds., *A History of American Literature*, vol. 4. Cambridge: Cambridge University Press; New York: G. P. Putnam's Sons: 610–34.

——. 1923. *The American Rhythm: Studies and Re-expressions of Amerindian Songs*. Boston: Houghton Mifflin.

Basso, Keith. 1970. *The Cibecue Apache*. New York: Holt, Rinehart, and Winston.

Berkhofer, Robert. 1979. *The White Man's Indian: Images of the American Indian from Columbus to the Present*. New York: Vintage.

Boas, Franz, and Pliny E. Goddard. 1924. Vocabulary of an Athapascan Dialect of the State of Washington. *International Journal of American Linguistics* 3:39–45.

Boelter, Homer H., with Lonnie Hull. 1966. *Edward S. Curtis: Photographer-Historian*. Los Angeles: Westerners' Brandbook, Los Angeles Corral.

Boesen, Victor, and Florence Curtis Graybill. 1977. *Edward S. Curtis: Photographer of the North American Indian*. New York: Dodd, Mead.

Bourke, John G. 1891. Notes Upon the Religion of the Apache Indians. *Folk-Lore* 2:419–454.

——. 1892. The Medicine Men of the Apache. *Ninth Annual Report of the Bureau of American Ethnology*. 451–595.

Brandon, William. 1964. *The American Heritage Book of Indians*, with an Introduction by John Fitzgerald Kennedy (first published 1961). New York: Dell.

Brown, Dee. 1971. *Bury My Heart at Wounded Knee: An Indian History of the American West*. London: Barrie and Rockliffe.

Cardozo, Christopher, ed. 2000. *Sacred Legacy: Edward S. Curtis and the North American Indian*. New York: Simon and Schuster (includes preface by N. Scott Momaday).

Ceram, C. W. 1971. *The First American: A Story of North American Archaeology*. New York: Harcourt Brace Jovanovich.

Cole, Fay-Cooper. 1957. Frederick Webb Hodge, 1864–1956. *American Anthropologist* 59:517–520.

Coleman, A. D. 1998. Edward S. Curtis: The Photographer as Ethnologist. In: Coleman, *Depth of Field: Essays on Photography, Mass Media, and Lens Culture*. Albuquerque: University of New Mexico Press. 133–158.

Coleman, A. D., and T. C. McLuhan, eds. 1972. *Portraits from North American Indian Life by Edward S. Curtis*. New York: Dutton.

Curtis, Edward S. 1898. The Rush to the Klondike Over the Mountain Passes. *Century* 55 (March): 692–697.

———. 1906a. Vanishing Indian Types: The Tribes of the Southwest. *Scribner's* 39 (May):513–529.

———. 1906b. Vanishing Indian Types: The Tribes of the Northwest Plains. *Scribner's* 39 (June):657–671.

———. 1907–1930. *The North American Indian*, ed. Frederick Webb Hodge. 20 volumes, 20 portfolios. Cambridge MA: Cambridge University Press; Norwood MA: Plimpton Press. (Cited as *NAI*, volume number, volume date, page number[s].)

———. 1907a. My Work in Indian Photography. *Photographic Times* 39 (May):195–198.

———. 1907b. A Triumph of Record Photography. *British Journal of Photography* 54 (August 23):636–637 (reprint of 1907a).

———. 1909a. Indians of the Stone Houses. *Scribner's* 45 (February):161–175.

———. 1909b. Village Tribes of the Desert Land. *Scribner's* 45 (March): 274–287.

———. 1914a. *Indian Days of the Long Ago*. Yonkers-on-Hudson NY: World Book (rpt. Tamarack Press, 1975).

———. 1914b. Plea for Haste in Making Documentary Records of the North American Indian. *American Museum Journal* 14.4:163–165.

———. 1915. *In the Land of the Head-Hunters*. Yonkers-on-Hudson NY: World Book (rpt. Tamarack Press, 1975).

———. 1997. *The North American Indian: The Complete Portfolios*, with an introduction by Hans Christian Adam. Cologne: Taschen.

Davis, Barbara A. 1985. *Edward S. Curtis: The Life and Times of a Shadow Catcher*. San Francisco: Chronicle Books.

de Brigard, Emily. 1973. The History of Ethnographic Film. Paper prepared for the Ninth International Congress of Anthropological and Ethnological Sciences, Chicago.

DeWall, Beth Barclay. 1980. The Artistic Achievement of Edward Sheriff Curtis. Master's Thesis, University of Cincinnati.

Dippie, Brian W. 1982. *The Vanishing American Indian: White Attitudes and U.S. Indian Policy*. Middletown CT: Wesleyan University Press.

Ewers, John C. 1955. *The Horse in Blackfoot Indian Culture*. Washington DC: Bureau of American Ethnology *Bulletin* 159.

Fabian, Johannes. 1983. *Time and the Other: How Anthropology Makes its Object*. New York: Columbia University Press.

Faris, James C. 1993. The Navajo Photography of Edward S. Curtis. *History of Photography* 17 (winter):377–387.

Genthe, Arnold. 1901. A Critical View of the Salon Pictures with a Few Words upon the Tendency of the Photographers. *Camera Craft* 2.4 (February):310.

Gidley, Mick, ed. 1976. *The Vanishing Race: Selections from Edward S. Curtis's "The North American Indian."* Newton Abbot: David and Charles; New York: Taplinger.

Gidley, Mick. 1979. *With One Sky Above Us: Life on an Indian Reservation at the Turn of the Century.* London: Smithmark; New York: G. P. Putnam's Sons.

————. 1981. *Kopet: A Documentary Narrative of Chief Joseph's Last Years.* Seattle: University of Washington Press.

————. 1982a. From the Hopi Snake Dance to "The Ten Commandments": Edward S. Curtis as Filmmaker. *Studies in Visual Communication* 8 (summer):70–79.

Gidley, Mick, ed. 1982b. A. C. Haddon Joins Edward S. Curtis: An English Anthropologist among the Blackfeet, 1909. *Montana* 32 (autumn):20–33.

Gidley, Mick. 1987. The Vanishing Race in Sight and Sound: Edward S. Curtis' Musicale of North American Indian Life. In: Jack Salzman, ed., *Prospects: An Annual of American Cultural Studies* No. 12. New York: Cambridge University Press. 59–87.

Gidley, Mick, ed. 1992. *Representing Others: White Views of Indigenous Peoples.* Exeter: University of Exeter Press (includes "Edward S. Curtis' Indian Photographs: A National Enterprise," pp.103–119).

Gidley, Mick. 1993. Pictorialist Elements in Edward S. Curtis' Representation of American Indians. In: Johan Callens, ed., *Re-discoveries of America: The Meeting of Cultures.* Brussels: VUB Press. 62–85.

————. 1994. Three Cultural Brokers in the Context of Edward S. Curtis's "The North American Indian." In: Margaret Connell Szasz, ed., *Between Indian and White Worlds: The Cultural Broker.* Norman: University of Oklahoma Press, 197–215 and 332–336.

————. 1998a. *Edward S. Curtis and The North American Indian, Incorporated.* New York: Cambridge University Press.

————. 1998b. The Repeated Return of the Vanishing Indian. In: John White and Brian Holden Reid, eds., *Americana: Essays in Memory of Marcus Cunliffe.* Hull: University of Hull Press. 209–232.

————. 1998c. A Hundred Years in the Life of American Indian Photographs. In: Jane Alison, ed., *Native Nations: Journeys in American Photography.* London: Barbican Art Gallery in association with Booth-Clibborn Editions. 152–167.

————. 2001. Ways of Seeing the Curtis Project on the Plains. In: *The Plains Indian Photographs of Edward S. Curtis.* Lincoln: University of Nebraska Press. 39–66.

————. 2003. Edward S. Curtis's Photographs for *The North American Indian*: Texts and Contexts. In: Ulla Haselstein, Berndt Ostendorf, and Peter Schneck, eds., *Iconographies of Power.* Heidelberg: Carl Winter. 71–92.

Gilb, Corinne. 1956. Transcript of "Frederick Webb Hodge, Ethnologist: A Tape Recorded Interview, April 1956." Berkeley CA: Regional Cultural History Project.

Goetzmann, William H., and Kay Sloan. 1982. *Looking Far North: The Harriman Expedition to Alaska 1899.* Princeton: Princeton University Press.

Goldman, Irving. 1975. *The Mouth of Heaven: An Introduction to Kwakiutl Religious Thought.* New York: John Wiley.

Gossett, Thomas F. 1965. *Race: The History of an Idea in America.* New York: Schocken.

Graybill, Florence Curtis, and Victor Boesen. 1976. *Edward Sheriff Curtis: Visions of a Vanishing Race.* New York: Thomas Crowell.

Green, Jesse, ed. 1979. *Zuni: Selected Writings of Frank Hamilton Cushing.* Lincoln: University of Nebraska Press.

Grinnell, George Bird. 1889. *Pawnee Hero Stories and Folk Tales, with Notes on the Origins, Customs and Character of the Pawnee People.* New York: Forest and Stream Publishing.

————. 1892. *Blackfoot Lodge Tales: The Story of a Prairie People.* New York: Charles Scribner's.

————. 1905. Portraits of Indian Types. *Scribner's* 37 (March):259–273.

Haddon, A. C. 1902. What the United States of America is Doing for Anthropology. *Journal of the Anthropological Institute* 33 (January–June):8–24.

————. 1911a. Review of McClintock, *The Old North Trail. Folklore* 22:126–128.

————. 1911b. Review of McClintock, *The Old North Trail. Nature* 86:83–84.

————. 1914. The Soul of the Red Man. *Rational Press Association Annual.* London: Rationalist Press. 39–43.

Hale, Horatio. 1885. *Report on the Blackfoot Tribes. British Association for the Advancement of Science Annual Meeting Report* 55:696–708.

Hausman, Gerald, and Bob Kapoun. 1995. *Prayer to the Great Mystery: The Uncollected Writings and Photography of Edward S. Curtis,* with an Introduction by Patricia Nelson Limerick. New York: St. Martin's Press.

Hodge, Frederick Webb, ed. 1910. *Handbook of American Indians North of Mexico.* 2 volumes. Washington DC: Bureau of American Ethnology.

Holm, Bill, and George I. Quimby. 1980. *Edward S. Curtis in the Land of the War Canoes.* Seattle: University of Washington Press.

Hoxie, Frederick E. 1989. *A Final Promise: The Campaign to Assimilate the Indians, 1880–1920.* Cambridge: Cambridge University Press.

Jung, Carl. 1930. Your Negroid and Indian Behavior. *Forum* 83 (April):193–199.

Kew, J. E. Michael. 1990. History of Coastal British Columbia Since 1846. In: Wayne Suttles, ed., *Northwest Coast* vol.7, *Handbook of North American Indians.* Washington DC: Smithsonian Institution. 159–179.

Liebersohn, Harry. 1998. *Aristocratic Encounters: European Travelers and North American Indians.* Cambridge: Cambridge University Press.

Littlefield, Daniel F., and James W. Parins. 1981. *A Bio-bibliography of Native American Authors, 1772–1924.* Metuchen NJ: Scarecrow.

Lowie, Robert H. 1909. Social Life of the Crow Indians. *Anthropological Papers of the American Museum of Natural History* no. 9, part 2.

————. 1935. *The Crow Indians*. New York: Rinehart.

Lyman, Christopher M. 1982. *The Vanishing Race and Other Illusions: Photographs of Indians by Edward S. Curtis*. Washington DC: Smithsonian Institution Press.

McGee, W. J. 1910. Review of Volume 5 of *The North American Indian*. *American Anthropologist* 12 (July-September):448–450.

Makepeace, Anne. 2001. *Edward S. Curtis: Coming to Light*. Washington DC: National Geographic.

Marshall, Edward. 1912. The Vanishing Red Man . . . Discussed by Edward S. Curtis. *The Hampton Magazine* 28.4 (May):245–253, 308.

Meany, Edmond S. 1907. [Report on Curtis]. *Seattle Sunday Times* August 11. In: *The North American Indian* (advertising brochure), n.d.[c. 1910], author's collection.

————. 1908. Hunting Indians with a Camera. *World's Work* 15 (March):10004–10011.

Merriam, C. Hart, ed. 1902. *Harriman Alaska Expedition* vol. 1. New York: Doubleday, and Washington DC: Smithsonian Institution.

Metcalfe, Gertrude. 1904–5. The Indian as Revealed in the Curtis Pictures. *Lewis and Clark Journal* [the journal of the Lewis and Clark Exposition, Portland, Oregon, 1904–5], 1, no. 5. 13–19.

Murray, David. 1991. *Forked Tongues: Speech, Writing, and Representation in North American Indian Texts*. Bloomington: Indiana University Press.

Pagden, Anthony. 1993. *European Encounters with the New World*. New Haven: Yale University Press.

Pandey, Triloki Nath. 1972. Anthropologists at Zuni. *Proceedings of the American Philosophical Society* 116:321–337.

Phillips, James W. 1971. *Washington State Place Names*. Seattle: University of Washington Press.

Pratt, Mary Louise. 1992. *Imperial Eyes: Travel Writing and Transculturation*. London: Routledge.

Prucha, Francis Paul. 1984. *The Great Father: The United States Government and the American Indians*. 2 volumes. Lincoln: University of Nebraska Press.

Quiggan, A. H. 1942. *Haddon the Headhunter*. Cambridge: Cambridge University Press.

Reagan, Albert B. 1904. Apache Medicine Ceremonies. *Proceedings of the Indiana Academy of Sciences* 14. 275–283.

Richards, Kent D. 1975. Edmond S. Meany. *Arizona and the West* 17 (autumn):201–204.

Rydell, Robert W. 1984. *All the World's a Fair: Visions of Empire at American International Expositions, 1876–1916*. Chicago: University of Chicago Press.

Said, Edward. 1978. *Orientalism*. New York: Pantheon.

Sandoz, Mari. 1953. *Cheyenne Autumn*. New York: Hastings House.

Scherer, Joanne Cohan. 1985. Review of Lyman 1982. *Studies in Visual Communication* 11 (summer): 78–85.

Stands in Timber, John, and Margot Liberty. 1998. *Cheyenne Memories*. New Haven: Yale University Press, 2nd ed.

Stevenson, Matilda Coxe. 1904. The Zuni Indians. *Twenty-third Annual Report of the Bureau of American Ethnology, 1901–1902*.

Thornton, Russell. 1987. *American Indian Holocaust and Survival: A Population History Since 1492.* Norman: University of Oklahoma Press.

Todorov, Tzvetan. 1984. *The Conquest of America: The Question of the Other.* New York: Harper and Row.

Trachtenberg, Alan. 1998. Wanamaker Indians. *Yale Review* 86 (spring):1–24.

Truettner, William H., ed. 1990. *The West as America.* Washington DC: Smithsonian Institution Press.

Turner, Frederick W., ed. 1974. *The Portable North American Indian Reader.* New York: Viking.

Upshaw, Alexander B. 1897. What The Indians Owe to the United States Government. *Red Man and Helper* 14 (April):8.

Washburn, Wilcomb E., ed. 1988. *History of Indian-White Relations.* Vol. 4 *Handbook of North American Indians.* Washington DC: Smithsonian Institution.

Waters, Frank. 1941. *The People of the Valley.* rpt. Athens OH: Swallow Press, 1969.

Watkins, Frances E. 1942. The Stewart C. Eastwood Collection. *The Masterkey* 16, no.6 (November): 199–202.

Weigle, Martha. 1976. *Brothers of Light, Brothers of Blood: The Penitentes of the Southwest.* Albuquerque: University of New Mexico Press.

Wissler, Clark. 1905. The Blackfoot Indians. *Annual Archaeological Report, being Part of the Appendix to the Reports of the Minister of Education.* Ontario: 162–178.

Wissler, Clark, and D.C. Duvall. 1908. Mythology of the Blackfoot Indians. *American Museum of Natural History, Anthropological Papers* 2:1–163.

Worcester, Donald E. 1979. *The Apaches: Eagles of the Southwest.* Norman: University of Oklahoma Press.

Index

Numbers in italic script refer to the figure numbers of illustrations, which follow page 84.

Acoma (Pueblo), 9, 48, 51–52; and Acomita, 52; and Enchanted Mesa, 9
Alaska, 5, 12, 95, 114–130. *See also* Alaska-Yukon-Pacific Exposition; Harriman Alaska Expedition; Klondike gold rush
Alaska Yukon-Pacific Exposition (Seattle), 70, 85, 86
Alberta, 57
Alert Bay BC, 91, 93
Aleut (Arctic), 114. *See also* Eskimo
American Museum of Natural History (NYC), 14, 70, 71, 72; and Secretary H. C. Bumpus, 72
Anasazi ruins, 55–56, 133, 134, 153 n.22
Angeline, Princess (Duwamish), 4
anthropology. *See* ethnologists
Apache (Southwest), 3, 31, 34–35, 36–44, 133; and alcohol, 25, 39–41; Chiricahua, 17, 30; Cibecue, 39, 45; and formation of Curtis project, 6; and Fort Apache AZ, 34 (*see also* Cooley, Corydon E.), 41–42; and Fort Sill OK, 30; material culture, 9; medicine men (*see* Bizhuan, Das Lan, Goshonne); and "messiah craze," 41, 45, 47; prayer, text of, 43–44; religion, 33, 39, 43–44, 47, 138; reluctance to impart spiritual information, 37–39, 40, 41–43, 45–47; reservations, 30; sub-groups 17, 30; mentioned, 1, 11, 50
Apsaroke. *See* Crow
Arapaho (Plains), 85
Arctic culture area and peoples, 114–130
Arikara (Plains), 10, 68, 136
Assiniboine (Plains), 57, 68, 69
Atsina (Plains), 12, 136
Austin, Mary, 146–147

Bannock (Great Basin), 17
Battle of the Little Big Horn, 10, 16, 64, 22
Bear Black (Cheyenne), 61–62, 12
Bear Black, Davy (Cheyenne), 60–61
Bizhuan (Apache), 39–44
Blackfeet, Blackfoot, or Piegan (Plains), 57, 58–59, 72, 73–81, 14; at Browning MT (Blackfeet Agency), 17, 73; at buffalo fall, 76–77, 80–81; and "buffalo stones," 80–81; and formation of Curtis project, 5; histories of, 76; landscape and reservation, 73–74, 84; medicine bundle, 77, 79–80, 81; Medicine Pipe ceremony, 80, 81; population of, 136; reluctance to disclose sacred information, 76; sun dance, 5, 58–59; sweat practices, 22, 78–79, 81; text of song to Weasel Woman, 80–81; tipis, 77, 81; as warriors, 63, 64; mentioned, 10
Blackfoot. *See* Blackfeet, Blackfoot, or Piegan.
Boas, Franz, 14, 95, 99
Boesen, Victor, 87, 100
Bourke, John G. (*On the Border with Crook*), 34
Bowditch, Charlotte, 99, 109
Brandon, William (*American Heritage Book of Indians*), 24
British Columbia, 18, 21, 70, 71
Bull Chief (Crow), 65, 66
Bureau of American Ethnology, 6, 9, 134. *See also* Smithsonian Institution
Burke, Thomas, 6
Burroughs, John, 5

Caddo (Plains), 17
Cahuilla (California), 109, 132; at Palm Cañon, 159 n.1
California culture area, 12, 19, 108–114, 135–136. *See also* names of specific peoples

Canadian Department of Indian Affairs, 16, 18, 20, 21

Cape Prince of Wales AK: and its Eskimo people, 115, 124–125, 127–128

Carlisle Indian Industrial School (PA), 10, 32, 154 n.6

Carnegie, Andrew, 8, 72

Carnegie Hall (NYC), 14

Carson, Kit, 16, 17

Cayuse (Plateau), 82

Chemehuevi (California), 109, 147, 24

Cherokee (Southeast), 15

Cheyenne (Plains), 16, 57, 59–63, 64, 84; folk-lore of, 61; at Fort Robinson NE, 16; medical practices, 61–62, 12; and Willow Dance (sun dance), 85; mentioned, 5, 11

Chinook (Northwest Coast), 18, 90–91

Chinook jargon, 18, 21, 82, 96

Chipewyan (subarctic), 57

Chiricahua. See Apache

Cibecue. See Apache

Cibola. See Zuni

Clallam (Northwest Coast), 18, 100

Clatsop (Northwest Coast), 94

Clayoquot (Northwest Coast), 100–101

Coastal Salish (Northwest Coast), 4, 18, 70, 95, 143; "Siwashes," 95. See also Puget Sound WA

Cochiti (Pueblo), 48

Coeur d'Alene (Plateau), 19

Collins, Henry B., 118, 122–123, 129, 160 n.12

Columbia (Plateau), 19, 24–25, 82, 84

Columbia River, 11, 18, 82, 83, 93–94, 136; Cascades or Great Falls of the, 89–90, Celilo Falls of the, 88, 92; The Dalles of the, 17, 83, 87, 90, 92, 136; and Hood River, 90; and Pasco, 91; voyage down, 87–91, 92, and Willamette River, 90. See also Willapa

Colville (Plateau), 19, 82

Colville Reservation WA, 19, 20, 24, 82, 84, 15; and Nespelem (agency), 19, 132

Comanche (Plains), 17, 57

Cooley, Corydon E., 34, 152 n.4; Cooley's, 34–35

Cowichan (Northwest Coast), 93, 95, 17

"Crane" (white trader), 65

Crazy Pend D'Oreille (Crow), 10

Cree (subarctic), 12, 57, 76

Creek (Southeast), 15

Crook, Gen. George, 34

Crow, Chief (Blackfeet), 77

Crow or Apsaroke (Plains), 17, 57, 63, 141, 25; as warriors, 63–65, 5; at Black Cañon, 15, 23, 132; and Crow Agency, 2; Little Big Horn River, 132, 22; population of, 136; at Pryor Cañon, 3; and A. B. Upshaw, 10; mentioned, 84

culture areas, Indian, 26–27. See also specific culture areas: Arctic; California; Eastern Woodland; Great Basin; Northwest Coast; Plains; Plateau; Southwest; subarctic

Cunningham, Imogen, 7

Curley (Crow), 64

Curtis, Clara Phillips (wife), 4, 7, 36, 113

Curtis, Edward S.: biographical data, 4–9, 26; character of, 4–5; and family role, 4 (see also Curtis family members); fieldwork of, 6, 7–8, 11, 25, 144 (see also Curtis, Edward S., reprinted writings by); friendships of, 4; photographed, 1, 2; photographic practice of, 4–5, 14, 15, 58, 59–60, 67, 145–148, 15 (see also titles of specific photographs); and patrons, patronage, 2, 6, 7–9, 70–71, 83 (see also Bowditch, Charlotte; Morgan, J. Pierpont); and publicity, 28, 70, 83; and Seattle studio, 4, 7, 30, 82, 92; and Los Angeles studio, 7, 115; and studio employees (see Cunningham, Imogen; McBride, Ella; Muhr, Adolf F.); writings of, discussed, 5, 74–75, 120, 146–148; writings of, quoted, 1, 6, 14, 27, 28, 45, 69, 71, 72, 73, 94–95, 99–100, 109, 120, 131, 133, 142, 145, 146, 147, 148; mentioned, 10, 18, 24, 25, 30, 32, 62. See also Harriman Alaska Expedition; Indian Days of the Long Ago; In the Land of the Head-Hunters; musicale or picture opera; The North American Indian

Curtis, Edward S., reprinted writings by, 45–47 (Apache); 49–54 (Pueblo); 58–59 (Blackfeet); 63–65 (Plains); 83–85 (Plateau); 86–87 (Shak-

erism); 100–103 (Kwakiutl); 103–104 (George Hunt); 104–105 (Indian song); 120–128 (Eskimo); 131–133 (pre-1905 fieldwork); 133–136 (Indian population); 138–141 (Indian religion); 142–145 (interview)

Curtis, Edward S., specific photographs: "Apache Still Life," 9; "Bear Black (Cheyenne)," 12; "Camp Curtis," 3; "A Chief—Chukchansi," 147, 19; "Eskimos at Plover Bay, Siberia," 20; "The Fisherman—Wishham," 146; "Hopi Snake Priest," 8; "Hunka Ceremony (Oglala)," 13; "The Invocation," 15; "Kenowun (Nunivak)," 147–148, 21; "Kominaka Dancer (Kwakiutl)," 18; "Modern Chemehuevi Home," 147, 24; "Modern Yurok Home," 147; "The Offering (San Ildefonso Pueblo)," 15, 7; "One Blue Bead (Crow)," 147–148, 25; "On Quamichan Lake (Cowichan)," 17; "On the River's Edge," 22; "Out of the Forest's Depths Stepped an Indian Maiden (Nespelem)," 15; "The Potter Mixing Clay-Hopi," 146 ; "San Ildefonso Tablita Dance," 11; "Stormy Day (Flathead)," 16; "A Swap (Crow)," 23; "The Talk (Crow)," 5; "Tearing Lodge and his Wife (Blackfeet)," 14; "The Three Chiefs (Piegan)," 146; "The Vanishing Race," 14; "The Village Herald (Oglala)," 6; "Women at Camp Fire (Jicarilla?)," 10

Curtis family members. See Curtis, Clara Phillips; Curtis, Harold Phillips; Curtis, Johnson; Graybill, Florence Curtis; Magnuson, Beth Curtis; Phillips, William Wellington

Curtis, Harold Phillips (son), 21–22, 30–31; reprinted writing by, 31–35

Curtis, Johnson (father), 4

"Curtis Scenics" (films), 8

Custer, Gen. George A., 10, 16, 17, 64, 154 n.11

Dalby, Edwin J., 18, 71, 83, 85, 98; biographical data, 69, 70; reprinted writing by, 69–70

Das Lan (Apache), 41, 46–47

Dawes Act. See U.S. General Allotment Act

Dixon, Joseph Kossuth, 146, 2

Dull Knife (Cheyenne), 16

Eastern Woodland culture area and peoples, 128, 143

Eastwood, Stewart C., 26, 115, 120, 127; biographical data, 128; quoted, 130; reprinted writing by, 128–129

Edward, Davis. See Marshall, Edward

encounter literature, 3. See also representation of Indians by the project; Vanishing Race, Indians as

Eskimo (Arctic), 105, 114–130

ethnologists: Cushing, Frank Hamilton, 51; Dorsey, George A., 70; Emmons, George Thornton, 99, 158 n.17; Ewers, John C., 10; Gifford, E. W., 12; Heizer, Robert, 147; Holmes, William Henry, 73, 145; Hrdlicka, Ales, 129; Lowie, Robert H., 10; Morgan, Henry Lewis, 98; Newcombe, C. F., 12, 106; Putnam, Frederick Ward, 14; Rasmussen, Knud, 129; Rivers, W. H. R., 71; Speck, Frank G., 128; Stevenson, Matilda Coxe, 51; Walcott, Charles Doolittle, 14. See also Boas, Franz; Bourke, John G.; Curtis, Edward S.; Dalby, Edwin J.; Eastwood, Stewart C.; Grinnell, George Bird; Haddon, Alfred Cort; Hodge, Frederick Webb; Hunt, George; Kroeber, Alfred L.; McClintock, Walter; McGee, William J.; Merriam, C. Hart; Mooney, James; Myers, William E.; Nelson, Edward W.; The North American Indian, Inc., fieldworkers; Phillips, William Wellington; Teit, James; Wissler, Clark

Eugene, Frank, 4

film. See "Curtis Scenics"; Hollywood; In the Land of the Head-Hunters

Flathead (Plateau), 18–19, 82, 136; at Jocko River MT, 16, 84; as warriors, 64; mentioned, 63

Flat Tail, Phillip (Blackfeet), 77

Geronimo (Apache), 17, 30

Gidley, Mick (Edward S. Curtis and the North American Indian, Incorporated), 146

Gilbert, Grove Karl, 5

Golovin Bay AK, 116, 128

Goshonne (Apache), 37–39, 46–47

Grant, Madison, 14

Gray Oliver or *Lapai* (Apache), 36–44

Graybill, Florence Curtis, 24, 31, 100, 109; biographical data, 112; quoted, 12; and *Visions of a Vanishing Race*, 87; reprinted writing by, 112–113

Great Basin culture area, 26. *See also names of specific peoples*

Greene, Belle de Costa, 72, 73

Grinnell, George Bird, 5, 6, 14, 58, 76

Haddon, Alfred Cort, 84, *14*; biographical data, 70; quoted, 71, 72, 98; reprinted writing by, 73–81; writings discussed, 73

Haida (Northwest Coast), 12, 95, 100, 105

Hampton Institute VA, 141

The Hampton Magazine, 8, 141, 145; reprint from, 142–145

Harold, Mr. (unidentified ornithologist), 118, 122–123

Harriman, Edward H., 5, 13, *20*

Harriman Alaska Expedition, 5, 83, 114, 127, *20*

Hearst Corporation, 8

Hidatsa (Plains), 10, 12, 57, 68, 136

Hill, Samuel, 4, 93; home at Maryhill WA, 93

Hodge, Frederick Webb, 6, 12, 128, 133; biographical data, 9, 70; and *Handbook of American Indians North of Mexico*, 9, 96; quoted, 11, 114, 130; receives correspondence, 11, 26, 49, 68, 98, 99, 142; mentioned, 6, 69, 73. *See also* periodical publications, *American Anthropologist*

Hollywood, 8, 26

Hooper Bay AK, 116, and its Eskimo people, 115, 119–120, 123, 129

Hopi (Southwest), 6, 12, 20; beauty, 63; Snake Dance, 25, 27, 28–29, 31, 59, *8*; villages, 50–51; and Walpi, 51, 52; mentioned, 1, 49, 107, 143

Howard, Gen. O. O., 17

Hudson, John Wilz Napier, 160 n.6

Hunt, George (Tlingit/Scottish), 10, 100, 103–104

Huntington, Henry E., 13

Hupa (California), 111

Indian Days of the Long Ago (Curtis), 8

Indian Territory, 15–16. *See also* Oklahoma

Indian Welfare League, 8

Indians, American: generalized commentary on, 75–76, 142–145; and hypnotism, 138–139, 141; population, 25, 54, 134–137, 145; religion, 137–141; and reservation policy, 15–25; and sweat bath, 139; and vision-seeking, 139–141. *See also* culture areas, Indian; linguistic groups, Indian; Vanishing Race, Indians as

In the Land of the Head-Hunters (Curtis film), 2, 8, 91, 100, 104

Inuit-Inupiak (Arctic). *See* Eskimo

Isleta (Pueblo), 51

Ivanoff, Micha, and wife (Eskimo/Russian), 119–120

Ivanoff, Paul, and wife (Eskimo/Russian), 117–118, 121–123, 129

Jemez (Pueblo), 51

Jicarilla (Southwest), 1, 6, 30, *10*

Joseph, Chief (Nez Perce), 19, 82, 132

Jung, Carl, 147

Kalapooia (Northwest Coast), 17

Karok (California), 111

Kato (California), 111

Kenowun (Nunivak), 147–148, *21*

King Island AK, 124, 129, and its Eskimo people, 115, 124, 128

Kiowa (Plains), 17

Kiowa-Apaches (Plains), 57

Klamath (California), 17, 108

Klikitat (Plateau), 82, 83, 86

Klondike gold rush, 5

Kotzebue AK, 129, and its Eskimo people, 115, 125–126, 127

Kroeber, Alfred L., 12; and *Handbook of the California Indians*, 109

Kutenai (Plateau), 17, 71, 84, 136

Kwakiutl (Northwest Coast), 1, 10, 26, 93, 95, 100–107, 143; architecture, 101, 102–103; and Canadian policies, 18; "cannibalism," 105–107, *18*; food, 102–103; and *In the Land of the*

Head-Hunters, 8, 26, 91, 100, 104; landscape, 101; and witchcraft, 101–102; song making, 104–105; theatricality and ceremonies, 102, 105–106, 138, *18*

Kwalhioqua. *See* Willapa

Laguna (Pueblo), 48, 51
Lake (Plateau), 19
Lakota. *See* Sioux
Lee, Mother Ann, 85
Leitch, Harriet, 120
Lewis and Clark Expedition, 87–91, 92, 136
linguistic group(s), Indian, 17, 111, 135; Algonkian, 17, 57, 108; Athapascan, 17, 57 30, 41, 96, 108; Caddoan, 57; Chinookan, 86, 96; Keresan, 49; Kitunahan, 17; Lutuamian, 17; Nootkan, 95; Penutian, 108; Salishan, 18–19, 82; Shahaptian, 18–19, 82, 86; Shoshonean, 17, 57; Siouan, 57, 143; Tanoan, 48, 132; Wakashan, 18, 82, 95, 100; Yukian, 108
Little Diomede Island AK, 128, 129, and its Eskimo people, 115, 125
Little Plume (Blackfeet), 76, 77, 78–79
Little Wolf (Cheyenne), 16
Lummis, Charles (*Land of Poco Tiempo*), 50

Magnuson, Beth Curtis, 7, 120, 121, 123, 128; biographical data, 115; and her husband (Manford E.), 115; reprinted writing by, 115–120
Maidu (California), 12
Makah (Northwest Coast), 95, 100
Makepeace, Anne (*Coming to Light*), 149 n.1
Mandan (Plains), 10, 68, 87, 136
Maricopa (Southwest), 27
Marshall, Edward, 8, 133; biographical data, 141; and reprinted interview with Curtis, 142–145
Martineau, Capt. [Michelle(?)], 87–88, 89–90, 91, 92
Mazamas (mountaineering club), 4, 5
McBride, Ella, 7, 91, 157 n.10
McClintock, Walter (*The Old North Trail*), 73
McGee, William J., 72, 134, 161 n.5
Meany, Edmond S., 18, 29, 69–70, 112, 131, biographical data, 66; fieldwork for project, 66, *4*,

6; friendship with Curtis, 4, 109, 113; quoted, 70; reprinted writing by, 66–67
Meares, John (*Voyages Made in Years 1788 and 1789*), 100–101
Merriam, C. Hart, 5, 135–136, 160 n.6
"messiah craze." *See* Apache
Mexican Americans, 55, 56
Mexico, 27, 29, 30
Meyer, Fred R., *4*
Millett, Esther (Salish informant on Willapa), 96–97
Millett, Sam (Salish informant on Willapa), 96–97
Mississippi River, 1, 57, 135, 143
Miwok (California), 12
Mohave (Southwest), 27
Momaday, N. Scott (Kiowa), 15
Mooney, James, 134, 161 n.5
Morgan, J. Pierpont, 6–7, 9, 13, 25, 72, 73, 131; and Morgan Bank, 6, 128. *See also* Greene, Belle de Costa; Morgan, J. P.; Morris, Robert Clark; The North American Indian, Inc.
Morgan, J. P. (Jack), 6
Morris, Robert Clark, 6, 31; and wife (Alice Parmalee), 31
Moses, Chief (Columbia), 19, 24–25, 82
Muhr, Adolf F., 7
Muir, John, 5
Müller, F. Max, 135, 161 n.5
museums: Field Museum (Chicago), 70; Los Angeles County Museum of Natural History, 103; Museum of the American Indian (NYC), 9; Southwest Museum (Los Angeles), 9, 128. *See also* American Museum of Natural History; Smithsonian Institution
musicale (picture opera), 8, 14, 36, 54, 95, 133, 137
Myers, William E., 26, 27–28, 48, 92, 99, 114; biographical data, 11–12, *4*; and fieldwork, 12, 83, 85, 87, 88, 109, 112, *3*; quoted, 26, 49, 88, 106; reprinted writings by, 68, 96–98; writing by, discussed, 69, 81; mentioned, 36, 83

Nambé (Pueblo), 48, 51

Nashalek, Joe, and wife (Eskimo), 126

Native Americans. *See* Indians, American

Navajo (Southwest), 1, 16–17, 30, 41; at Bosque Redondo NM, 16; at Cañon de Chelly AZ, 17; and "The Vanishing Race" image, 14 ; and Yebichai ceremony, 27, 28; mentioned, 6, 31, 50, 53

Nelson, Edward W. (*The Eskimo About Bering Strait*), 129

Nespelem (Plateau), 19, 82, *15*

newspapers: *Christian Science Monitor*, 72, 73; *Seattle Post-Intelligencer*, 70; *Seattle Star*, 12; *Seattle Sunday Times*, 66; *Seattle Sunday Times* reprint, 93–95; *Seattle Times*, 85; *Seattle Times* reprint, 86–87; *Sunday Call* (San Francisco) reprint, 58–59; *Tacoma Tribune* reprint, 104–105. *See also* periodical publications

Nez Perce (Plateau), 17, 20, 71, 73, 82; and Nez Perce War, 19, 144–145; and vision quest, 140–141; mentioned, 63, 84. *See also* Joseph, Chief

Noatak River AK, and its Eskimo people, 126

Nome AK, 116, 120, 123, 128, 129

Nootka (Northwest Coast), 18, 82, 95, 100, 143

The North American Indian (the text and project to produce it), 1–2, 7–13, 25–29; Apache text of, 30; California text of, 109; Eskimo text of, 114; hiatus in production of, 107; Northwest Coast text of, 96, 97, 98, 100, 106; Plains text of, 57, 58, 59, 66, 68–69, 81; Plateau text of, 82; publicity for, 137 (*see also* musicale); Pueblo text of, 48–49; quoted, 91; text as gift, 72; mentioned, 4, 14, 19. *See also* Curtis, Edward S.; Hodge, Frederick Webb; Myers, William E.; The North American Indian, Inc.

The North American Indian, Inc., 6–7, 99, 114, 128. *See also* Morgan, J. Pierpont

The North American Indian, Inc., fieldworkers: Allen, Henry B. (Skokomish), 83, 85; Armstrong, Ralph (Nez Perce-Delaware), 73; Crump(?), 83; Justo (Mexican cook), 32; Lang (ethnologist?), 32; Noggie or Nakamoto (Japanese cook), 87, 88, 90, 91, 92; Stewart (ethnologist?), 32; Strong, Charles Munro,

48, 83, 85. *See also* Dalby, Edwin J.; Eastwood, Stewart C.; Gray Oliver or *Lapai*; Hunt, George; Ivanoff, Paul; Martineau, Capt.; Meany, Edmond S.; Myers, Williams E.; Phillips, William Wellington; Schwinke, Edmund August; Sojero; Upshaw, Alexander B.

Northcliffe, Lord, 70, 72

Northwest Coast culture area, 10, 12, 20, 95–107, 114, 143. *See also names of specific peoples*

Nunivak AK, 116, 128, 129; and its Eskimo people, 115, 116–118, 121–123, 129, *21*

Oglala. *See* Sioux or Lakota

Okanogan (Plateau), 19

Oklahoma, 17, 128

Oklahoma Indians, 128

Oliver, Gray (Apache). *See* Gray Oliver or *Lapai*

One Blue Bead (Crow), 147–148, *25*

Osage (Plains), 17

Osborn, Henry Fairfield, 14, 70, 72–73

Oto (Plains), 17

Paiute (Great Basin), 50

Palouse (Plateau), 82

Papago (Southwest), 27

Pawnee (Plains), 5, 57, 68, 70

Pecos (Pueblo), 51

Pend d'Oreille (Plateau), 19

Penitentes (Hispanic sect), 56, 153 n.23

periodical publications: *American Anthropologist*, 9, 45, 73; *Century*, 5; *Forest and Stream*, 5; *Frank Leslie's Magazine*, 8; *World's Work*, 66; *World's Work* reprint, 66–67. See also *The Hampton Magazine*; newspapers; *Scribner's Magazine*

Phillips, William Wellington, 16, 25, 30, 48, 92; biographical data, 36; fieldwork, 11, 82, *11*, *12*; reprinted writings by, 36–44, 54–56, 59–63; writing by, discussed, 65–66

Photo-Secession. *See* pictorialism

Picket Pin (Sioux), *13*

pictorialism, 4, *15*

picture opera. *See* musicale.

Picuris (Pueblo), 51

Piegan. *See* Blackfeet, Blackfoot, or Piegan

Pima (Southwest), 27, 143

Pinchot, Gifford, 8, 13, 83

Plains culture area, 5, 10, 12, 16, 20, 22, 25, 57–81, 82; sign language, 60. *See also names of specific peoples*

Plateau culture area, 18–19, 24, 25, 63, 82–95. *See also names of specific peoples*

Plover Bay, Siberia, and Eskimos, *20*

Pojuaque (Pueblo), 51, 132

Pomo (California), 111

Portland OR, 83, 90, 92

Pratt, Mary Louise (*Imperial Eyes*), 115, 147

Pueblo (Southwest), 6, 12, 20, 48–56, 63, 85, 143; ceremonies and their supposed indecency, 25; creation story, 132–133; farming, 52–53; religion, 50, 53; social organization, 50. *See also names of individual pueblos*

Puget Sound WA, 4, 18, 36, 71, 85, 95; Indians of, 5, 83, 95, 109, 136

Puyallup (Northwest Coast), 86

Quamichan Lake BC, *17*

Quatsino (Northwest Coast), 100

Quinault WA, 91, 93, 98–99

Red Cloud (Sioux), 64–65, 154 n.13, *4*

Red Hawk (Sioux), 66–67

Red Plume (Blackfeet), 77

representation of Indians by the project, 3, 29, 131–148

reservation, 15–16, 19–25; Navajo (AZ), 23; Spokane (WA), 83, *1*; Tulalip (WA), 5; Umatilla (OR), 84; White Mountain (AZ), 6, 17, 30, 32; Yakima (WA), 83, 85, 86. *See also* Colville Reservation

Rio Grande River, 6, 30, 48, 56, 132

Rocky Mountains, 19, 55–56, 57, 58, 73, 74, 82

Roosevelt, Theodore, 8, 10, 13, 15, 83, 141; quoted, 6

Running Owl (Blackfeet), 77

Russell, Billy (Blackfeet interpreter), 77

St. Michaels AK, and its Eskimo people, 116

Saishimulut (Willapa), 97–98

Saliva (Sioux), *13*

Sandia (Pueblo), 51

Sandoz, Mari (*Cheyenne Autumn*), 16

San Felipe (Pueblo), 51

San Ildefonso (Pueblo), 15, 48, 51, 132, *7*, *11*

San Juan (Pueblo), 48, 51, 56, 132

San Poil (Plateau), 19, 20

Santa Ana (Pueblo), 51

Santa Clara (Pueblo), 48, 51, 132

Santee (Plains), 68

Santo Domingo (Pueblo), 48, 49

Sarsi (Plains), 12, 17, 57

Schwinke, Edmund August, 11, 29, 87, 88, 158 n.12; biographical data, 91, reprinted writing by, 91–93; possible photograph by, *1*

Scribner's Magazine, 6, 8, 27, 45, 68; reprints from, 49–51, 63–65

Seattle (or Sealth), Chief (Duwamish), 4

Seattle WA, 4, 17–18, 66, 91, 112, 115; mentioned, 5, 6, 83. *See also* newspapers; Seattle, Chief

Selewik River AK, and its Eskimo people, 126–127

Seminole (Southeast), 143

Shakerism, Indian, 25, 85–87

Shasta (California), 111

Shoshone (Great Basin), 17, 85

Shot-in-the-Hand (Crow), 65, 66

Sia (Pueblo), 51

Sioux or Lakota (Plains), 16, 57, 63–65, 133–134, 143, *6*; Foster Parent ceremony, 68–69, 132, *13*; Pine Ridge Reservation and agency SD, 23, 132; of Rosebud area MT, 59, 62, 64; of Wounded Knee, 66–67; mentioned, 10, 12. *See also* Battle of the Little Big Horn; Wounded Knee

Slocum, John (Squaxon), 86

Slow Bull (Sioux), 67, *13*

Small Leggins (Blackfeet), 59, 154 n.4

Smithsonian Institution (Washington DC), 6, 14

Snake River ID, 94

"Snake River Indians," 94

Snohomish (Northwest Coast), 18

Snokomish (Northwest Coast), 19

Sojero (San Juan Pueblo), 10, 54–56

Southwest culture area, 6, 27, 30–56, 134. See also names of specific peoples

Spanish exploration and conquest: by Columbus, 50, 54; in the Northwest, by "Kunupi," 94; —, by "Soto," 94; in the Southwest, 50; —, by Coronado, 51; —, by Estevan, 50; —, by Marcos, 50; —, by Oñate, 51; —, by Zaldivar, 51

Speckled Snake (Creek), 16, 20

Spokan (Plateau), 83, 1

Squaxon (Northwest Coast), 86

Steptoe, Lt. Col. Edward J., 19

Stevens, Gov. Isaac Ingalls, 18, 19

Stewart, T. Dale, 118, 122–123, 129

Stieglitz, Alfred, 4

Strathcona, Lord, 72

subarctic culture area, 26. See also names of specific peoples

Suquamish (Northwest Coast), 18

Taos (Pueblo), 48, 51, 53–54, 56

Tearing Lodge (Blackfeet), 78–79, 81, 14

Teit, James, 12, 96, 99; quoted, 97–98

Tesuque (Pueblo), 51

Thornton, Russell (Cherokee), 133

Three Eagles (Nez Perce), 140

Tlingit (Northwest Coast), 95

Tolowa (California), 111

Tonimahl, Mrs. (Willapa), 97–98

Torres Straits Expedition, 70, 71

Truettner, William H. (The West as America), 13

Tsimshian (Northwest Coast), 95

Ukiah CA, 109, 112

Umatilla (Plateau), 19, 82

U.S. Bureau of Indian Affairs, 15, 20–25, 35;

U.S. Bureau of Indian Affairs agents: Anderson, Albert M., 24; Bubb, John W., 24

U.S. Bureau of Indian Affairs commissioners: Atkins, J. D. C., 21; Leupp, Francis E., 8; Morgan, Thomas J., 22

U.S. Census Bureau, 133, 161 n.5

U.S. General Allotment Act (Dawes Act; 1887), 23–24

University of Washington, Seattle, 4, 36, 48, 66, 131; and The Pacific Wave (student magazine), 131

Upshaw, Alexander B. (Crow), 32, 132, 137, 3, 4, 5; biographical data, 10, 85, 157 n.5; with Cheyennes, 59–62; as fieldworker, 83; as organizer, 66; mentioned, 31

Ute (Great Basin), 17

Vancouver, George, 102–103

Vancouver Island BC, 95, 98

Vanishing Race, Indians as, 5, 13–15, 75, 133–137, 145–146

Victoria BC, 93, 98

Wailaki (California), 111

Wanamaker stores, 2

Washington (state), 21, Indians of, 70

White Calf (Blackfeet), 59, 154 n.4

Wichita (Plains), 57

Wild Gun (Blackfeet), 77

Willapa (Northwest Coast), 17, 95–98

Wishham (Plateau), 83, 86, 88–89, 90

Wissler, Clark, 71, 73, 78

world's fairs, 8. See also Alaska-Yukon-Pacific Exposition

World War I, 26, 107

Wounded Knee SD, massacre at, 19

Wright, Col. George H., 19

Yakima (Plateau), 19, 82, 83, 84

Yankton (Plains), 68, 69

Yellow Kidney (Blackfeet), 77

Yellow Owl (Blackfeet), 77

Yokuts (California), 12, 147, 19

Yuki (California), 111

Yuma (Southwest), 27, 143

Yup'ik (Arctic), 114. See also Eskimo

Yurok (California), 111, 147

Zuni (Pueblo), 48, 51, 143